ART AND ARTISTS OF THE SOUTH

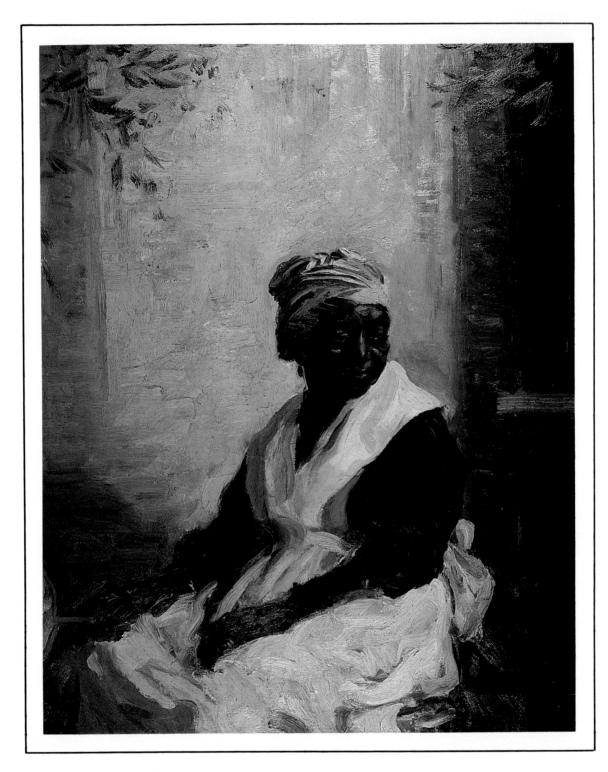

New Orleans Mammy by Wayman Adams

ART AND ARTISTS OF THE SOUTH

The Robert P. Coggins Collection

Essay and Catalogue entries by

BRUCE W. CHAMBERS, Ph.D.

University of South Carolina Press

Exhibition organized by the Columbia Museum of Art with the support of the South Carolina Committee for the Humanities, an agent of the National Endowment for the Humanities.

Manufactured in the United States of America

Library of Congress Cataloging in Publication Data

Chambers, Bruce W.
 Art and artists of the South.

 Catalog of an exhibition organized by the Columbia
Museum of Art.
 Bibliography: p.
 1. Art, American—Southern States—Exhibitions.
2. Coggins, Robert P.—Art collections—Exhibitions.
3. Art—Private collections—Georgia—Exhibitions.
I. Columbia Museum of Art. II. Title.
N6527.C48 1984 759.15′074′915 84-7385
ISBN 0-87249-432-2

CONTENTS

"ART AND ARTISTS OF THE SOUTH: THE ROBERT P. COGGINS COLLECTION"
EXHIBITION SCHEDULE
organized by
THE COLUMBIA MUSEUM OF ART

1984 June 9–October 14 Cheekwood Fine Arts Center, Nashville, Tennessee
 November 11–December 30 San Antonio Museum Association, Museum of Art,
 San Antonio, Texas

1985 January 13–March 3 Hunter Museum, Chattanooga, Tennessee
 March 24–June 16 Huntsville Museum, Alabama
 July 1–September 1 The Museum of the Confederacy, Richmond, Virginia
 September 17-November 2 Telfair Academy of Arts & Sciences, Savannah, Georgia

1986 January 5–March 30 Columbia Museum of Art, South Carolina
 April 13–June 15 Mint Museum, Charlotte, North Carolina
 July 25–August 31 High Museum of Art, Atlanta, Georgia
 September 12–November 9 Mississippi Museum of Art, Jackson
 November 20–January 11, 1987 The Arkansas Art Center, Little Rock

PREFACE

This exhibition is the culmination of an effort by myself, my staff and many other interested parties to acquire and study art and artists of the South. Being Southern born, reared and educated, I had included in my first exhibition of 1976–77 a nucleus of paintings executed in the South. It was after this exhibition that the direction of the collection was changed to primarily Southern Art. Because of the lack of definition on the subject, we had to come up with our own. After much thought and scholarly guidance, we included artists of Southern birth who remained sentimental to the South, or any artist who worked in the South and developed a Southern quality to his or her art, regardless of where they were born or reared.

I was dismayed by the cultural analysis of the state of the arts in the South presented by H. L. Mencken and William Faulkner in the 1920s and 1930s. I continued to believe this land below the Mason Dixon Line with its lowland swamps, beautiful forests, long stretches of farm and pasturelands and gentle mountains had to have inspired many artists to produce quality works consistent with the academic traditions of their contemporaries. I have not been disappointed in this pursuit and have found a large group of artists to choose from. Unfortunately, some of them could not be included in the collection because of economics or the lack of availability of their work.

There are several collections of regional art. Among them are the Groves Collection of Louisiana Art and the numerous private collections of the work of William Aiken Walker. I am sure many other collections exist, but they have not been exhibited or become well known.

There have been two museum exhibitions dealing with Southern Art. The exhibition American Painters of the South organized by the Corcoran Gallery of Art, Washington, D.C., in 1960 was the first exhibition, museum or private, devoted to the South. The more ambitious exhibition, Painting in the South, organized by the Virginia Museum of Art, spanning five centuries, is a major step in the direction of examining the role of the Southern artist in the academic American community. Ms. Ella Prince Knox, exhibition coordinator, and Professor Jesse Poesch, Newcomb College of Tulane University, have both been extremely helpful in their enthusiastic support for my project while completing a major exhibition of their own.

This exhibition differs in that it covers one and one quarter centuries. It begins in the first quarter of the nineteenth century, when the region was first being identified as a unified entity. This unity remained fairly stable until the end of the first half of the twentieth century when the migration to the Sun Belt began. I will not try to define the South for everyone. While the South does exist as a regionally unified region, each area maintains its own distinct integrity. However, some of the traits that culturally unify the South to its citizens are an innate love for this land below the Mason Dixon Line and the romantic remembrance of Southern gallantry, honor and the resolute idea that the socioeconomic identity of the south will last as long as there is Southern honor and culture. This spirit we hope to portray in this exhibition.

The South has experienced a leisurely economic and cultural development because of many factors. Our heat and humidity, the War Between the States, Reconstruction, the Great Depression, and lack of electrical power facilities have all been factors.

The documentation of Southern contributions to literature, music, and architecture have readily been identified and included in the overall perspective of their academic disciplines. It is hoped that this exhibition will help tear down the stereotype that the art of the South is merely a provincial footnote in art history and identify it as a viable and yet underdeveloped area of American art history. It is my final wish that this exhibition will be as pleasant and refreshing an experience for you as it has been for us.

ACKNOWLEDGMENTS

While it is impossible to single out the specific contributions of all those who have contributed to this project, I would like to especially thank the following: James M. Sauls, curator of the Robert P. Coggins Collection; D. Scott Chase and Gerald R. Tippens, members of my staff; and J. Mark Post, formerly of my staff; Dr. Bruce Chambers, author of the catalogue; Dr. Nina Parris, chief curator; Walt Hathaway, director; and Harriett Green, registrar, the Columbia Museum of Art, organizers of the exhibition; Robert Crowe, Hardy's Studio, photography; Shirley Lewis, secretary; Dr. W. Edward Holladay, Dr. George T. Mims, and Dr. Maury C. Newton, my partners in medicine; and Devant Crissey and Elizabeth Hatmaker, conservators of the collection.

The numerous dealers that have shared my interest in Southern Art and without whose real enthusiasm I could not have built this collection are listed in the provenance for the individual works within the catalogue.

Robert P. Coggins

FOREWORD

As a newcomer to the South I was somewhat bewildered when I discovered on my arrival that no one seemed to be an expert in the art produced by the southeastern states after early colonial days. Bit by bit I picked up a fact here or the name of a painter there, always surprised that excellent and sensitive works had been ignored by scholars and museum curators over the years.

Meeting Dr. Robert P. Coggins and his staff was a revelation, for as we explored his collection the history of southeastern art began to unfold before our eyes. While the collection is certainly not complete (no collection ever is) it is large enough in scope to reveal much of the history, the concerns and the feelings of those painters who knew the area so well.

For museum curators the sense of discovery is always an exciting prospect and working with the collection presented a learning experience. The staff of the Columbia Museum of Art has enjoyed the privilege of organizing the exhibition and we feel sure that the public will enjoy its own discovery of a unique collection assembled with both love and foresight. The essay by Dr. Chambers speaks eloquently for the artists who produced so much exciting work over the one hundred fifty years covered by the exhibition and provides the background for our understanding of the works. We would like to thank Dr. Coggins for establishing the collection and for making it available to the public and to thank the South Carolina Committee for the Humanities, an agency of the National Endowment for the Arts, for their assistance in bringing the project to fruition.

Nina Parris, Ph.D.
Chief Curator
Columbia Museum of Art

ABBREVIATIONS IN BIBLIOGRAPHICAL ENTRIES

AAA	*American Art Annual*
Champlin	John Denison Champlin, Jr., ed. *Cyclopedia of Painters and Paintings*, 4 Vols., New York, N.Y., 1913
Civil War	National Gallery of Art. *The Civil War: A Centennial Exhibition of Eyewitness Drawings*, Washington, D.C., 1961
Clement & Hutton	Clara Erskine Clement and Laurence Hutton. *Artists of the Nineteenth Century and Their Works*, 7th ed., rev., 1894; reprint, St. Louis, Mo., 1969
Coggins	Bruce W. Chambers, *Selections from the Robert P. Coggins Collection of American Painting*, Rochester N.Y., 1976
DAB	*Dictionary of American Biography*
DNB	*Dictionary of National Biography*
Fielding	Mantle Fielding. *Dictionary of American Painters, Sculptors and Engravers*, 1926; rev. ed., James F. Carr, comp., New York, N.Y., 1965
Groce & Wallace	George C. Groce and David H. Wallace, *The New-York Historical Society's Dictionary of Artists in America, 1564–1860*, New Haven, Ct., 1957
NCAB	*National Cyclopedia of American Biography*
PITS	Virginia Museum, Richmond. *Painting in the South, 1564–1980*, Richmond, Va., 1983
Samuels	Peggy and Harold Samuels. *The Illustrated Biographical Encyclopedia of Artists of the American West*, New York, N.Y., 1976
Sheldon	George W. Sheldon, *Amerian Painters*, enlarged ed., 1881; reprinted, New York, N.Y., 1972
Thieme-Becker	Ulrich Thieme and Felix Becker, et al. *Allgemeines Lexikon der Bildenden Künstler, von der Antike bis zur Gegenwart*, 36 Vols., Leipzig, 1907–1947
Tuckerman	Henry T. Tuckerman, *Book of the Artists: American Artist Life*, New York, N.Y., 1867
WWAA	*Who's Who in American Art*
WWWA	*Who Was Who in America*

INTRODUCTION

It is not often that an art historian has the opportunity to explore a whole subcontinent of information that has lain largely unmapped. But such is the case with the historic art of the American South. True, there have been those who have gone before, who have documented the art of particular cities or states, and have studied distinctive types of artifacts, such as portraits. On a state-by-state, cultural center by cultural center basis, the art of the South has been explored, and many of its individual artists have received scholarly scrutiny as well as retrospectives. But much of this information is fragmentary and little effort has been made to gather the available local and biographical information, to expand it, or to probe that larger body of images and data for its meanings.

The two such efforts that have been made are the Corcoran Gallery of Art's exhibition American Painters of the South held in 1960 and, opening in 1983, the Virginia Museum of Fine Arts' monumental survey of four centuries, Painting in the South.[1] These were both immensely important exhibitions, in which a massive effort was made to search out representative examples of art produced in the South over several centuries. The exhibits were accompanied by catalogues that contributed significantly to our knowledge and understanding of Southern art and artists.

These efforts required years of research digging into obscure sources and locating missing works, and such effort is itself a sign of the current state of knowledge of Southern art. As Ella-Prince Knox noted in her Introduction to the catalogue of Painting in the South, the current level of scholarship in Southern Art "is similar to the state of scholarship in American painting in general as late as the 1950s."[2]

One important reason for this paucity of knowledge is the almost total absence of collections of Southern art, whether formed privately or by museums. In almost every instance, the collecting of particular kinds of art, whether they be Italian trecento painting, Georgian silver, or Tiffany glass, has accompanied (if not preceded) their rediscovery and documentation by scholars. Each of the great museum collections in this country owes its unique character to the perspicacity and passions of individual collectors or curators. And yet in the South, there has been historically a curious absence of the collecting instinct which, even when it has surfaced, has tended to prefer anything but the art of its own region.

Where major art collections have been formed in the South, by individuals or by museums, they have been built around European ceramics, New England and Philadelphia furniture, French Impressionist painting, African sculpture, or even American Hudson River painting, but notably not around specifically Southern forms of artistic expression. In museums, Southern art is usually buried in storage, to be paraded out only to keep the local garden clubs and artists associations at bay. Until recently, it has been viewed as a provincial (perhaps retarded) cousin from the back pasture, who may lend a bit of local color to the proceedings, but who is an embarrassing rustic when it comes to matters of fine art.

This essentially defensive reaction—"we are our own severest critics (and don't need any help from the North, thank you, in noting our flaws)"—is unjustified in the extreme, even while it is prevalent to the same degree. For, to put it directly, when the effort of discovery is actually made, it will be found that the art of the South is as complex, diverse, and fascinating as the art of any other region in America, and just as often compelling, delightful, and beautiful.

It is not enough to say, as has been said in the past, that the South is just too big, too sprawled out, too broken up into isolated provinces for a coherent study of its art. Similar conditions existed in many parts of the North, the Midwest and the West, but the effort of scholarship and the discovery of the art of those regions have nonetheless gone on apace. The simple fact is that, in the absence of any drive to collect the art of the South, the art itself has naturally failed to emerge. In the complementary absence of any drive to understand the art of the South, there has been little effort to uncover and compile its documents, diaries, or other primary sources of information.

Which brings us to the point of this collection, the collecting instinct as conscientiously applied to Southern art.

Dr. Robert F. Coggins, of Marietta, Georgia, is not the only major collector of Southern art today, but he is the only one of my knowledge who has actively encouraged its exhibition and interpretation. If this makes him unusual, so too does the breadth of his interest in Southern art. For, while his collection is in no way definitive of historic Southern art—being constrained by available opportunities and resources—it is certainly both comprehensive and catholic in its dimensions, encompassing both professionals and self-taught naive painters, men as well as women artists, blacks and whites alike without prejudice as to their relative contri-

butions, but rather included simply because they had created works that piqued Dr. Coggins' curiosity and sparked his admiration. There are examples not only of painting in oil and watercolor, but also of drawing in a wide variety of media, and of crewelwork, and even a painting on a window shade!

In short, Dr. Coggins' collection is a personal selection, adventuresome and exploratory in character, rather than a survey that attempts conclusive definition. At the same time, there has been a conscious effort to achieve balance and range, and to avoid stereotypes. The artists represented in the exhibition worked in Georgia, Alabama, Mississippi, Louisiana, Tennessee, Virginia, North Carolina, South Carolina, and Florida. They ranged from Gatlinburg to New Orleans, from Richmond to Apalachicola, and from Blowing Rock and Tallapoosa to Marietta and Mobile. Their paintings and drawings span a century and a half of Southern art, from the end of the first quarter of the nineteenth century to the middle of the twentieth. There are artists who were born in the South and stayed—or returned—there to work, and others who spent only a few seasons there as winter residents.

There are those who specialized in still lifes, or portraits, or landscapes, and others who did a bit of each. There are visionaries and illustrators, seamstresses as well as ministers and lawyers, each of whom found ways to express his or her perceptions, insights and emotions in their art.

In all this variety of background, approach and subject matter, what is there that is identifiably Southern? Is it enough to say that the term, "Southern art," applies to any art that was produced in the South? Are there characteristics to be found in the art itself that parallel or complement traits of Southernness that have been identified by historians and writers?

It would be utterly fascinating if there were neat correlations between the art of the South and the dominant myths of Southern culture. That is, for example, if in the era of the Plantation South the efforts of Southern painters were confined solely to the portrayal of white-columned mansions, their patriarchal masters and sensuous (while still innocent) belles, and happy darkies singing in the fields as they slaved; or if, alternatively, in the age of William Faulkner and Erskine Caldwell, Southern art were filled with images of decadence, cruelty and ruin, redolent with the aroma of rotting vegetation and filtered through the dust of unpaved roads.

Just as the profound simplifications of Southern mythology continue to distort the perceptions of Northerners and Southerners alike, so do they also deflect any objective assessment of Southern art. In a phrase, if we continue looking for images that illustrate our time-honored fantasies of the region, we are bound to be locked into those few examples of Southern art in which our expectations are realized and to ignore the vast majority of instances where the art of the South does not correspond to our mythologies.

It is to Dr. Coggins' credit that he has not tried to force his collecting of Southern art into any preconceived set of ideas about the South. As a native Southerner, he is aware of the variety and independence of outlook and diversity of cultures that are more characteristic of the South throughout its history, and he has collected Southern art with a mind open to surprises.

If myth be believed, the biggest surprise is that there was any art worthy of the name produced in the South at all—at any point in its long history. Writing about the Old South in 1941 in his pivotal book, *The Mind of the South*, W. J. Cash stated that "the intellectual and aesthetic culture of the Old South was a superficial and jejune thing, borrowed from without and worn as a political armor and a badge of rank; and hence . . . not a true culture at all."[3] Writing in 1951 about the New South of the years 1877–1913, C. Vann Woodward registered the identical complaint:

Apart from religion, literature, and scholarship, the South of this period found extraordinarily meager means of expression. Painters there were, as well as sculptors, musicians, and architects. Aside from expressions of a strictly folk level of art, however, this generation of Southerners was almost totally devoid of any aesthetic achievement that can be recorded as a permanent contribution to the culture of which they were a part. The region was as dependent aesthetically as it was economically. It imported its art—what little it got—as it did other consumers' goods, from the North or from abroad. Standard art museums, like standard Carnegie libraries, appeared on town squares—mausoleums to house the remains of picked-over collections from the estates of the wealthy. They rarely contained a single worthy example of the masters or anything vital from the studies of living artists. Scarcely any generation of Southerners, save that which wrestled with the frontier, was so completely isolated from the main streams of Western culture."[4]

If both Cash and Woodward—whose contributions to understanding other aspects of Southern history and culture are immense—begin to sound like H. L. Mencken when they are reviewing the art of the south, it is probably because they had been utterly convinced by Mencken's 1920 critique in "The Sahara of the Bozart," that in the South, when it came to cultural attainments, there was simply no "there" *there*:

It is as if the Civil War stamped out every last bearer of the torch, and left only a mob of peasants on the field. One thinks of Asia Minor, resigned to Armenians, Greeks and wild swine. . . . In all that gargantuan paradise of the fourth-rate there is not a single picture gallery worth going into, or a single orchestra capable of playing the nine symphonies of Beethoven, or a single opera-house, or a single theater devoted to decent plays, or a single public monument that is worth looking at, or a single workshop devoted to the making

of beautiful things. . . . In all these fields the South is an awe-inspiring blank—a brother to Portugal, Serbia and Albania."[5]

It was as though it were easier to believe that the South of Jefferson and Randolph, Allston and Fraser, Calhoun and Lee, had been so ravaged by the North that no possibility existed of its cultural recovery. Since the possibility could not exist, neither could there be any accomplishment in the arts that could be allowed to disprove the general thesis.

This collection presents a contrary testimony. We see not only the tangible evidence of Dr. Coggins' collecting, but also the results in documentation of years of research and connoisseurship, performed and articulated by the doctor and his curator, James Sauls, as the collection took shape. This recovery of information (and, thereby, context) is no less important a contribution than the recovery of the artworks themselves.

I would like to acknowledge the considerable assistance in the preparation of this essay of the following persons, each of whom contributed insights, knowledge and moral support to its progress: Dr. Robert P. Coggins, James Sauls, Nina Parris, Boyd Saunders, Martha Severens, Robert M. Hicklin, Jr., Terry H. Lowenthal, Dave Knoke, Robert B. Mayo, David Bundy, Ella-Prince Knox, Jessie Poesche, Elizabeth Scott Shatto, Feay Shellman, William Scheele, John Henry, Margaret A. Murphy, Charles Shannon, David Silvette, Kevin Grogan, Gudmund Vigtel, William Barrow Floyd, Bernard Lemann, Frederick D. Hill, and James Berry Hill. I would like to make special acknowledgment, too, to my wife and children, whose patience and understanding eased the pressures of research and writing.

PORTRAITURE IN THE ANTEBELLUM SOUTH

From the early eighteenth century through the 1850s, the South's preference in art was portraiture, either in miniature or in full scale. The development of a system of property ownership that centered in the plantation and, with the plantation, in the family, led to the propagation of hundreds of likenesses, memorials to the physiognomies as well as status of their sitters. While the fondness of portraiture drew its inspiration first from the habits of the English aristocracy, by the last third of the eighteenth century it also echoed the interest of the Enlightenment in individual human distinctions and character. By the 1790s, the demand for such personal documentation had spread to the professional and mercantile classes—of both North and South—to such a degree that, until the advent of photography, all manner of artists, professionally trained or otherwise, were encouraged to try their hand at it.

The variety and range of early nineteenth-century portraiture in the South is clearly reflected in Dr. Coggins' collection. Charles Fraser, the leading portrait painter in Charleston in the 1820s and 1830s, and perhaps the finest American miniaturist of his era, is represented by a delicately tinted pencil drawing that is typical of his elegance as a draughtsman and of his keen perception of personality. James H. Shegogue, a Charlestonian of the following generation, painted an extraordinarily sympathetic—and early—portrait of one of his family's house servants. The existence of such a portrait is partly explained by the fact that house servants, as contrasted to field slaves, held a special status in both the white and the black communities, but one can also imagine that, in this instance, there were bonds of respect and familial affection between the artist and his sitter. In a similarly romantic style of portraiture, William Edward West, a Kentucky-born painter, portrayed the nineteen-year-old son of his patron in England, Joshua Bates—a portrait that remained unfinished due to the untimely death of the sitter in 1834.

The portrait of Alton Pemberton, by an unknown artist, is of a prosperous and wary plantation owner of the Georgia Piedmont, one of the new breed of landowners—ambitious, tough-minded, and shrewd—who flooded the interior of the South, particularly following the Indian Removal Act of 1830. A decade or so later, Joseph Jackson depicted a couple who had already established themselves in the upland South, in Asheville, North Carolina. English-born and trained, Jackson worked in a stiffer, more provincial manner which, in its resulting formality, also suggests his sitters' more Victorian outlook.

In contrast, there is the portrait of Rebecca Bowen, painted by a local limner in 1849 as a record for a grieving husband of his deceased wife—after she had been laid out in her coffin. Such posthumous portraits were common in the Victorian era and demonstrate the extent to which portraiture had become a habit of documentation almost more than an interpretation of individuality.

CHARLES FRASER (1782–1860)

Charles Fraser was born in Charleston, South Carolina, the youngest of fourteen children of Alexander and Mary Grimké Fraser. His father died in 1791; a year later Fraser was enrolled in the classical academy (later to become the College of Charleston) of the Rev. Robert Smith, where he formed a life-long friendship with his classmate, Thomas Sully. As the definitive book on Fraser (Alice R. Huger Smith and D. E. Huger Smith, *Charles Fraser*, Charleston, S.C.: Garnier & Co., 1924/1967) notes, Fraser was "fortunate in the social surroundings of his childhood and youth, for his family relations placed him at once in the circle of people of good breeding, education, and good taste."

Fraser graduated from the Academy in 1798, by which time he was already an accomplished amateur watercolorist, producing at the time a now famous sketchbook depicting the homes of his friends and acquaintances in Charleston and the surrounding countryside. These still stand as one of the earliest records of the South Carolina landscape.

His interest in art as a career increased with his associations with his classmate Sully and the slightly older painters Washington Allston—also a Charlestonian—and Allston's New-port, Rhode Island, friend, Edward Green Malbone. Fraser's friendship with Malbone, particularly, encouraged him to try his hand at miniatures as early as 1800.

But Fraser still felt obliged to continue in the legal career on which he was already well-embarked. He completed his law studies in 1807—the year of the deaths both of his mother and of his friend Malbone—and practiced law in Charleston until 1818. In the meantime, however, he maintained an active correspondence with other artists, visiting Malbone in Newport, Gilbert Stuart in New York, and John Trumbull in New York in 1806, and returning to New England, New York, and Philadelphia to see his many friends in 1816, 1824, and 1831.

Fraser retired from the law in 1818, and began to paint miniatures and portraits in Charleston on a full-time basis. The fineness of his draftsmanship, the delicacy of his modeling and color, and his acute grasp of individual mien and character quickly placed him in the first rank of portraitists, and he is acknowledged today as the premier miniaturist of his era. Universally admired by his friends as a raconteur and counsellor, he was honored in 1857 by a retrospective exhibition of 313 miniatures and 139 oils held in Charleston.

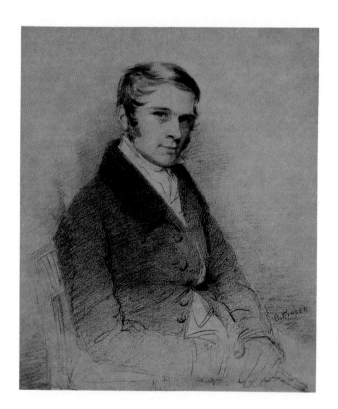

1. *Portrait of a Man*. ca. 1820–25.

Pencil and watercolor on paper. 6½″ × 5⅜″.
Signed in pencil, lower right: "C. Fraser".
Provenance: Ray Holsclaws, Charleston, South Carolina.

JAMES HAMILTON SHEGOGUE (1806–1872)

Too little is known of the life and artistic career of James H. Shegogue. Born in Charleston, South Carolina, he is said to have begun his professional career in New York City in about 1833, when he first exhibited at the American Academy. Except for several trips to Europe, he worked as a portrait, genre, historical, and landscape painter in New York until he moved to Warrenville, Connecticut, in 1862. Elected to full membership in the National Academy of Design in 1843, he served for a time as that institution's corresponding secretary. He died in Warrenville in 1872.

Clearly this large miniature with its inscription dates from before Shegogue's removal from Charleston, and portrays a household slave cherished by the Shegogue family. The competence and style of this portrait suggest a professional training already obtained by Shegogue in Charleston before 1833, possibly from a member of the Sully family of painters.

Groce & Wallace, 574–575; Fielding, 330

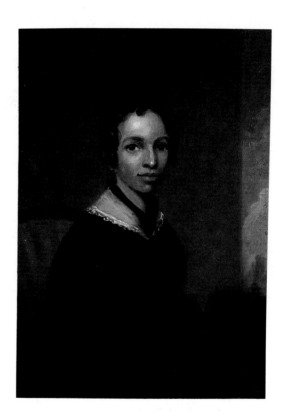

2. Colored Slave. between 1825 and 1833.

Oil on panel. 8″ × 6¹⁵⁄₁₆″, in case.
Inscribed on slip of paper attached to case: "Colored Slave—whom my Grandfather James Hamilton Shegogue—The artist, raised and of whom they were all very fond—He painted this portrait."
Provenance: Steve Miller, New York City; to Robert M. Hicklin, Jr., Spartanburg, South Carolina.

WILLIAM EDWARD WEST (1788–1857)

William Edward West, one of the more elusive of the South's major early nineteenth-century portrait painters, was born in Lexington, Kentucky, in 1788, the son of an ingenious watchmaker and inventor. West began his career as an artist by painting miniatures in Lexington, followed by several years' study with Thomas Sully in Philadelphia. For the next few years, he worked in Natchez, Mississippi, painting portraits, until a Natchez resident, Mr. Evans, provided him with funds to go to Europe in 1822.

West chose his first European sitters well, painting Lord Byron, and Byron's mistress, the Countess Guiccioli, at Leghorn, Italy, thereby winning widespread celebrity (the sitting, and the incidents that surrounded it, are described in Moore's *Life of Byron*). West spent three years in Italy, and then the winter of 1824–25 in Paris, finally settling in England where he remained until about 1840. He was befriended by a wide circle of British and American writers and artists, including Shelley, Leigh Hunt, Keats, Charles Robert Leslie, Sir David Wilkie, and Washington Irving, painting many of their portraits as well as an important portrait of the poet, Felicia Hemans. He exhibited at the Royal Academy and other London exhibitions from 1826 until 1837, but, due to an unfortunate financial speculation, he was obliged to return to the United States. From 1840 to 1850, he appears in New York City directories, as he does also in 1852; in the early 1850s, he was also painting in Baltimore. Due to illness, in about 1852 or 1853, West moved to Nashville, Tennessee, to live with relatives. He died in Nashville in 1857.

Among West's patrons in London was Joshua Bates, the wealthy American financier who served America's interests while a partner with the British banking firm of Baring Brothers and Company. Bates assisted many American travelers in Europe—among them West—and, in 1852, provided the foundation of the Boston Public Library. He also served as umpire between the British and American commissioners in 1854 in the settlement of claims still outstanding from the War of 1812.

The portrait is of Joshua Bates' only son, William Rufus Gray, who was killed in a hunting accident at age nineteen, on December 22, 1834. West's portrait of Bates' son could not have been begun much before the accident, and it appears in some respects never to have been completed. It remains, however, an expressive and sensitive portrait in West's romantic portrait style.

DAB, XX, 12; Tuckerman, 197–202 (and, for Joshua Bates: DAB, II, 52; NCAB, V, 195; DNB, I, 1318; George Walter Chamberlain, *History of Weymouth, Massachusetts*, III: *Genealogy of Weymouth Families*, Weymouth, Mass., 1923, 37)

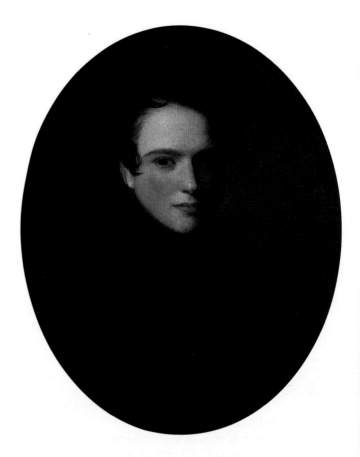

3. *Portrait of William Rufus Gray Bates.*
 ca. 1833–34.

Oil on canvas. 12⅝″ × 10⅜″.
Inscribed on stretcher: "Her Ladyship's bedroom" and "an unfinished picture by W. West. Eng. London".
Provenance: British importer, to Richmond, Va., art dealer, to David Silvette, Richmond, Va.

ARTIST UNKNOWN.

The 1820 Census for Burke County, Georgia (located on the Savannah River between Augusta and Savannah) lists Alton Pemberton, Jr., as head of a prosperous plantation that contained, besides himself, four white males, six white females, and thirty-six slaves (sixteen of them men and boys, twenty girls and women). Three of the members of his household were non-naturalized citizens, while twenty-six were listed as engaged in agriculture. Pemberton also operated a blacksmith shop with one employee. (Data provided in Robert Scott Davis, Jr., and Rev. Silas Emmet Lucas, Jr., compilers, *The Families of Burke County, 1755–1855, a Census*, Southern Historical Press: Easley, South Carolina, 1981).

The 1830 Census shows a considerable shrinking of Pemberton's resources: at that time, there were on his establishment only two white males besides himself, no white females, and twenty-three slaves, of whom fifteen were still men, but only eight women. The family of foreigners had presumably moved out, as had the daughters and at least one of the sons, and—if the record can be interpreted correctly—his wife had died. All of these changes had reduced the need for female slaves, while the male slaves were retained for the work of the plantation. The 1840 Census shows no record of Pemberton, who, if he had lived that long, would have been in his mid-to-late sixties at the time.

In 1820, Pemberton is shown as being between the ages of 45 and 49, his probable age in this portrait. Although the painter of this portrait cannot presently be identified, it was certainly someone—possibly French in training—with a gift for delineating character and attitude, and someone, too, probably stationed in Savannah. Among the portraitists known to have worked in Savannah around this time were David Bourdon, Jean Belzons, and Joseph P. P. L. de Clorivière, but neither these nor any other identified portraitist of the era can be associated with this intriguing likeness.

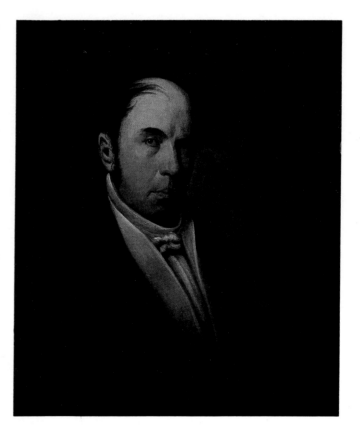

4. *Portrait of Alton Pemberton, Jr.* ca. 1820.

Oil on board. 15⅝" × 12½".
Inscribed, verso, upper center; "Alton Pemberton/ Burke
 County/ Georgia".
Provenance: Sammy J. Hardeman, Atlanta, Georgia.

JOSEPH JACKSON (1796–1850)

Joseph Jackson was born in 1796 in the village of Crawley, Oxfordshire, England. Between 1816 and 1823, he sent ten miniatures to exhibition at the Royal Academy from his home in Holywell, Oxfordshire. In 1822 he married Sophia Matilda Watts; they lived in Oxford and Cheltenham until 1824, when they moved to London, where Jackson was engaged in drawing the monuments in St. Paul's Cathedral. In 1825, they returned to Oxford, where they resided until 1831, although Jackson continued to send miniatures to exhibition in London.

Joseph Jackson emigrated to the United States in August, 1831, living in New York until 1833 when, joined by his wife, they moved to Charleston. Jackson, his wife, and his son Henry were active in Charleston as miniature painters, portraitists and painting restorers from 1833 to 1850, when Joseph died of a paralyzing stroke. At first "struggling against misfortune and adversity," Jackson's "urbanity of manner and attention to his business", especially in the restoration of old paintings, won him increasingly positive notice in the Charleston community (Charleston *Courier*, Aug. 12, 1847; Charleston *Mercury*, Oct. 3, 1848; Charleston *Courier*, June 15, 1850, obituary)

These two portraits are of members of the Woodfin family of Asheville, North Carolina. Their exact identity is unknown, but they may represent either Col. Nicholas W. Woodfin (1810–1875), a prominent lawyer, farmer, and state

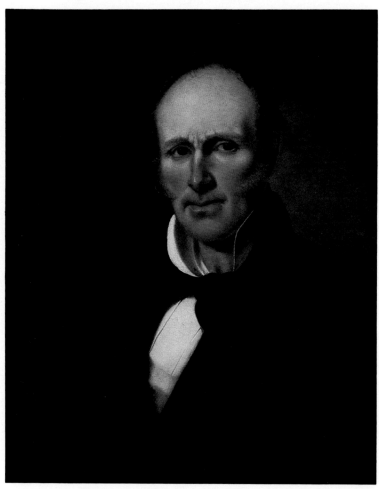

5. *Portrait of a Gentleman of the Woodfin Family.*
1841.

Oil on canvas. 24⅛″ × 19⅝″.
Signed and dated, lower left: "By Jos. Jackson, 1841".

senator, and his wife, Eliza Grace McDowell, whom Nicholas married in June, 1840, shortly before these portraits were painted, or Nicholas' brother, John W. Woodfin (1818–1863), also a lawyer and a soldier, and his wife, Maria, Eliza McDowell's sister. The portraits were probably painted in Charleston.

Coggins, 55–56; Anna Wells Rutledge, comp., "Notes on Joseph Jackson, Miniature Painter, from Gallery Files," in Gibbes Art Gallery, Charleston, S.C.: Artist Files

6. *Portrait of a Lady of the Woodfin Family.* ca. 1841.

Oil on canvas. 24¾″ × 19⅝″.
Signed and dated, lower right: "By Joseph Jackson 184 (1?)".
Provenance for both works: Private dealer, Charleston, S.C.
Exhibitions: Memorial Art Gallery of the University of
 Rochester, "Selections from the Robert P. Coggins Collec-
tion of American Painting," The High Museum of Art, Atlanta, Georgia, December 3, 1976–January 16, 1977; Memorial Art Gallery of the University of Rochester, Rochester, N.Y., February 25–April 10, 1977; Herbert F. Johnson Museum of Art, Cornell University, Ithaca, N.Y., May 4–June 12, 1977 (illustrated in catalogue, pp. 55 and 56).

ARTIST UNKNOWN.

The product in all likelihood of an itinerant limner, this painting was evidently intended to serve as a permanent record for a grieving husband of his deceased young wife, and was completed while she was already laid out in her coffin.
—James M. Sauls, Curator, The Robert P. Coggins Collection

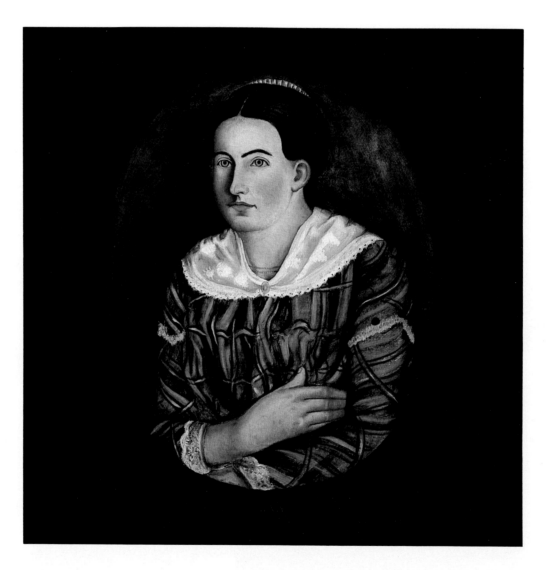

7. *Portrait of Rebecca Bowen.*
 1849.

Oil on canvas. 26¼" × 26¼".
Inscribed on frame, at bottom, in gold leaf: "Rebecca Bowens Port. She was married to Joseph Bowen the 30th day of June, 1848. She was departed this life the 22 day of March, 1849, Aged 17 yrs. 10 months 3 weeks 4 days"

Provenance: Atlanta estate sale; Charles Murphy, Atlanta; Terry H. Lowenthal, Savannah, Ga.
Exhibitions: Georgia Council for the Arts, "Missing Pieces: Georgia Folk Art, 1770–1976," Atlanta Historical Society, Dec. 5, 1976–Feb. 27, 1977; The Telfair Academy of Arts and Sciences, Savannah, April–July, 1977; The Columbus (Ga.) Museum of Arts and Crafts, Sept.–Oct., 1977 (illustrated in catalogue, No. 10).

LANDSCAPE PAINTING: 1830–1865

While landscape painting in its own right (as opposed to its use as a background to portraiture) was uncommon in American art of the eighteenth century, by the 1790s there were a number of artists—in the South as well as in the North—who had begun to record the landscape in their sketchbooks or, more rarely, in finished pictures. In this exercise, they were following in the footsteps of English painters who had discovered "the tour" as a pictorial mode. Records of particularly notable places one had seen might be either documents of their architectural features or, if they were natural wonders, interpretations of their picturesque character.

In English aesthetics of the late eighteenth century, "the picturesque" had become a category of the beautiful, one connoting irregularity and movement rather than the more classical balance and repose. A cabin in the woods, a meandering stream, cattle grazing in the meadow—these were picturesque. They spoke, not of avenues, but of walks. They had a rustic quality that compelled poetic meditation.

It is against this background that the development of Southern landscape painting should be seen, for painters working in the South shared fully in the changes of perception and taste that marked American landscape painting generally between 1800 and 1860.

Outside of Baltimore, Alexandria, and other older centers of Southern culture, the earliest Southern landscapes appear in amateur artists' sketchbooks, such as that which Charles Fraser assembled of views of the homes of his family and friends in South Carolina in the late 1790s. George Washington Sully, Thomas Sully's nephew, also painted scenes in watercolor of places he had lived in or visited in the Florida Panhandle in the early 1830s, such as his *Episcopal Church at Apalachicola*, executed when the artist was seventeen. Although the works of a precocious observer, Sully's paintings are also among the earliest documents of Florida settlement.

At the same time as Sully was painting his scenes of Florida, the picturesque landscape was in full blossom in the North with the Hudson River landscapes of Thomas Doughty, Asher B. Durand, and Thomas Cole. Among the more prolific practitioners of landscape painting as poetic scenery was Russell Smith of Philadelphia, who was in fact a painter of theatrical scenery for playhouses and music halls up and down the eastern seaboard. In Renaissance fashion, however, Smith was not only an accomplished easel painter, but an amateur geologist and geological illustrator. It was in this latter capac-

ity that he traveled to Charlottesville, Virginia, in 1844, bringing along his watercolor sketchbook to record, in his words, "the gracefull and picturesque ranges of the Blue Ridge," with their "cultivated slopes," "tufted woods," and "long clouds of mist."[6]

Smith had already made several paintings of Mount Vernon which, of all American houses, had become the one most enriched with historical associations, and an important and popular subject in an age of national self-discovery. To be discovered and painted, however, were not only the familiar landmarks of American history, but also the habits and mores of the American people, including those activities that confirmed the promise of the new nation. Smith's *Baptism in Virginia* is just such an image, showing a group of Tidewater Episcopalians gathering at a river for a mass baptism.

If Smith brought to his landscapes an appreciation of national identity as it was expressed in its regional manifestations, T. Addison Richards gave clearer definition to a specifically Southern identity through his paintings and writings. For, even though Richards spent only six years of his life in the South, his stories, travel accounts, and pictures of the South in the 1840s and 1850s were to have a major impact on the growing awareness, on both sides of the Mason-Dixon Line, that the South had become a distinctive and in many ways unique sort of place.

It was Richards' hope, early in his career when he was living in Penfield, Georgia, to record the many undiscovered and unusual features of the Southern landscape. From 1842 through 1859, he was to accomplish his goal through a series of illustrated books and articles on the South. His two landscapes in this exhibition present a telling contrast between the settled Plantation South and the hazardous Southern wilderness. *River Plantation* is an idealized image of the gracious, unhurried life of the Southern gentry who had brought a cultivated sense of order to the landscape. *Encountering an Alligator* is a scene of exaggerated fierceness that takes place in the kind of overripe, alien nature that even then still threatened to regain its hold on the land.

William C. A. Frerichs brought a third point of view to landscape painting in the South in the years immediately prior to the War between the States. Born in Ghent and trained at The Hague and in Brussels, Frerichs' style reflects the Dutch precedents of Ruisdael and Hobbema with their dense foliage and shifting patterns of light and shade. After

emigrating to the United States in 1850, Frerichs obtained a teaching position at Greensboro Female College in North Carolina. From this base of operations until 1863 or 1864, he explored the forests and waterfalls of the Blue Ridge at a time when these were still uncharted territory.

The different facets of the Southern landscape as they were understood by 1860 are neatly conflated in a single image in the curious *Constitution Window Shade*. Painted window shades, used much like colored glass to enliven a domestic interior, were nonetheless a fairly uncommon form of decoration. This one, probably painted in the early 1860s, seems to celebrate the Constitution of the South as a whole (that is, of the Confederate States), for it borrows elements from the State Seals and landscapes of the South's different parts—its rice and wheat fields, tropical palms, riverboats, and sea-

coast, together with some impossibly alpine mountains. Each of these features, together with the ubiquitous cotton which is notable by its absence from this enigmatic summary, was to become in its own right one of the characteristic types of Southern landscape after the War between the States.

In 1863, during the war, the city of Charleston was under siege by Union naval forces. The commander of those forces assigned at least one artist to sketch the Confederate defense positions, among them Secessionville, the site of a Union defeat the previous year. Working in a manner not unlike the earlier sketchbook artists, this anonymous watercolorist records what he sees with meticulous attention to detail. In this case, the skills of the landscape painter had a direct, pragmatic function, to capture a likeness of use to the Federal war effort.

GEORGE WASHINGTON SULLY (1816–1890)

George Washington Sully was one of seven children of Chester and Ann Hendree Sully, and thus the nephew of Chester's brother, the artist Thomas Sully. Born in Norfolk, Virginia, in 1816, George Washington Sully moved with his parents to Florida in the early 1820s.

He was already painting in watercolors at age 13, when he recorded a visit to Bermuda (see Linda V. Ellsworth, "George Washington Sully," *Antiques*, Vol. 123, No. 3 (March, 1983), pp. 600–605). Between 1829 and 1833, he and his family were living in the Florida Panhandle, probably in Magnolia, a now-abandoned village on the St. Mark's River just south of Tallahassee. Sully also visited and recorded in watercolor the hamlets of Aspalaga and St. Mark's, and the larger towns of Tallahassee (in 1832) and Appalachicola (in 1833). It is possible that the artist served in the war against the Seminole Indians in 1833, and he can be found in Pensacola in 1834.

When his father died in Columbus, Georgia, in 1834, Sully moved with his mother and family to New Orleans, arriving there by 1835. His mother died a year later, and Sully seems to have taken on the profession of cotton broker by 1836. He continued to paint watercolors of New Orleans, however, until about 1840 or 1841, among the most interesting of which are three trompe l'oeil rack pictures showing New Orleans calling cards. In addition to these still-lifes and his many views of Florida and New Orleans buildings and landscapes, Sully also painted birds and a number of charming cartoons and caricatures.

The remainder of Sully's life was spent as a cotton broker. He married Julia Meigs Austin in 1839; she died two years later shortly after their daughter Julia was born. In 1845, he married Harriet Jane Green and lived with her in New Orleans until the 1850s, when they moved to Mississippi. Their son Thomas, later a prominent New Orleans architect, was born in Mississippi in 1855. By 1862, the Sullys were living in Covington, Louisiana, just north of Lake Pontchartrain, where Sully and his wife both died in 1890.

Acknowledgment to William Barrow Floyd, Lexington, Ky.

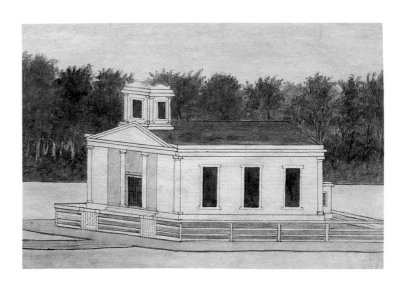

8. *Episcopal Church, Appalachicola, Florida.* ca. 1833.

Watercolor on paper. 4¾" × 6¼".
Inscribed across bottom: "Episcopal Church, Appalachicola, Florida".

SEE ALSO #44

WILLIAM THOMPSON RUSSELL SMITH
(1812–1896)

W. T. Russell Smith was one of the Renaissance men of the nineteenth century, a landscape artist, architect, scientific illustrator, and theatrical scenery and curtain painter. Born in Glasgow, Scotland, the son of a manufacturer of edge tools, he came with his family to the United States in 1819, settling first in the Ligonier Valley in Pennsylvania, and then in Pittsburgh.

By 1831, Smith had already done both scenery painting and acting for the local Thespian Society, and had served as caretaker of James Reid Lambdin's museum in Pittsburgh while taking lessons from Lambdin in painting. In 1833, he was asked by Francis C. Wemyss, a Philadelphia theatrical manager, to do scenery painting for the first professional theater in Pittsburgh, which Wemyss had been invited to orga-

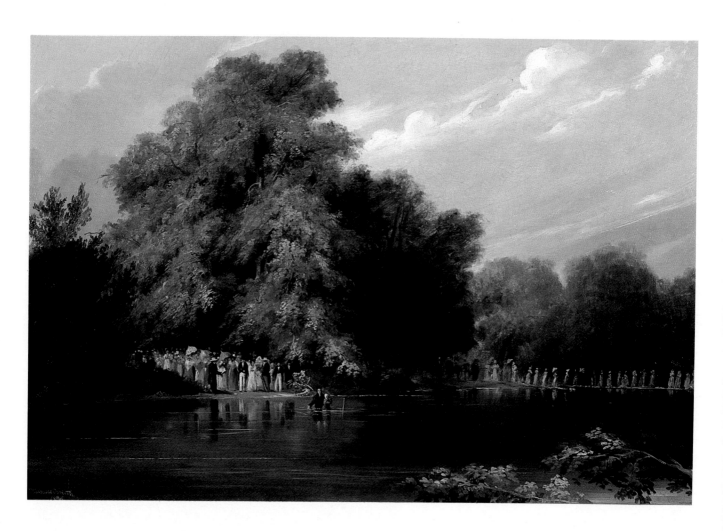

9. Baptism in Virginia. 1836.

Oil on canvas. 19¼″ × 28¼″.
Signed and dated, lower left: "W. T. Russell Smith 1836".
Provenance: Kennedy Galleries, Inc., New York.
Publications: William C. Davis and the Editors of Time-Life Books, *Brother against Brother: The War Begins (The Civil War:* Vol. I), Time-Life Books, Alexandria, Va., 1983, illustrated pp. 12–13.

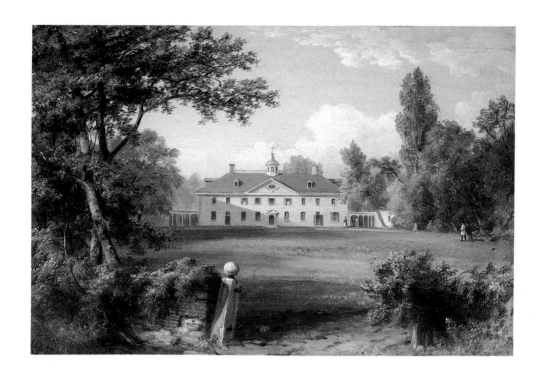

10. *Mount Vernon. 1836–1876.*

Oil on canvas. 12″ × 18″.
Signed and dated, lower left: "R. S. 1836–76".
Provenance: Vose Galleries, Inc., Boston, Mass.

nize. He continued working for Wemyss' theaters in Philadelphia and Washington into the 1840s, achieving such renown in his specialty that he received commissions for other theatrical scenery and drop curtains throughout the East, from Boston to Georgia, right up to the eve of the War between the States. After the war, he continued as a theatrical artist, identified primarily with the Pennsylvania Academy of Music in Philadelphia.

But Smith's activities were seldom confined to scenery painting alone. He spent his summers on sketching tours, of the Juniata, Susquehanna, and Potomac rivers, the White Mountains, and Upstate New York, and spent two years (1851–52) painting landscapes in Europe, traveling in England, Wales, Scotland, Switzerland, Italy, France, and Holland. He designed and built two studio-homes near Philadelphia, the first in Branchtown, the second, called "Edgehill", near Jenkintown, which was equipped with a special apparatus to accommodate the full-scale scenery painting

that Smith preferred to work on at home.

He was in demand, too, as a scientific illustrator, particularly of geological treatises, but he also painted lecture illustrations and at least one large "oriental landscape" for the Peale Museum in Philadelphia in 1838. His geological interests took him on several expeditions, most notably with William Barton Rogers to Virginia in 1844, and he corresponded as well with Benjamin Silliman and Sir Charles Lyell, both of whom sought Smith's assistance.

Of the three works by Russell Smith in this collection, two date from a trip which the artist made in 1835–36 to Washington, D.C., to paint scenery for Wemyss for the old Washington Theatre. While in Washington, Smith was also asked to look after the actor, Junius Brutus Booth (father of Edwin) by keeping him "away from barrooms and other temptations" (Virginia E. Lewis, *Russell Smith, Romantic Realist*, University of Pittsburgh Press: Pittsburgh, Pa., 1956, p. 51). In order to accomplish this feat, the painter escorted the actor

to all of the historic landmarks around the city, including Mount Vernon, all the time making his own sketches for use later in easel paintings. Both *Baptism in Virginia* and *Mount Vernon* originated in these tours, although *Mt. Vernon* was not deemed completed until forty years later.

The watercolor of Charlottesville dates from the geological expedition of 1844, during which Smith and William Barton Rogers spent several weeks in Charlottesville while Rogers lectured on geology at the University of Virginia. In his journal for July 4, 1844, Smith wrote a description of the landscape around Charlottesville that closely parallels his painting (the grammar and spelling are Smith's):

The characteristics of the scenary here is the gracefull and picturesque ranges of the Blue Ridge, Southwest into the Ragged mountains and Monticello. The intermixture of cultivated slopes with the tufted woods is a beautifull feature, the long clouds of mist skirting their bases in the morning and their rosey summits at evening. (Lewis, *Russell Smith*, pp. 100–101).

DAB, XVII, 340; Vose Galleries, *The First Exhibition in Fifty Years of Oil Paintings by Russell Smith (1812–1896), and His Son, Xanthus Smith (1839–1929)*, Boston, Mass., 1977; Vose Galleries, *Russell Smith (1812–1896); Xanthus Smith (1839–1929): Pennsylvania Landscapes, 1834–1892*, Boston, 1979; Vose Galleries, *Russell Smith (1812–1896): Views of Europe, 1851–1852 and Later*, Boston, 1981

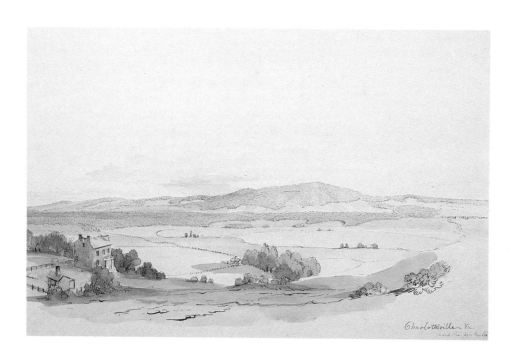

11. *View of Charlottesville.* 1844.

Watercolor on paper. 11″ × 16¼″.
Inscribed, lower right: "Charlottesville, Va., and the South Mt."
Provenance: Vose Galleries, Inc., Boston; Robert M. Hicklin, Jr., Spartanburg, S.C.

THOMAS ADDISON RICHARDS (1820–1900)

T. Addison Richards—painter, illustrator, writer and teacher—can be counted among the leading artists of the South in the mid-nineteenth century, for, even though he spent only six years of his life there, his drawings, prints, paintings, stories and travel accounts of the South had a major impact on the way in which the South was perceived for the remainder of the century.

The son of William Richards, a Baptist minister, Thomas Addison Richards was born in London, England, in 1820. He emigrated with his parents to the United States in 1831; stopping briefly in New York City, the Richards family first settled in Hudson, New York. Some time before 1838, they moved to Charleston, South Carolina, and then to Penfield, Georgia, where William was appointed a charter trustee of Mercer Institute (now, University), and where, in 1839, he became the first teacher at the Penfield Female Seminary.

By 1838, Addison had already collaborated with his brother, the editor William Carey Richards, in the publication of a book on flower painting, *The American Artist.* For the next few years, Addison taught art classes in Augusta before the largely unexplored landscape of his adopted state drew him to record its picturesque features. The result of his curiosity and natural skill as a draftsman was *Georgia Illustrated* (1842), a series of eleven steel engravings, based on Richards's drawings, and accompanied with texts by various authors. This book drew the favorable attention of Horace Greeley, the New York editor, who called Richards "the [Thomas] Doughty of the South."

Soon after this book was published, the two Richards brothers embarked upon a monthly literary publication, *The Orion.* William Carey Richards described Addison's role in the magazine in the first issue:

Our brother is permanently connected with the work as artist, and, we are happy to add, as a contributor. He will travel from Virginia to Louisiana to make drawings of such scenery as may be worthy of delineation . . . the moment our subscription list will allow it, we will furnish one splendid original southern landscape every number." (cited in Louis T. Griffith, "T. Addison Richards: Georgia Scenes by a Nineteenth Century Artist and Tourist," *Georgia Museum of Art Bulletin,* Vol. 1, No. 1 (Fall, 1974), p. 11).

In 1842, the engraving of Addison's drawings for the magazine was done by James Smillie—at a cost, William Carey noted in one issue, of $300 a plate. In 1843, the second and final year of *The Orion's* publication, the plates were both drawn and lithographed by Addison himself, in one of the first uses of lithotints in the United States.

In the last months of *The Orion's* existence, it was moved to Charleston, South Carolina, where Addison was engaged in portrait painting and art instruction. In 1845, he moved to New York City, where he began two years of study at the National Academy of Design. Professional success came swiftly: in 1845, three of his paintings were selected for the American Art Union lottery. Chosen an associate member of the National Academy of Design in 1848, he became a full member three years later, and from 1852 to 1892 served as the Academy's corresponding secretary. He was one of the founders of the Artists' Fund Society, president of the New York Sketch Club, the first director of the Cooper Union School of Design for Women (1858–60), and professor of art at New York University from 1867 to 1887.

Addison continued to work with his brother, William Carey, who in 1848 had moved to Athens, Georgia, where he edited a new weekly illustrated magazine, the *Southern Literary Gazette,* to which Addison contributed both articles and illustrations. In the 1850s and 1860s, Addison also wrote travel articles, stories and novelettes for such Northern publications as *Harper's New Monthly Magazine* and *The Knickerbocker,* while traveling widely to sketch and paint landscape views. Some of his tales appeared in a book entitled *Tallulah and Jocassee* (1852), which was republished in 1853 as *Summer Stories of the South.* In these and other stories published a year later as *American Scenery,* Addison attempted, in his words, "so to relieve the gravity of fact with the grace of fiction, as to present at the same time an instructive topography and an entertaining romance" (Preface).

This attitude is well-illustrated in his descriptions of Southern life that appeared in his article, "The Rice Lands of the South" (*Harper's New Monthly Magazine,* Vol. 19, No. 114 (November, 1859), pp. 721–738). This documentary of plantation life in the rice belt of the Georgia-Carolina coast also describes the pastimes of plantation owners, among which was alligator hunting—which Richards illustrates in an engraving in the article (p. 736) which serves as the study for the painting in this exhibition.

In the painting, Richards captures the primordial eerieness of the swampy landscape with its moss-laden trees, brackish water, cypress knees, and peculiar slant of light; the presence of man seems almost incidental to the natural exaggerations of the setting. The scale of the alligator, which at first seems startling, is accounted for by Richards himself in his chapter on Georgia that appeared in his major publishing (and illustrating) achievement, the *Appleton's Illustrated Hand-book of American Travel* (1857; 2nd ed., 1860):

When I first read Bartram's account of alligators more than twenty feet long, and how they attacked his boat and bellowed like bulls, and made a sound like distant thunder, I suspected him of exaggeration; but all my inquiries here and in Louisiana convinced me that he may be depended upon. (p. 272)

In the same chapter, Richards also describes a humorous example of the alligator's voracious appetite:

The alligator is often seen sunning himself on the shores of the lower waters of the Savannah, being abundant in the contiguous swamps. They are dangerous reptiles to deal with, especially when in ill humor. We once saw a large specimen of this genus, who had swallowed, as his "post-mortem" discovered, a bottle of brandy and a certificate of membership in a Methodist church. The coroner's inquiry asked after the owners of the articles, but inference, only, answered the question. (p. 271)

On the same page on which this incident is related appeared a view of the Savannah River that is close in many of its features to *River Plantation*. In this painting, Richards captures the alluring quality of the quiet, slow-paced life of the plantation; both the river and the figures riding alongside it assume the same unhurried gait, which the artist, in his article on "The Rice Lands of the South," attaches to the "habits of life" to which "may be traced the certain air of gentlemanly and chivalrous character" of the Southern plantation owner, who "never buries the man in the business,

12. *River Plantation.* ca. 1855–60.

Oil on canvas. 21¼″ × 30″.
Signed, lower left: "T. A. Richards".
Provenance: Kennedy Galleries, Inc., New York; Robert M. Hicklin, Jr., Spartanburg, S. C.
Exhibitions: Atlanta Historical Society, "Land of Our Own: 250 Years of Landscape and Gardening Tradition in Georgia, 1733–1983," Atlanta, Ga., March 1–August 31, 1983.
Publications: Mary Levin Koch, "The Art of Thomas Addison Richards," *op. cit.*, pp. 19–20 (Fig. 21), and No. 12 in catalogue, p. 33.

but makes of his business itself his social enjoyment and his true life." (p. 736)

In addition to his many landscapes, Richards frequently exhibited still life paintings such as the *Basket of Peaches*. Placed in an outdoor setting, this is probably one of three such paintings of peaches that the artist exhibited between 1865 and 1883, and was once accompanied by a companion piece, now lost.

After a long and full career that encompassed nearly the whole of the nineteenth century, Richards died in Annapolis, Maryland, in 1900. Only recently have scholars begun to re-examine his extensive contributions to American art and literature. —James M. Sauls, Curator, The Robert P. Coggins Collection

DAB, XV, 559; NCAB, VIII, 425; Groce & Wallace, 535; Clement & Hutton, II, 208–209; Coggins, 73. Special acknowledgment to Mary Levin Koch and Louis T. Griffith.

SEE ALSO #46

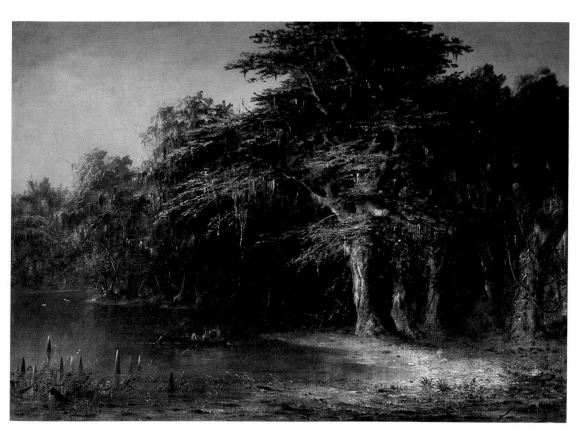

13. *Encountering an Alligator.* ca. 1857–59.

Oil on canvas. 21¼″ × 30″.
Signed, lower left: "T. Addison Richards".
Provenance: Sotheby-Parke Bernet Auction, Los Angeles.
Publications: Mary Levin Koch, "The Romance of American Landscape: The Art of Thomas Addison Richards," *Georgia Museum of Art Bulletin*, Vol. 8, No. 2, 1983, p. 19 (Fig. 20), and No. 11 in catalogue of "Extant Paintings, Prints, and Drawings by T. Addison Richards," p. 33.

WILLIAM CARL ANTHONY FRERICHS
(1829–1905)

William Karel Anthonius Frerichs (he was to Anglicize his names later upon moving to the United States) was born in Ghent, then part of The Netherlands, on March 2, 1829. From the ages of six through fourteen, he attended the Royal Academy at The Hague, studying art as part of his regular curriculum with Andreas Schelfhout and Bartholomeus J. van Hove, two forerunners of the "Hague School." For the next three years he attended the University of Leyden in preparation for a medical career, but he returned to the art school at The Hague in 1846, graduating with honors the following year. From 1847 to 1849, he continued his professional art training at the Royal Academy of Brussels, and then spent a year traveling in Europe, until Major August Davasae, the American Charge d'Affaires at The Hague, suggested that Frerichs begin his career in the United States and provided him with letters of introduction to that end.

Thus, in 1850 Frerichs arrived in New York, fully trained as an artist in the Dutch tradition. For four years, he lived in Manhattan, exhibiting once at the National Academy of Design in 1852, the same year he was elected to the New York Sketch Club (thereby demonstrating an affiliation with the Hudson River School landscape painters). In 1854, he married and accepted a teaching post as Professor of Arts and Languages at Greensboro Female College (now Greensboro College) in North Carolina, a post he assumed in 1855.

While portraits were among Frerichs' earliest recorded paintings, he soon discovered an untapped trove of landscape subjects in the North Carolina mountains. Despite the difficulties of access and occasional thefts by Indians of his paintings and supplies, Frerichs thus became the first painter to explore and give pictorial definition to the gorges, waterfalls, and foliage of the Blue Ridge around the French Broad and the Sauratown Range. His early preference, particularly, for waterfall scenery, while comparable to the interests of Thomas Cole and John F. Kensett, also reflects Frerichs'

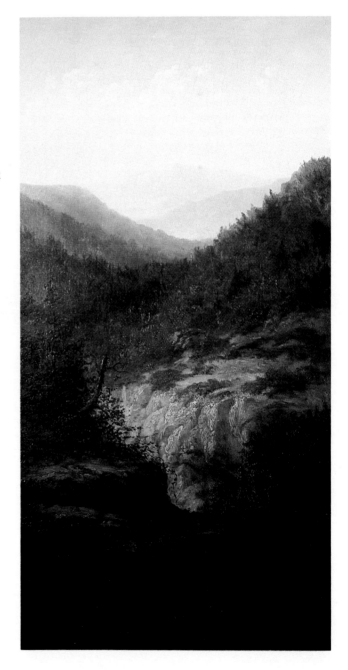

14. *Gorge, North Carolina.* ca. 1855–60

Oil on canvas. 30″ × 16¼″.
Signed, lower left: "W.C.A.F."

knowledge of Ruisdael and other Dutch masters of the seventeenth century.

In 1863, Greensboro College was destroyed by fire, and along with it, Frerichs' entire art collection. He was then invited to teach at Edgewood Seminary and, when the seminary was taken over as a hospital for Confederate troops, at Quaker College in New Garden, North Carolina. While at New Garden, he was appointed to special duty as an artist with a Confederate corps of engineers inspecting the iron mines and works of the Sauratown range. After being taken prisoner—and released—three times, Frerichs decided to evacuate himself and his family to the North. They arrived ill and penniless in New York in the late winter of 1865.

From 1865 to 1869, Frerichs maintained a studio in Manhattan, while living first in Jersey City and then in Morrisania. They then moved to Tottenville, on Staten Island, where they became neighbors of Jasper Cropsey, William Page, and Christopher P. Cranch. Frerichs continued traveling in search of landscape subjects, for his paintings record the features of the Connecticut River Valley, the White Mountains of New Hampshire, the Hudson River, and even Quebec. He also painted marines, animal (especially cattle) subjects, and winter skating scenes, in all three strongly reflecting his Dutch precedents and training.

In 1880, Frerichs moved with his second wife (his first had died in 1874) to Newark, New Jersey, where he was to remain a resident for twenty years. In 1900, he returned to Tottenville to live with his eldest son, although he maintained a mailing address in Newark until 1902. He died in Tottenville on March 16, 1905.

Acknowledgment for this information is made to Hildegarde J. Safford and Benjamin F. Williams, essayists for the catalogue, "W. C. A. Frerichs", North Carolina Museum of Art, Raleigh, 1974.

W. C. A. Frerichs—Groce & Wallace, 243

15. *Waterfall, North Carolina.* ca. 1855–60

Oil on canvas. 30″ × 16″.
Signed, lower center: "W.C.A.F."
Provenance for both works: Jeffrey Alan Galleries, New York

ARTIST UNKNOWN.

Window shade paintings, while relatively uncommon, were a form of interior domestic decoration. This one may well have been painted at about the time of secession for a Southern home, as it alludes to a "Constitution" that unites the Southern states. Its central shield combines emblematic motifs from the state seals of Tennessee, Virginia, and Louisiana, together with a bust that may be a portrait of Calhoun. The palm seems to denote the tropical landscape of Florida, while the riverboat clearly belongs on the Mississippi. The rice fields could be found in South Carolina, as could the wheat fields of the plateau region. The mountains, here exaggerated in scale, complete the spectrum of Southern geography. There is one glaring omission in the painting, however, and that is the absence of any reference to cotton, which was the dominant cash crop of the South. Since many secessionists believed that, because cotton was King, the south would prove self-sufficient after its separation from the Union, the absence of cotton in what otherwise seems to be an emblem of Southern unity is, at the very least, curious.

(Assistance in identifying the various motifs of this painting was provided by Nina Parris, Curator, Columbia Museums of Art and Science, by Professor Walter Edgar of the University of South Carolina Southern Studies Program, by the South Carolina Archives, and by Beverly DuBose of Atlanta, Georgia. Professor George Rogers of the University of South Carolina suggests a quite different interpretation from that given above: if the woman (Liberty) is unsheathing her sword to *protect* the Union—and the presence of the eagle may also intend to symbolize national unity under the Constitution—then the window shade may be read to convey a principle quite the opposite of secession, that is, that the South in all its variety is—and *should be*—harnessed to the Constitution!)

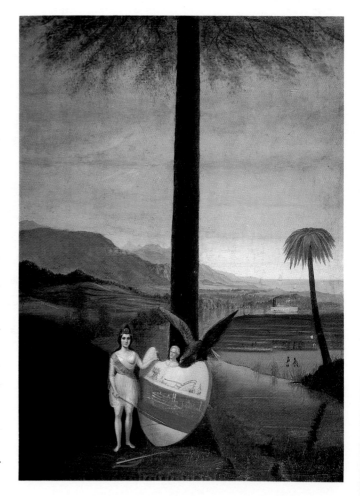

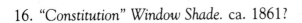

16. *"Constitution" Window Shade.* ca. 1861?

Oil on silk, mounted on canvas. 36″ × 26″.
Inscribed across bottom: "Constitution".
Provenance: Bunce Estate, Atlanta, Ga., to Terry H. Lowenthal, Savannah, Ga.

ARTIST UNKNOWN.

During the siege of Charleston, Secessionville was a key Confederate defense point. Situated on the seaward side of James Island, Secessionville consisted of a small cluster of summer homes belonging to the island's planters, together with a small earthworks fort constructed in 1862.

Secessionville itself predated the war—and the issue of secession—by many years. "In the long ago," wrote one James Island resident in 1961:

the planters had to leave their plantations in the summer on account of what they called "Country fever," which is known now as malaria. The place selected by the planters of James Island was that beautiful point, Fort Johnson. . . . The road to the place (for horse and buggy) was long, hot, and of very heavy sand. There were about twenty-five or thirty families gathered there with quite a bit of social life among them.

After a long time, however, some of the people grew tired of the monotonous trip back and forth to their plantations and began looking around for a similar place near the water. . . . They finally decided that a place called Stent's Point would suit; so several families built summer cottages there and moved in. Those who remained at Fort Johnson ridiculed them . . . that they were seceding from the fold. These pioneers answered the taunt by naming their place Secessionville. (letter, William E. McLeod to Bishop Albert S. Thomas of Columbia, S.C., cited in Claude Henry Neuffer, Depart-

ment of English, University of South Carolina, ed. *Names in South Carolina*, Vol. 8, Winter, 1961, pp. 84–85).

Secessionville was the site of a decisive battle during the siege of Charleston which took place on June 16, 1862, and resulted in a rout of the Union forces, thus preserving Charleston from capture at a critical juncture of the war. By September, 1863, Black Island was the site of a four-gun Federal battery used in the bombardment of Charleston (E. Milby Burton, *The Siege of Charleston, 1861–1865*, University of South Carolina Press: Columbia, S.C., 1970; see also Gerard A. Patterson and Wilbur S. Nye, "The Battle of Secessionville," *Civil War Times Illustrated*, Vol. 7, No. 6 (October, 1968), pp. 4–10, 43–47). It is therefore possible that this drawing was made by an artist attached to the Union forces who was responsible for recording—as were William Aiken Walker and Conrad Wise Chapman for the Confederate side at the same time—the still-intact Confederate defense works.

(Further acknowledgment is made for assistance to Nina Parris, Curator, Columbia Museums of Art and Science, and to Robert McIntosh of the University of South Carolina.)

17. *Secessionville, South Carolina, from Black Island.* 1863.

Watercolor and pencil on paper. 5⅝″ × 8¹¹⁄₁₆″.
Inscribed in pencil, lower center: "Secessionville, S.C., from Black Island. Sept. 15 1863".
Provenance: John Garnier, Charleston, S.C.

ARTISTS AND ILLUSTRATORS OF THE WAR BETWEEN THE STATES

The War Between the States brought with it a demand for artistic skills on both sides of the conflict. Of those artists represented in this exhibition, William Aiken Walker, W. C. A. Frerichs, Nicola Marschall, and Conrad Wise Chapman all served as draughtsmen for the Confederacy (with Walker and Chapman painting Charleston's defenses from the Confederate side), while Xanthus Smith and James Rusling Meeker served similar functions for the Union. The talents that were more publicly in evidence during the war, however, were those of the artist-correspondents for the many illustrated magazines that reported on the war to the folks back home.

Among the most important of these correspondents was Edwin Forbes, who produced dozens of images of camp life and battles for *Leslie's Illustrated Weekly* between 1862 and 1864. The public demand for information about the progress of the war extended, in Forbes' work, not only to the war's violent engagements, but to the conditions of the troops in winter camp and to particular incidents of pathos and humor, like the struggle with a recalcitrant mule near Falmouth, Virginia.

Like Forbes, but painting many years after the war's conclusion, both Gilbert Gaul and Thure de Thulstrup provided information to a public whose curiosity about the war had remained unabated through Reconstruction and the early years of the New South. The endless stream of memoirs, historical reappraisals, and fiction by the war's participants continued to create a lively market for military illustrators until the time of the Spanish-American War's new heroes and distinctly different issues. And yet, for some thirty years, it had been as though the great war had never ended, and its great battles continued to be refought in paintings and in at least two notable Cycloramas that are still on public view in At-

lanta and Gettysburg. One of the more romantic engagements of the war, the sea-fight between the *Kearsarge* and the *Alabama*, was reconstructed in several versions both by Xanthus Smith, son of Russell Smith, and by Edouard Manet.

The only painting in this exhibition of an incident of the war that was actually painted by a combatant is John A. Mooney's *Surprise Attack near Harper's Ferry, 1863*. Painted in the late 1860s, it portrays both the unexpected risks of battle and the war's occasional, if inadvertent, humor, as Mooney and his Confederate artillery company are caught, literally, with their pants down as they are bathing in the river while Union troops come firing over the opposite bank. In Mooney's view—as in Forbes'—the lot of the ordinary soldier was one of survival against mud, disease, and heat, as well as bullets, more than it ever was a set piece of fancy tactics and battles clearly won or lost.

But the war was won by the Union, and its devastating effects in the South were felt for many years to come in a collapsed economy, a decimated population, and in the abolition of slavery. While in the North, save for the illustrations that appeared alongside memoirs and articles and for the occasional cyclorama or celebratory portrait, the war was soon set aside as a subject for *painting*, in the art of the South the war's effects lingered in curious ways.

When an artist who identified himself only as "M" copied Henry Mosler's *The Lost Cause* in 1869, it was because Mosler's original work underscored an important side of the South's real losses. For, it was not only the glorious "Cause" that had been lost forever by the large slave-holders and cotton factors; it was also, in Mosler's painting and this copy, the economic base that had supported the yeoman farmer of the upland South, who was in all likelihood never a slave-owner but who had nonetheless faithfully answered the Confederate call.

EDWIN AUSTIN FORBES (1839–1895)

Born in New York in 1839, and a student of Arthur F. Tait, Forbes became one of the foremost artist-correspondents of the War Between the States, serving from 1862 through 1864 as a special artist for *Leslie's Illustrated Weekly*, covering most of the campaigns of the Army of the Potomac from Manassas Junction through Antietam, Chancellorsville, Gettysburg, the Wilderness, Spotsylvania Courthouse, and Petersburg.

In 1876, Forbes' etchings for his book, *Life Studies in the Great Army*, were awarded a special medal at the Philadelphia Centennial Exposition, and in 1890, he published *Thirty Years After: An Artist's Story of the Great War*, containing some three hundred illustrations based on his war sketches. The Forbes Collection, acquired for the Library of Congress in 1919 by J. Pierpont Morgan, is drawn from the artist's voluminous sketches and prints.

These four drawings were all done in preparation of the plates in *Thirty Years After*, the plates being reduced versions of the original drawings. *Defending a Battery* appears as an illustration at the end of Chapter 64; *A Tough Customer*, at the end of Chapter 36. A separate and earlier version of *A Tough Customer*, entitled *Scenes in Camp Near Falmouth, Va.—Army Blacksmith Shoeing a Refractory Mule*, appeared in the March 14, 1863, issue of *Leslie's Weekly*, and was based on an actual incident in the Army of the Potomac's winter camp.

The Mud March appeared as an illustration in the chapter of the same title (Chapter 53) in *Thirty Years After*, and portrays the Army of the Potomac departing from Falmouth in order to advance on Richmond in December, 1863. It captures exactly the misery of forced marches under adverse conditions. In Forbes's own description: "The roads that had been passable became quagmires. The infantry picked their way as they could, but were soon covered with yellow mud and soaked to the skin by the blinding rain . . . mules would sink in the mire to die, and by midday everything was at a standstill. . . . Never was there a more disheartened body of men."

Writing It Up (Chapter 21, *Thirty Years After*) is in all likelihood a self-portrait of the artist, composing his report on a battle in a rare moment of quiet. The artist-correspondents of the war, for North and South alike, faced most of the same hazards as the troops with the added obligation of producing—against deadlines—timely and articulate images of the war that would not only inform and even entertain the folks back home, but also rally their support to the cause.

DAB, VI, 504; NCAB, V, 549; Civil War, 116; Olympia Galleries: Artist Files

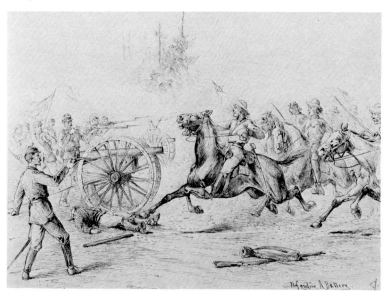

18. *Defending a Battery—Confederate Cavalry Charge.*

Pen and ink on paper. 10¾″ × 14⅞″.
Signed and inscribed, lower right: "Defending a Battery. E. F."

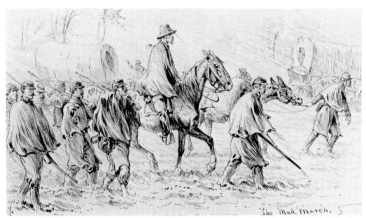

19. *The Mud March—Army of the Potomac.*

Pen and ink on paper. 3⅞″ × 7⅛″.
Signed, lower left: "E. F."; inscribed, lower right:
"The Mud March".

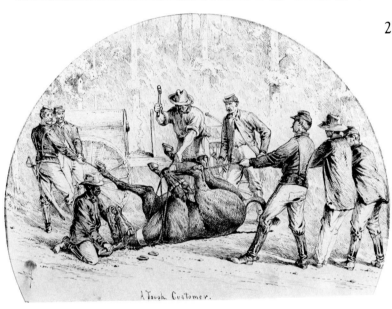

20. *A Tough Customer—Near Falmouth, Virginia.*

Pen and ink on paper. 7¼″ × 9⅝″.
Signed, lower left: "E. F."; inscribed, lower center:
 "A Tough Customer".

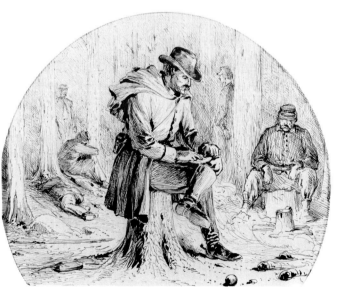

21. *Writing It Up—Heroic Soldier of the Pen.*

Pen and ink on paper. 4⅞″ × 7¼″.
Unsigned.
Provenance for all four drawings: Olympia Galleries,
 Ltd., Philadelphia and Atlanta.

WILLIAM GILBERT GAUL (1855–1919)

Although he was an accomplished genre painter whose early work demonstrates a knowledge of Impressionism, Gilbert Gaul is best known for his military subject paintings. Born in Jersey City, New Jersey, in 1855, at age 17, after completing his secondary education at the Claverack Military Academy, he moved to New York, where he studied drawing and painting under John George Brown and also under Lemuel E. Wilmarth at the National Academy of Design. In 1876, he traveled in the West, where he became fascinated with the United States Army's campaigns against the Sioux and their allies. He began that year to paint the military scenes that were to make his reputation as an artist and gain him election to the National Academy in 1882.

In 1881 he had inherited a small farm in Van Buren, Tennessee, where his mother's family was located. For the next thirty years, he maintained a studio on the farm and lived there regularly. By 1887, Gaul's work began to be widely used to illustrate magazine articles and serve as frontispieces for books. His work appeared through the 1890s in such periodicals as *Century Magazine*, *Harper's*, *Scribner's Monthly*, and *Cosmopolitan*.

In 1890 he accepted a position as special agent for the United States government to assist in a comprehensive census of the Indians. On this trip, which took him again to the Sioux territory of the Dakotas, he painted scenes of cavalry and trooper confrontations with the Indians, while recording specific subjects for the census. Just as often, however, throughout his career, Gaul was called upon to render convincing representations of the campaigns of the War Between the States, so long as there remained an active public interest in the war.

By the early twentieth century, though, the taste for military and battle subjects had diminished, and, in financial straits, Gaul returned to Tennessee where he took on occasional teaching duties. His final publication of prints based on his paintings, *With the Confederate Colors*, issued in 1907 by the Southern Art Publishing Company, was a disheartening failure. Gaul, now ill, went to live with his step-daughter in Charleston, but by 1910 had moved back to Ridgefield, New Jersey, where he died in 1919.

DAB, VII, 193; NCAB, XII, 366; James F. Reeves, *Gilbert Gaul*, Nashville, Tenn., 1975; WWWA, I (1897–1942), 445

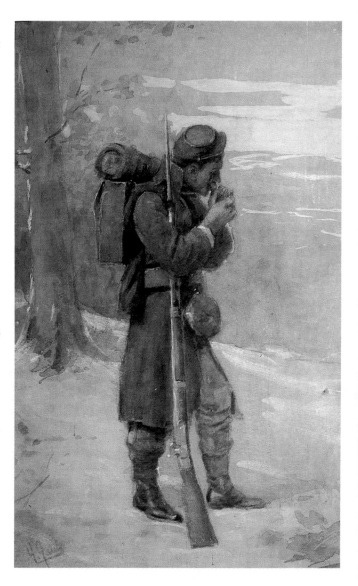

22. The Infantryman.

Watercolor on board. 16½″ × 10″.
Signed, lower left: "G. Gaul".
Provenance: Greg Javo, Atlanta, Ga.

THURE DE THULSTRUP (Bror Thure Thulstrup) (1848–1930)

Bror Thure Thulstrup (known in America as Thure de Thulstrup) was born in Stockholm, Sweden, the son of Sweden's secretary of naval defense. After graduating from the Swedish National Military Academy, he went to France in 1870, where he became an officer of the French Foreign Legion. While a member of the Legion, he served in Algeria and then in France during the Franco-Prussian War of 1871. In 1872, he studied drawing in Paris, with particular attention to topographical engineering. The following year Thulstrup emigrated to Canada to pursue a career as a topographical painter, but after a brief time there, moved to Boston where he felt his opportunities as an artist would be greater.

In Boston, he found employment as an artist with the Prang lithographic firm. These two drawings are preparatory to large Prang chromolithographs of the battles of the War Between the States. Later in his career, Thulstrup settled in New York, becoming a newspaper and magazine illustrator specializing in military subjects. He did numerous illustrations for the *New York Daily Graphic*, *Leslie's Illustrated Weekly*, and *Harper's Weekly*.

While not an eyewitness to the War Between the States, Thulstrup's military experience and passion for accuracy, together with his spirited drawing style, give a convincing sense of the swirl and confusion of battle.

DAB, XVIII, 512; Fielding, 367; Civil War, 543

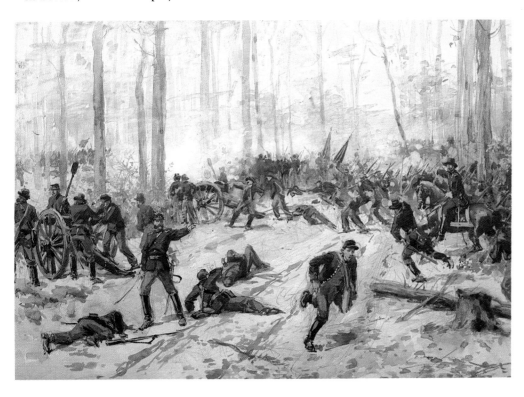

23. *Battle of Shiloh—The Hornet's Nest.* ca. 1888.

Watercolor and pencil on paper. 17¼″ × 24⅞″.
Unsigned: artist's notes in margins identify "Hickenlooper's Battery", "Confederate Charge", "Peach Orchard", "W.H.S. Wallace's troops", "General Prentiss", and "Old Road?", as well as "Battle of Shiloh—The Hornets Nest".
Provenance: Private collection, Boston; Greg Javo, Atlanta, Ga.

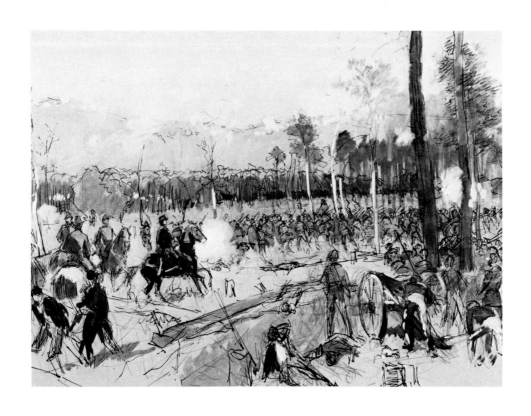

24. *Sketch of Battle of Kennesaw Mountain.*

Pencil, ink, ink wash, and white gouache on paper.
16¾" × 23⅛".
Signed and inscribed, lower right: "Sketch of Battle of Kennesaw Mountain by Thulstrup".
Provenance: Greg Javo, Atlanta, Ga.

XANTHUS R. SMITH (1839–1929)

The son of Russell Smith, Xanthus Smith was born in Philadelphia in 1839. As early as 1848, he accompanied his father on a sketching trip to the White Mountains of New Hampshire, and painted alongside his father as well on their trip to Europe in 1851–52. Between 1855 and 1858, he completed his art studies at the Pennsylvania Academy of Fine Arts, while working towards a degree in chemistry at the University of Pennsylvania.

The direction of Xanthus Smith's art, however, was determined in his service with the United States Navy during the War Between the States. Smith joined the Navy in 1862, participating in the blockade of Charleston and Port Royal,

South Carolina, on the U.S.S. *Wabash*. His sketches of Union and Confederate ships were well received, and he was given leave in 1863 to assist Admiral DuPont with his book on ironclads and monitors. Thereafter Smith's specialty lay in marine subjects.

Returning to service in May, 1864, Smith served aboard the U.S.S. *Augusta* in escort and patrol duty along the Eastern seacoast from Hampton Roads to Pensacola. Discharged in October of the same year, he made one sketching trip to the battlefield at Gettysburg, but was soon thereafter painting canvases of the naval battles of the war. Among these were two which established his fame: *The Monitor and the Merri-*

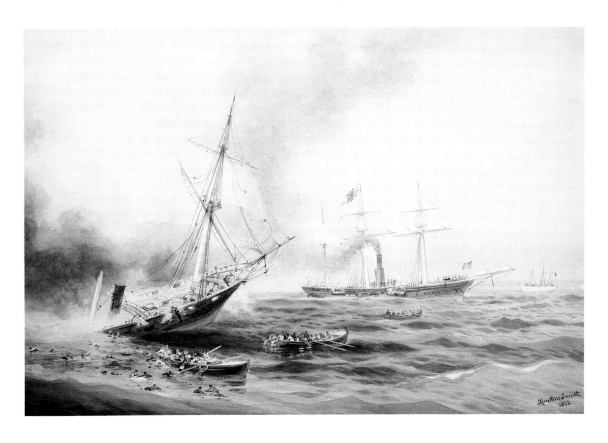

25. Battle of the Kearsarge and Alabama. 1892.

Watercolor on board. 19¾″ × 29¾″.
Signed, lower right: "Xanthus Smith 1892"; inscribed on label on verso: "Close of the engagement between the U.S. Steamsloop Kearsarge and Confederate Cruiser Alabama. Off Cherbourg France. June 19th, 1864. Painted for M. D. Evans, Esqr. by Xanthus Smith."
Provenance: David Ramus Gallery, Atlanta, Georgia.

mac, and *The Kearsarge and Alabama*, both now in the Union League Club in Philadelphia.

In 1877, Smith began a series of trips to Mount Desert Island and Bar Harbor, Maine, to paint seascapes, but his growing interest in photography led him gradually to give up painting in the 1890s in order to write for photographic publications.

The watercolor of the *Battle of the Kearsarge and Alabama* which Smith painted for M. D. Evans in 1892 is one of at least four known versions by Smith of this subject, including the monumental painting now in the Union League Club that Smith had exhibited at the Philadelphia Centennial Exposition in 1876 (itself based on a smaller oil sketch of 1868). While the encounter of the *Kearsarge* and *Alabama* had little effect on the outcome of the war, it was nonetheless one of the war's more dramatic events, of which the most famous image is Edouard Manet's.

The battle took place on June 19th, 1864, off the mouth of the harbor at Cherbourg, France. On June 14th, the Union ship, *Kearsarge*, had sailed into the harbor for a look at the Confederate cruiser, *Alabama*, which was anchored there for refitting. The *Kearsarge*, under Captain Winslow, would have departed gracefully, but the captain of the *Alabama*, Semmes, issued a challenge through the U.S. Consul. The *Alabama* carried a crew of mostly British sailors, while those of the *Kearsarge* were Americans.

On the morning of the engagement, the *Alabama* sailed out of the harbor—by then crammed with spectators on its heights and ramparts—directly into the guns of the *Kearsarge*. The greater accuracy of the American gun crews told quickly, and the *Alabama* was forced to haul down her colors after an hour and a quarter, sinking shortly thereafter. The loss of the *Alabama* had a lasting effect on the morale of the Confederacy, and further discouraged British participation in the Confederate war effort.

DAB, XVII, 371; NCAB, XXI, 41; Vose Galleries, *The First Exhibition in Fifty Years of Oil Paintings by Russell Smith (1812–1896), and His Son, Xanthus Smith (1839–1929)*, Boston, Mass., 1977; Vose Galleries, *Russell Smith (1812–1896); Xanthus Smith (1839–1929): Pennsylvania Landscape, 1834–1892*, Boston, Mass., 1979; Coggins Collection of American Art: Artist Files

JOHN A. MOONEY (ca. 1843–1918)

John Mooney's birthplace and birthdate are not known. The first record of his activities comes with his enlistment in the Army of the Confederacy in Savannah, Georgia, on May 18, 1861. He served as a private in Captain J. C. Fraser's Battery, Pulaski Artillery, Cabell's Brigade, McLaw's Division of Georgia. He was apparently captured in the first year of the war, being released by order of General Benjamin F. Butler from the Parish Prison, Parish of Orleans, Louisiana, on December 3, 1862. He returned to duty with Fraser's Battery, and served in the Virginia campaigns after the Battle of Fredericksburg, including the Peninsula Campaign and the Battle of Gettysburg.

This painting, painted by Mooney from recollection in the late 1860s, shows an incident of the war just prior to the Battle of Gettysburg, when Mooney's squadron was surprised by the Union advance troops while bathing in the Potomac River on the Virginia side of Harper's Ferry. Shells bursting above them, the Confederate soldiers—Mooney among them—scamper for cover, donning their uniforms as best as they can. According to Clifford L. Walker, a friend of Mooney's, the painting was never completed. Nonetheless, it is almost unique in its eyewitness account of the trials of Confederate army life as portrayed by a participant in the action.

After the war, Mooney turned to other figurative, landscape and still life subjects. However, there are no records of his exact location until 1898, when he is listed in the Washington, D.C., directory with a studio in the Corcoran Building. He remained in Washington until 1901–02, when he moved to Richmond. He died on December 9, 1918, in the Richmond City Poor House. One of his patrons, Granville G. Valentine, provided funds for his burial.

The Valentine Museum, Richmond, Va.: Artist Files; also acknowledgment to Robert B. Mayo, Richmond, Va.

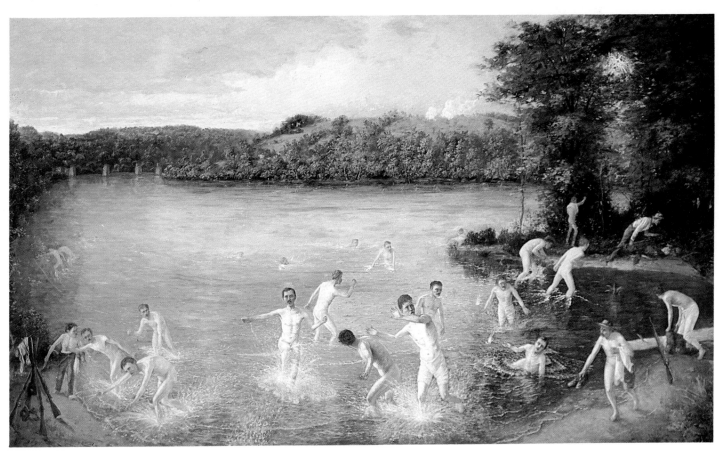

26. *Surprise Attack near Harper's Ferry, 1863.* late 1860s.

Oil on canvas. 54⅛″ × 96¼″.
Provenance: Westmoreland Club, Richmond, Va., to Youngs Art Shop, Richmond, to Gallery Mayo, Richmond, to James A. Williams, Savannah, Ga.

SEE ALSO #48

ARTIST UNKNOWN.
(Monogrammist "M").

This is a highly-finished copy of Henry Mosler's large painting, *The Lost Cause*, which was exhibited at the National Academy of Design in 1868 to general acclaim. Mosler (1841–1920) was born in New York of German immigrant parents. He moved to Cincinnati, Ohio, in 1851, to Nashville, Tennessee, in 1854, and back to Cincinnati in 1859, where he studied two years under the painter, James Henry Beard. In 1861–63, he served as an artist for *Harper's Weekly*, attached to General R. W. Johnson's Union Army command in the West. After further artistic training in Düsseldorf,

Germany, in 1864, and in Paris, in 1865, he returned to Cincinnati, where he painted *The Lost Cause*, which takes as its subject the devastation of the war in the South as it affected, not the wealthy plantation owner, but rather the yeoman farmer of the highlands. This copy is one of several known to have been made of the Mosler original, but the only one to appear with the curious "M" monograph.

For Henry Mosler: DAB, XIII, 279; NCAB, IX, 50

27. *The Lost Cause.* 1869.

Oil on Canvas. 19¾″ × 26¹³⁄₁₆″.
Inscribed, lower right center: "M 69".
Provenance: Sammy J. Hardeman, Atlanta, Georgia.

GENRE PAINTING

Genre painting, highly popular in the North from the time of Andrew Jackson, was not much practiced in the South. This was due, in part, to the fact that there was not a large urban population to sustain genre's sentimental regard for a disappearing rural past and also because there were fewer vehicles in the South for the distribution of popular prints. The two examples of nineteenth-century genre painting in the Northern mode were both painted at the time of the War Between the States, one by Enoch Wood Perry, entitled *Good Doggie*, and the other by John Beaufain Irving, entitled *Little Johnny Reb*.

Perry was a Boston-born artist with wide experience in the South. He had worked in New Orleans from 1848 to 1852, and returned there in 1860 after his training in Europe was completed. Although he left New Orleans for lack of portrait commissions in 1862 (it being that his clientele was otherwise preoccupied), two years later, looking back, he placed *Good Doggie* in a New Orleans setting as though there had never been a conflict capable of casting a shadow on the lighthearted encounter of girl and pet.

Irving's *Little Johnny Reb* is, of the two genre paintings, perhaps the more eerie in its sentiment. Scion of a wealthy Charleston family, Irving, like Perry, had studied abroad with Emanuel Leutze at Düsseldorf. In 1858 he had returned to Charleston where, like Perry in New Orleans, he found himself occupied primarily with portrait commissions. When his family's fortune was destroyed during the war, he moved to New York, where, like Perry again, he returned to genre and historical subjects.

Among the first paintings that Irving completed in New York was *Little Johnny Reb*, of 1866. It shows a small boy in his nightgown who has taken up his toy sword to guard his home against (presumably, Yankee) intruders. In choosing this subject, Irving suggests strongly that the courtly gestures and cavalier sense of honor had not died in the war, but were ready to be exercised anew in defense of the South by the South's succeeding generation. It was as though the devastation of the war, once finished, could be swept aside, and life returned somehow to its prior "normalcy" and its prevailing ethos. To paint such a picture in the face of his own family's overwhelming losses in the war says a great deal about Irving's instantaneous nostalgia for a more halcyon, pre-war past.

A comparable image of gallant Southern boyhood was created four years later, in 1870, by the Marion, Alabama, artist, Nicola Marschall. Though Prussian-born, Marschall had by 1861 become Alabama's leading portrait painter. In that capacity, he had been invited to submit a design—soon accepted—for the flag of the Confederacy. He was also responsible for designing the familiar gray Confederate army uniform, and he served the Confederacy during the war as chief draughtsman in General Richard Taylor's corps of engineers. After the war, he returned to portrait painting in Marion, and, among his commissions, was asked to depict Thomas King, one of three sons of Judge Porter King, a staunch supporter of the Confederacy and later of Southern states' rights. Marschall's striking image of undaunted childhood is, again like Irving's, a potent sign of the defiant optimism of the old Southern aristocracy.

ENOCH WOOD PERRY (1831–1915)

Born in Boston in 1831, Perry clerked in a New Orleans commission house from 1848 to 1852. With the money he had saved, he then went to Europe to study painting, spending two years with Emanuel Leutze at Düsseldorf (1852–55) and another year with Thomas Couture in Paris (1855–56). The next two years he served as United States Consul in Venice.

Returning to the United States in 1858, Perry stayed briefly in Philadelphia, but by 1860 was established in New Orleans as a portrait and genre painter. In January, 1861, the Louisiana State Legislature at Baton Rouge signed the ordinance of secession, which Perry recorded in an oil sketch, and he also completed a large portrait of Jefferson Davis standing before a map of the Confederate States. Nonetheless, his portrait business slacked off during the war, and by 1862 he was in California, following that with visits to Hawaii in 1863, where he painted portraits of Kings Kamehameha IV and V, and to Salt Lake City, Utah, in 1865, where he painted· Brigham Young and other elders of the Mormon Church.

In 1866, he opened a studio in New York City, where he thrived as a genre painter into the 1880s. *Good Doggie*, which uses as background the yard of a Louisiana dwelling, is typical of Perry's style in its light-hearted sentiment and crisp technique.

DAB, XIV, 485; Sheldon, 70–72; AAA, XIII (1916), 318; Clement & Hutton, 173–174; Champlin, 418–419; Groce & Wallace, 500–501

28. *Good Doggie.* 1864.

Oil on board. 15″ × 12″.
Signed, lower left: "E. W. Perry/ 64".
Provenance: Knoke Gallery, Marietta, Georgia.

JOHN BEAUFAIN IRVING (1825–1877)

John Beaufain Irving was born into a wealthy physician's family in Charleston, South Carolina, and learned the rudiments of art as part of his formal education as a gentleman. Going to Europe in 1851, Irving settled in Düsseldorf, Germany, where he studied privately with Emanuel Leutze until 1857. In that year, while still living abroad, he sent two history paintings to exhibition at the National Academy of Design in New York. These paintings, like those he was to do later in his career, showed the strong influence both of Leutze's grand historical machines and of Ernest Meisonnier's more intimately scaled and detailed historical costume pieces.

In 1858, Irving returned to Charleston, where he found himself painting portraits instead of the more ambitious subjects that he preferred. When his family's fortune was destroyed in the War between the States, Irving moved to New York City in 1865, and returned to genre and history painting, particularly of the lives of the French and English

nobility of the sixteenth and seventeenth centuries. Among his patrons were John Jacob Astor and August Belmont; it was Belmont who hosted a benefit for Irving's family after the artist's death in 1877.

Little Johnny Reb of 1866 possesses a curious sentimentality in the immediate aftermath of the nation's most destructive war, seemingly as if the courtly gestures and Cavalier ethos of the Southern aristocracy had passed unscathed through the devastation, and were but to be exercised once again in order to recover their former glory. And yet, it is now a small boy—and not his missing father—who guards his home against the intruders from the North.

DAB, IX, 501; National Academy of Design, *From All Walks of Life: Paintings of the Figure from the National Academy of Design*, New York, N.Y., 1979, 55

29. *Little Johnny Reb.* 1866.

Oil on canvas. 18⅛″ × 14″.
Signed, lower right: "Beaufain Irving/ 66".
Provenance: Robert M. Hicklin, Jr., Spartanburg,
 South Carolina

NICOLA MARSCHALL (1829–1917)

Marschall was born in St. Wendel, Rhenish Prussia, in 1829, the son of a tobacco manufacturer and wine merchant. Although his father took him on in the tobacco business at an early age, Marschall soon left to pursue his interests in art and music, traveling to Rome, Florence, Naples, Paris, London, Berlin, Düsseldorf, and Munich before he had reached the age of twenty. Because of a childhood accident that had impaired his hearing, Marschall was exempted from compulsory military service in Prussia and received permission to emigrate to the United States in 1849.

Stopping briefly in Mobile, he settled in Marion, Alabama, where he established a studio. For a number of years, he taught modern languages, music and painting at the Marion Female Seminary. With the outbreak of the War Between the States, Marschall, who had become a much sought-after portrait painter, enlisted in the Army of the Confederacy, and served during the war as chief draughtsman in General Richard Taylor's command of engineers, making sketches of Federal defenses and planning bridges and fortifications for the Confederate forces.

Before he enlisted, however, Marschall was invited by the daughter of Alabama's governor to submit a design for the flag of the Confederacy, the contest for which had been announced in February 1861. The winning design—which was Marschall's—was the "Stars and Bars," consisting of three bars of equal width—red, white, red—with a square blue canton, or field, in the upper left hand corner. Originally the field contained seven stars, which were later expanded to eleven as more states joined the Confederacy. Because of confusions in battles between Marschall's "Stars and Bars"

design and that of the Union flag, Marschall's design was eventually replaced by the "Southern Cross," or "Dixie" flag. Marschall was also responsible for designing the familiar gray Confederate Army uniform.

From 1865 to 1873, Marschall returned to portrait painting in Marion. One of his subjects was Thomy (Thomas) King, one of three sons of Judge Porter King and his wife Callender McGregor Lumpkin King, of Marion. Born in about 1858 or 1859, Thomy King was portrayed by Marschall in a way that emphasizes King's boyish exuberance—an exuberance that was humorously recorded by Marschall on the back of the painting in his reference to the exasperation of the "five hundredth" (underscore—500th) position!! (King, who was the brother of Porter King, Jr., a lawyer and mayor of Atlanta from 1895–96, was later employed with the Bessemer Steel Works of Troy, New York.)

Shortly after this portrait was completed, Marschall, at the request of relatives of his Alabama friends who wanted their portraits painted by the artist, moved to Louisville, Kentucky, in 1873, where as artist and musician he occupied the same studio until his death in 1917. His favorite diversions in Louisville were collecting curios, coins, and old violins, and painting portraits of Confederate and Union leaders he had known over his lifetime.—James M. Sauls, Curator, The Robert P. Coggins Collection

NCAB, XVII, 51; Milwaukee Art Center, *From Foreign Shores: Three Centuries of Art by Foreign-Born American Masters*, Milwaukee, Wisc., 1976, 52–53 (and, for Thomas King: Thomas McAdory Owen, *History of Alabama and Dictionary of Alabama Biography*, Chicago, Ill., III, 982)

30. *Portrait of Thomy King.* 1870.

Oil on canvas. 36½″ × 29″ (oval).
Signed, lower left: "N. Marschall 1870"; inscribed on label,
 verso: "Thomy King aged. . . .The (500th) Five hundredth
 position. Marion, Ala. Oct. 1st. 1870".
Provenance: Private home, Washington, D.C.; Jerry Crowley,
 Charlottesville, Virginia.

THE PICTURESQUE COTTON SOUTH

Despite its nostalgia for a mythic Plantation past, the South was undergoing many wrenching changes in the period of Reconstruction. The emancipated slaves and urban freedmen alike were at first supported by the North in their desire for participation in the political and educational systems, as they were in their application for farm land. Southern whites, on the other hand, either took an openly rebellious stance toward Reconstruction or, in the case of many of the more established members of the aristocracy, withdrew altogether from public affairs. The economic vacuum that resulted was quickly filled by speculators and brokers, land and crop-owners by fiat of bankruptcy or desertion. The cotton-producing land, particularly, was parceled into shares, worked by white and black farmers alike on a rental basis. In the haste to restore the power of cotton in the marketplace, little thought was given to crop rotation or variation; land and labor alike were exploited often to exhaustion. Mill-towns were developed so that the cotton could be processed at home, rather than in the North. Railroad systems were repaired and expanded, both to deliver the finished cloth to Northern fabricators, and to serve the growing tourist industries of the Carolinas, Florida, and the Gulf Coast. The New South was proclaimed, although the Old South hung over it in all matters of race and class distinctions once Reconstruction was abandoned in the mid-1870s.

A new ideal of the picturesque South arose to accommodate these changes. In depicting the Reconstruction and post-Reconstruction South, Southern and Northern artists alike tended to divide the South into two unrelated entities, the picturesque South of cotton and the mysterious, romantic South of bayous and swamps. Nothing in the late nineteenth-century portrayal of the Cotton South could be distinguished from its pre-war Plantation South predecessor; the land was occupied primarily by blacks who worked the soil and harvested, weighed, and transported the resulting cotton to market. The alternative South was wholly *unoccupied*, tropical, and to that extent paradisical. It was the New Eden, a land both for pioneers and for poets, as hazardous as it was unearthly in its beauty.

In all of this separation of uniquely Southern elements, an odd transformation had taken place. For where, in the pre-war years, images of Southern landscape had tended to parallel images of landscape elsewhere—the Blue Ridge could be portrayed in terms applicable to the Adirondacks or Catskills,

and plantation houses nestled in groves of oak or pecan were not too unlike Federal and Greek Revival mansion farther north—after the war the Southern landscape became identifiably different in *both* its dominant guises from landscape anywhere else in this country or abroad. Portrayed as distinct, it came to be imagined as separate.

Among the unique features of the Cotton South as it was portrayed in the 1880s and 1890s was its almost total absence of any white presence, an exact reversal of Northern landscapes of the same period. There were, of course, many more white sharecroppers, mill-hands, mountain men, and merchants than there were black ones in the South, but in the images that prevail of the South it is the black who dominates the landscape, even as he is dominated by his now "invisible" white masters. It might even be said that, in the paintings of the agricultural South of the late nineteenth century, it was the blacks who gave the South its distinctive character.

Let us take some examples from works presented here. Lucien Whiting Powell was, like John Beaufain Irving, a Southerner of substantial heritage. He was a Virginian who served with the Confederate cavalry in 1863. While he would later achieve distinction as a painter both of Venice and of the Grand Canyon, an early work, *The Old Log Cabin*, dating probably to just after the War Between the States, presents a highly picturesque image of the life of the Southern black, with his ramshackle dwelling, colorful dress, and carefree habits. *The Old Log Cabin* is thus Powell's reply to Eastman Johnson's by-then-already-famous *Negro Life in the South*, first exhibited in New York in 1859. As Johnson's painting had received acclaim as a summary depiction of a peculiarly American form of picturesque life, so too might have Powell's.

The context in which both paintings were understood in their day was conditioned by several centuries of European artistic precedent, dating back to the Dutch and Flemish "little masters" of the seventeenth century, who had first given popularity to paintings of rural and urban "low-life"—the drunkards, boors, and wenches of the lower (that is, peasant) classes. The seventeenth-century painters' audience was the respectable middle class of Holland, patrons who found the uncouth behavior of the poor humorous—at a distance—and instructive, too, as moral tales, of follies and errors to be avoided.

The peasant class of Europe provided stock figures in the genre painter's repertoire of humanity, although not inevi-

43

tably with the bawdiness of the Dutch example. Murillo in Spain, the LeNain brothers in France, Morland, Hogarth and Rowlandson in England—to name only a few—made substantial reputations as interpreters of the poor, and thereby laid the groundwork for the American genre painters of the nineteenth century. Until the eve of the War Between the States, such picturesque figures in America tended to be drawn from both rural and urban types, from riverboatmen as well as street urchins and hurdygurdy players, and from blacks and whites alike. As in the seventeenth century, the audience for these depictions of the nineteenth-century American common man tended to be the more prosperous mercantile classes, who could admire the colorful antics of society's base without themselves stepping down from the ladders by which they had ascended above it. In America, too, the poor were seldom portrayed as ignoble or as brutalized by their poverty. They were all simply waiting their turn; the democratic mass leavened the American experience and gave it, in the popular imagination, the special energy that drove America forward.

In the South, however, the myth of social order that tended to be perpetuated was not that of the democratic "melting-pot" of free-wheeling potential. Rather, it was one in which social places were more or less fixed, in which the lower class (or "mudsill") was as permanently assigned to its position as was the upper class that ruled it. The broad variety of human types that occupied the picturesque place in the art and literature of the pre-war years gave way in the post-war South to a single type of occupant—the black—as the South struggled to recapture its Old South character and thus re-drew the boundaries of its separate identity.

In the sequence of images of the Cotton South's black population that unfolds between 1865 and 1915, Powell's painting is among the earliest. The "classic" statements of Southern black picturesqueness—those of William Aiken Walker and Harry Roseland—do not occur until much later, toward the end of the century, and are largely the ironic result

of a growing demand on the part of Northerners for souvenirs of the antebellum South. Like Remington's cowboys, which are contemporaneous, they are reminders of what has already passed, viewed nostalgically at a time when America had already geared up its industrial capacity for a new and more powerful international role, and when men like Henry Grady were already deeply engaged in promoting the New South's more progressive agriculture and commerce.

Between the early expressions of the Old South myth—such as Powells—and the later ones of Walker and Roseland, there were many other and often more interesting variations on the theme. Hal Morrison, a Canadian-born physician, art teacher, outdoorsman, and painter who was active in Atlanta between 1882 and 1918, created a dispassionate if slightly naive rendering of *Weighing the Cotton*, presented almost as if it were one of his more popular still-lifes, as a straightforward and unsentimental representation of a characteristic activity. Lyell Carr's French academic training shows in his monumentalizing treatment of a scene of upcountry Georgia folk life of 1891. Interested in "local color" and colloquial expression (as were Joel Chandler Harris and Mark Twain as well), Carr nonetheless manages to compose his picture so as to lend a certain heroic dignity to his central figure, a black drover pausing to listen for unwary game.

Of similar date, and seemingly like these images in tone, is Willie M. Chambers' *Uncle Hamp and His Cart, Montezuma, Georgia . . .* until one realizes that this work—the result of the part-time artistic recreations of an Atlanta seamstress—is a sensitive portrait of a specific acquaintance, rather than a sentimental generalization on a type. Uncle Hamp, like Chambers a native of Montezuma, was, though crippled, a significant landowner in Montezuma and a figure of respect in that community. The painting is thus one neighbor's pictorial weighing of another's characteristic features, together with the no-less-carefully-observed features of the setting that they shared in common.

LUCIEN WHITING POWELL (1846–1930)

Lucien Powell was born in Levinworth Manor, Upperville, Virginia, the son of a distinguished Virginia family. Educated at the district schools and under private tutors, he enlisted in the 11th Virginia Cavalry in 1863. After the war, he studied with Thomas Moran in Philadelphia and at the Pennsylvania Academy of Fine Arts. He also studied in New York, at the London School of Art, in Rome, in Venice, and in Paris with Leon Bonnat. He became known as a landscape and seascape painter whose style was strongly influenced by Moran and Turner, and whose subjects—Venice, the Holy Land, and, after 1901, the Grand Canyon—lent themselves to Turneresque treatment.

His earliest paintings, however, dealt with life in his native Virginia, such as *The Old Log Cabin* which, like Eastman Johnson's *Negro Life in the South* (*My Old Kentucky Home*) of 1859, portrays the "picturesque" life of the impoverished Southern black.

DAB, XVI, 149; NCAB, XXIII, 137; Samuels, 379

31. *The Old Log Cabin.* ca. 1865–70.

Oil on canvas. 30″ × 25″.
Signed, lower right: "L. Powell".
Provenance: Sagamore Fine Arts, Huntington, N.Y.

WILLIAM AIKEN WALKER (1838–1921)

William Aiken Walker is considered by many to be the epitome of the Southern painter of the late nineteenth century, and yet his unusual career belies his typicality even as his paintings seem to nourish certain stereotypes of Southern life-styles.

Born in 1838 in Charleston, South Carolina, Walker was the son of an Irish immigrant cotton-factor. When his father died in 1842, Walker's mother took her family to Baltimore, where they remained until returning to Charleston in 1848. Something of a prodigy as an artist, Walker exhibited his first painting in 1850, and received his first one-man show in Charleston at age twenty.

In 1861, he enlisted in General Wade Hampton's South Carolina brigade, under whose command he was wounded at the Battle of Seven Pines in 1862. On his recovery, Walker was transferred back to Charleston, where he was eventually placed on picket duty and thus freed to resume his painting. For the next two years his service to the Confederacy con-sisted mainly of drawing maps and sketches of Charleston's defenses, until he was mustered out at the end of 1864.

A poet and linguist, accomplished baritone, pianist and violinist, as well as painter, Walker was something of an eccentric as well as debonair figure, who delighted in passing himself off as a professor when he was not playing the role of landless gentry (see August P. Travioli and Roulhac B. Tole-dano, *William Aiken Walker, Southern Genre Painter*, Louisiana State University Press: Baton Rouge, La., 1972). Welcomed as a house and hotel guest, he made regular stops annually at as many of the growing resorts of the South as he could manage in a season, working his way from New Orleans to the Blue Ridge mountains, down to Charleston, and along the coast southwards to Florida, at each stop placing some of his small-scale paintings of rural black cabins, sharecroppers working in the fields, or palmetto-lined beaches for sale to passing tourists.

For Walker was the quintessential—and perhaps earliest—

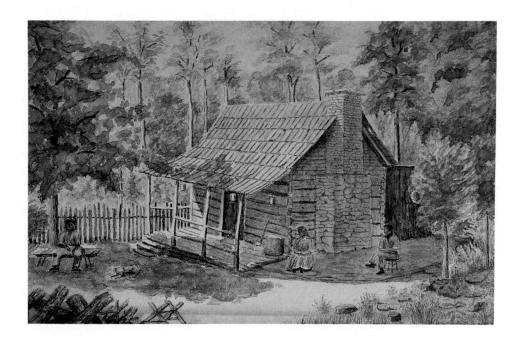

32. *Cabin Scene.* 1918.

Watercolor on paper. 6⅛″ × 8⅞″.
Signed, lower right: "W. A. Walker 1918".
Provenance: Long Island House Sale; Robert M. Hicklin, Jr., Spartanburg, South Carolina.

artist in the South to make a living from the tourist trade. His paintings served much like postcards, mementoes—of a size to be tucked in a suitcase—of the "Old South" in all its quaintness and picturesqueness. The dialect writing of George Washington Cable, Lafcadio Hearn, and even Mark Twain is echoed in Walker's images, which also parallel the kind of drama (or, more accurately, melodrama) being written about the South in the same period. Like the consumers of consciously "regional" literature, the consumers of Walker's paintings were not those who had passed their lives in the rural South, but rather were the Yankees and the urban businessman of the New South, admirers of a mythic, unhurried and untroubled Southland that existed mainly in their imaginations.

PITS, 96–97, 252

33. *Opossum Hunting.*

Pencil on paper. 6½″ × 8⅝″.
Signed, lower left: "WAW"; inscribed, lower center, "Opossum Hunting".
Provenance: Bentley-Sellars Collection, Marietta, Georgia.

HARRY ROSELAND (1866, 1867, or 1868–1950)

There is some dispute over the birth date and artistic training of Harry Roseland. Depending on which biographer is writing, Roseland was born on May 12, of 1866, 1867, or 1868 in Brooklyn, New York, the son of German immigrants. All agree that he was initially self-taught, and that he obtained advice and additional training from J. B. Whittaker at the Adelphi Academy in Brooklyn and J. Carroll Beckwith in New York. At least one early biographer, however, adds that Roseland also studied with Thomas Eakins in Philadelphia (Stevens, comp., "Autobiographies of American Artists," in Archives of American Art, Roll D-34).

A description of Roseland's early career can be found in the *National Cyclopaedia of American Biography* (Vol. 11, pp. 286–287):

After painting landscapes and portraits, he turned to still life and flowers with better success, but figure painting was the branch of art he preferred. . . . In his search for subjects unused by others of the craft he found material close at hand in the suburbs of Brooklyn: vegetable gardens and farms, whose cultivators, foreigners chiefly, were as picturesque as they would have been in the old world.

But even these transplanted peasants failed to interest him, after a time, and it occurred to him that there were indigenous subjects nearer at hand: negroes, especially of the ante-bellum type, worthy of perpetuation on canvas; and the more he studied their manners, their costumes, and their ways of living, the richer did the "find" appear.

Enormously successful in his chosen specialty, Roseland won the silver medal of the Brooklyn Art Club in 1885, and its gold medal in 1887. He was also awarded the Second Hallgarten Prize of the National Academy of Design in 1898. A resident of Brooklyn until his death on December 20, 1950, Roseland never seems to have ventured into the South, although his genre scenes were once widely accepted as authentic studies of the life of the Southern black at the turn of the century.

NCAB, XI, 286–287; WWWA, III (1951–60), 742; Fielding, 308

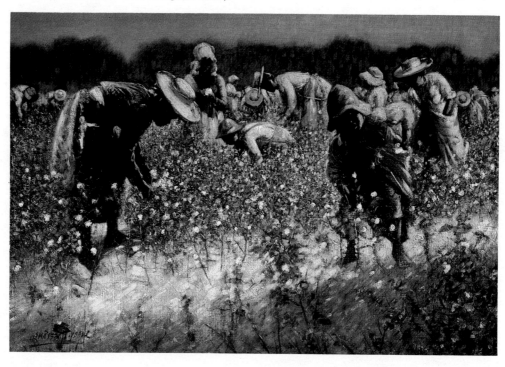

34. *The Co'tin.* 1898.

Oil on canvas. 20″ × 30″.
Signed, lower right: "Harry Roseland".
Provenance: Sotheby-Parke Bernet Sale, New York; Berry-Hill Galleries, Inc., New York.
Exhibitions: Trosby Auction Galleries, "Atlanta Collects," Atlanta, Ga., April 27–May 1, 1980, illustrated p. 47; The Museum of Arts and Sciences, Macon, Georgia, "Two Hundred Years of American Painting, 1700–1900," Macon, Ga., June 4–November 8, 1981.
Publications: *National Cyclopaedia of American Biography,* Vol. 11, p. 287.

HAL ALEXANDER COURTNEY MORRISON (1848 or 1852–1927)

Morrison, born on Prince Edward Island, Canada, was educated as a physician at Harvard School of Medicine. After his graduation, he worked two years on the medical staff of the Intercolonial Railroad, spending most of his time, by his own admission, painting and fishing, his two favorite avocations. He subsequently spent perhaps as many as seven years in Europe, traveling and studying art, but by 1882 had located in Bainbridge, Georgia, from where he moved to Atlanta in the following year.

According to Carlyn Gaye Crannell, his biographer ("In Pursuit of Culture: A History of Art Activity in Atlanta,

1847–1926", Ph.D. dissertation, Institute of Liberal Arts, Emory University, Atlanta, 1981), Morrison remained in Atlanta until the death of his wife in 1918, and achieved popularity there especially for his still-lifes of fish and game. He made many trips to Florida in the winters and to North Carolina in the summers, and occasionally returned to Canada as well. He exhibited extensively in state fairs and regional expositions, and also taught painting in his Atlanta studio. Shortly after his wife's death, he remarried and moved to Auburndale, Florida, returning to Atlanta only upon his final illness in 1927.

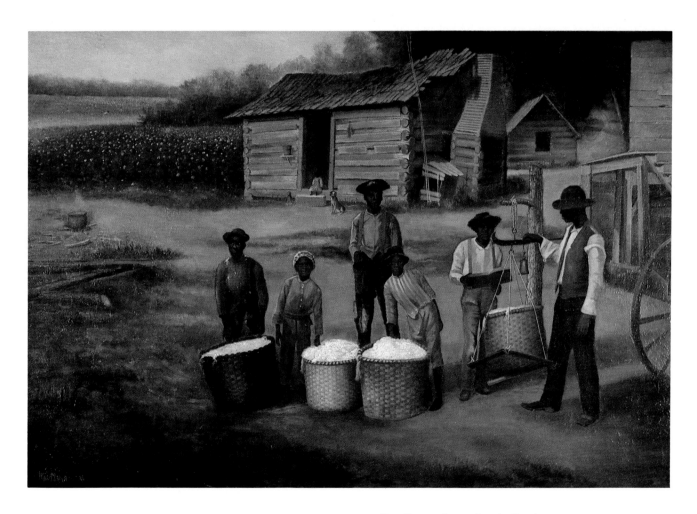

35. *Weighing the Cotton.* ca. 1885–90.

Oil on canvas. 31½″ × 45½″.
Signed, lower left: "Hal Morrison".
Provenance: Henry Holt, New Jersey; to Robert M. Hicklin,

Jr., Spartanburg, South Carolina.
Exhibitions: Atlanta Historical Society, "Land of Our Own: 250 Years of Landscape and Gardening Tradition in Georgia, 1733–1983," Atlanta, Georgia, March 1–August 31, 1983.

LYELL E. CARR (1857–1912)

Born in Chicago, Carr studied at the Ecole des Beaux-Arts in Paris, returning to Chicago by 1880. In 1881, he moved to New York, regularly exhibiting thereafter at the National Academy of Design. He traveled to Mexico in the 1880s in search of subjects, and did a number of paintings of the Spanish-American War in Cuba in 1896, but he was best-known for a series of paintings of rural Georgia life done in the early 1890s.

These paintings were described in an article by Marguerite Tracy in *The Quarterly Illustrator* in 1894 as being the logical—and almost sole—successor to that time of Eastman Johnson's and Winslow Homer's Southern genre paintings. They were all painted in the vicinity of Tallapoosa, Georgia, where Carr had moved in 1891 in order to portray, in the words of the article, "the picturesque side of Georgia life," from the "open routine of the plantations" to the "irregular work of the moonshiners."

By 1891, Tallapoosa had become an excursion stop for visitors from the North, but it had earlier been a sleepy little crossroads occupied by nothing more elaborate than a trading post. The colloquial name of "Possum Snout" which natives applied to Tallapoosa seems to have derived from an incident that took place in those early years, when a settler, looking in vain for necessities that were not to be found at the store, exclaimed in disgust as he left empty-handed, "It's nothin' but an old possum snout anyway!"

It is this colloquial element that Carr emphasizes both in his inscription and in his style of presentation, aptly described by Tracy as a "rough, strong rendering . . . peculiarly adequate to expressing the types of the 'cracker' people." Yet this painting also possesses a monumentality and gravity that transcends the deliberate quaintness of its subject.

Thieme-Becker, VI, 52; Coggins, 25

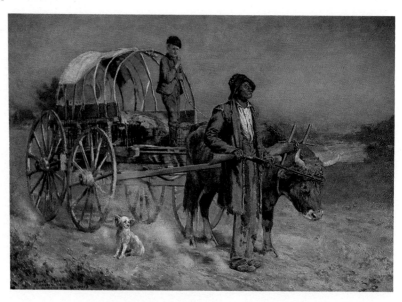

36. *Opossum Snout, Haralson County, Georgia.*
 1891.

Oil on canvas. 28½″ × 40¼″.
Signed, lower left: "Lyell Carr/ opossum snout/ Harrolson Co. Ga. 1891."
Provenance: Parke-Bernet Sale, New York; Berry-Hill Galleries, Inc., New York.
Exhibitions: Memorial Art Gallery of the University of Rochester, "Selections from the Robert P. Coggins Collection of American Painting," The High Museum of Art, Atlanta, December 3, 1976–January 16, 1977; Memorial Art Gallery of the University of Rochester (N.Y.), February 25–April 10, 1977; Herbert F. Johnson Museum of Art, Cornell University, Ithaca, N.Y., May 4–June 12, 1977 (illustrated in catalogue, p. 25); Trosby Auction Galleries, "Atlanta Collects," Atlanta, Ga., April 27–May 1, 1980 (illustrated in catalogue, p. 14).
Publications: Marguerite Tracy, "A New Field in American Art," *The Quarterly Illustrator*, Vol. 2, 1894, pp. 268–272, illustrated p. 271; Bruce W. Chambers, "A Southern Odyssey: The Robert P. Coggins Collection of American Painting," *American Art Review*, Vol. 4, No. 2, August, 1977, illustrated p. 32.

H. T. WEST

Nothing is known about the artist of this astonishingly rendered drawing of 1901.

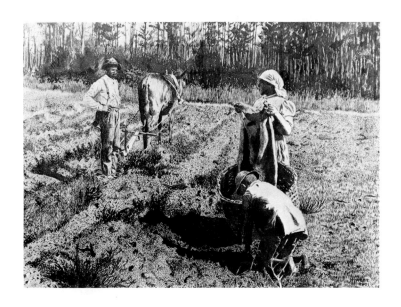

37. *Sharecroppers.*
1901.

Pen and ink on paper. 12⅛″ × 16¼″.
Signed and dated, lower left: "H. T. West 1901".
Provenance: Berry-Hill Galleries, Inc., New York.

WILLIE M. CHAMBERS (Late 19th–Early 20th Centuries)

According to family accounts, Willie M. Chambers, the eighth of nine children of William B. and Martha H. Chambers, was born sometime in the late 1850s. Her early life remains undocumented until she appeared in Atlanta, Georgia, as a owner of a seamstress shop. Her niece, Mrs. W. H. Pate, recalled Chambers as a clothing designer doing the more intricate and elegant types of handwork herself. She employed several other seamstresses who performed the more ordinary business of the shop, while she took on the commissions for bridal dresses and other special apparel.

A confirmed spinster, the income from her shop provided her with an independence unusual for women of her era. Chambers frequently traveled to Montezuma, Georgia, to visit her brother, Dr. T. E. Chambers, a dentist, and her sister, Mrs. Liggins, a doctor's wife. Chambers did most of her oil paintings during these trips to Montezuma, although she is known to have done china painting as well.

Apples in a Straw Hat (see #47) is an example of one of her still-life paintings. Its strong, direct composition, flat perspective, and carefully observed realism produce a fine example of naive art. In addition to fruit and floral still-lifes and landscapes painted at sunset, however, Chambers enjoyed painting the human figure. While her pictures of women with languid, classical features probably originate from prints, her men seem to derive from direct observation. This is certainly the case with *Uncle Hamp and His Cart*, a portrait of a well-known figure in the Montezuma community. The white-bearded, derby-hatted Hamp Barnes, the owner of considerable acreage in Montezuma, became the subject of an unusually bold effort by Chambers. The careful rendering and spirited composition of *Uncle Hamp* depart considerably from the usual subjects of naive or folk painting of the period. Uncle Hamp, who was crippled, is positioned on a makeshift seat made from a discarded crate, from which he drives a two-wheeled, ox-drawn flat cart. He holds a crocus sack on his lap, and behind him is a hand-woven basket filled with cotton—the kind of basket still produced in Westville, near Montezuma. The landscape incorporates Chambers's usual salmon-colored sunset sky, against which moss-draped pines, cotton plants, and a single mimosa are silhouetted.

These two paintings, together with other of "Miss Willie's" works, establish her as one of the South's more important nineteenth-century naive painters.—James M. Sauls, Curator, The Robert P. Coggins Collection

Coggins Collection of American Art: Artist Files

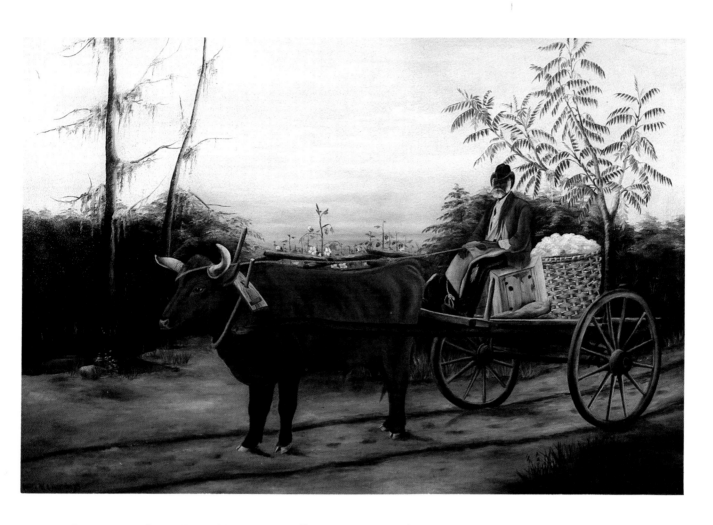

38. *Uncle Hamp and His Cart, Montezuma, Georgia.*

Oil on canvas. 24″ × 36″.

Signed, lower left: "Willie M. Chambers"; inscribed, lower right: "Uncle Hamp and His Cart, Montezuma, Georgia".

Provenance: New England Art Market; Berry-Hill Galleries, Inc., New York City.

Exhibitions: Memorial Art Gallery of the University of Rochester, "Selections from the Robert P. Coggins Collection of American Painting," The High Museum of Art, Atlanta, Georgia, December 3, 1976–January 16, 1977; Memorial Art Gallery of the University of Rochester, Rochester, New York, February 25–April 10, 1977; Herbert F. Johnson Museum of Art, Cornell University, Ithaca, New York, May 4–June 12, 1977 (illustrated in catalogue, pp. 6 and 27); Trosby Auction Galleries, "Atlanta Collects", Atlanta, Georgia, April 27–May 1, 1980 (illustrated in catalogue, p. 16); Arnold Gallery, Shorter College, "Women in Art: Early Twentieth Century Selections from the collection of Robert P. Coggins, M.D.," Rome, Georgia, November 16–25, 1980, No. 2, illustrated in catalogue.

Publications: Bruce W. Chambers, "A Southern Odyssey: The Robert P. Coggins Collection of American Painting," *American Art Review*, Vol. 4, No. 2 (August, 1977), pp. 34–35, illustrated; Violet Moore, "Miss Willie: Montezuma's 'Grandma Moses'", *Macon (Ga.) Telegraph*, March 30, 1977 (illustrated).

SEE ALSO #47

THE MYSTERIOUS SOUTHERN TROPICS

If the rebuilding of the Old South in story, song, and pictures was one route by which the south redeemed its sense of purpose in the late nineteenth century, another form of redemptive vision was taking shape at the same time in the many landscapes that were painted of the south's tropical bayous and swamps. Originally perceived as hostile, filled with roaring alligators, poisonous snakes, malarial mosquitoes and hostile Indians, the great swamplands of the South also came to be seen as an exotic alternative to mundane reality, a natural paradise teeming with game and flowers. They were, in fact, one of the last remaining stretches of untouched American wilderness.

Florida's special characteristics, particularly, were recognized very early. In his *Travels*, published in 1791, the botanist William Bartram gave the first impetus to the legend of Florida as a new Eden:

What a beautiful display of vegetation is here before me! seemingly unlimited in extent and variety: how the dew-drops twinkle and play upon the sight, trembling on the tips of the lucid, green savanna. . . . what a beautiful retreat is here! blessed unviolated spot of earth. . . . What an elysium it is! where the wandering Siminole, the naked red warrior, roams at large, and after the vigorous chase retires from the scorching heat of the meridian sun. Here he reclines, and reposes under the odiferous shades of Zanthoxylon, his verdant couch guarded by the Deity; Liberty, and the Muses, inspiring him with wisdom and valor, whilst the balmy zephyrs fan him to sleep.[7]

Yet, because of disputes over land titles (Florida's ownership had gone back and forth between Spain and Great Britain until 1821, when it was acquired by the United States), continual warring with the Seminoles well into the 1840s, and its general inaccessibility, Florida was to remain a distant paradise until the end of the Reconstruction period. From the 1870s through the end of the century, however, Florida's tourism and settlement blossomed. Promotional advertisements noted the fecundity of Florida's plant life indicating a soil and climate conducive to unprecedented agricultural potential. Since Florida was also largely uninhabited, ingenious and industrious men would discover there almost unlimited prospects for wealth. If this were not enough to attract ambitious settlers, Florida was also a sportsman's paradise and offered such a balmy environment that even the most dismally-afflicted consumptives would find their health regenerated. Florida was truly the Fountain of Youth.

But the myth of America's tropical Eden went further. As a place of respite and healing, its bounteous landscape could serve as "an antidote to wearisome civilization" where there could occur, in the words of Sidney Lanier, an "enlargement of many people's pleasures and many people's existences as against that universal killing ague of modern life—the fever of the unrest of trade."[8] This sort of Southern landscape, it was implied, was a haven from Time, at least insofar as time was the unrelenting measure of productivity and progress.

The dichotomy of Florida's attraction—it was perceived simultaneously as a field for the application of Yankee drive and as that drive's very antidote—was summarized by Robert Barnwell Roosevelt, Theodore's uncle, in 1884: "To the rough, practical Northern mind, Florida is a land of dreams, a strange country full of surprises, an intangible sort of place, where at first nothing is believed to be real and where finally everything is considered to be possible."[9]

Florida was not the only part of the South to which this dream imagery was applied; the Louisiana bayous, the Great Dismal and Okeefenokee swamps, and the South Carolina lowlands all were perceived similarly. Writing about the bayous in a sketch entitled "The Garden of Paradise", Lafcadio Hearn in 1883 described their seductions:

And the great dreaminess of the land makes itself master of thought and speech,—mesmerizes you,—caresses with tender treachery,—soothes with irresistible languor,—woos with unutterable sweetness. . . . Afterward when you have returned into the vast metropolis, into the dust and the turmoil and the roar of traffic and the smoke of industry and the iron cares of life,—that mesmerism will not have utterly passed away, nor the perfume of that poppied land wholly evaporated from the brain."[10]

In short, where the Cotton South might serve as the conscious rejection of the North's several ailments, the mysterious and sensual South of the swamps could prove to be their cure. It should be pointed out, however, that the fantasy of this "garden of paradise", whether found in Florida or Louisiana, was primarily a Northern production, "made by northern hands, for northern consumption."

This fantasy is as true of the painters of the Florida, Carolina, and Louisiana swamplands as it was of the writers of travel accounts and guide books. Oertel in South Carolina, Herzog and Higgins in Florida, and Meeker in the Mississippi delta country were all northern- or European-bred and trained (as were their contemporaries Martin Johnson Heade

and Thomas Moran, who also gave definition to the tropical South). Only in New Orleans did a community of native Southern artists develop—including Richard Clague and Marshall J. Smith—that took on the Southern landscape as its subject.

Oertel's, Herzog's, and Meeker's paintings share certain dominant features, even though they are depictions of three separate places. (Higgins' painting, *Florida Cabin Scene*, stands somewhat apart as a conflation of the Cotton South image with that of the Paradise Garden.) Each of the three paintings shows a lushly-foliated landscape inhabited by exotic species of plants and an occasional bird. A placid body of water, rippled by unseen breezes, occupies a central place in the composition. Otherwise the landscape is wholly unoccupied, and bears no sign of man's past or present intrusion. The leading presence in the landscape is the sun, whose light, whether filtered through atmospheric haze or casting its last glow at evening, infuses the entire scene with an aura of plenitude and calm. When W. J. Cash wrote *The Mind of the South* in 1941, in explaining what he saw as the Southern tendency to fantasy, he placed the blame in part on the excesses of "the Southern physical world." He could just as easily have been describing one of these paintings: "The country is one of extravagant colors, of proliferating foliage and bloom, of floating yellow sunlight, and, above all, perhaps, of haze . . . [It is] a sort of cosmic conspiracy against reality in favor of romance."[11]

GEORGE F. HIGGINS (Flourished 1859–1884)

Very little is known about Higgins except that he exhibited at the Boston Atheneum in 1859 and 1861, and remained active in Boston until 1884. A number of his Florida scenes have come to light recently, which, if they date to the 1870s, are among the earliest views of the Florida pine woods and swamplands.

Groce & Wallace, 315

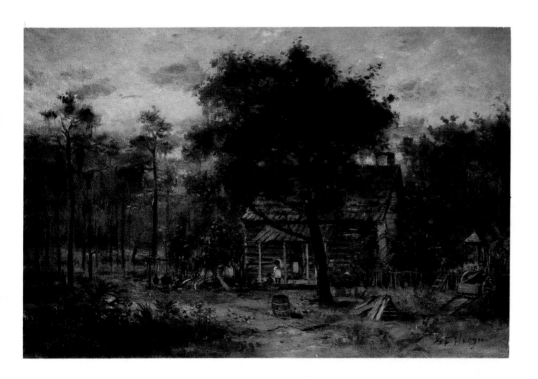

39. *Florida Cabin Scene.* 1870s?

Oil on canvas. 12″ × 18″.
Signed, lower right: "G.F.Higgins".
Provenance: Robert M. Hicklin, Jr., Spartanburg, South
 Carolina

JOHANNES ADAM SIMON OERTEL (1823–1909)

Born in Fürth, Bavaria, in 1823, Oertel was first educated to become a missionary. Because of his skill in drawing, however, he was encouraged to study art, to which end he was given instruction by the Munich painter and engraver, J. M. Enzing-Müller. In 1848, Oertel emigrated to the United States, settling in Newark, New Jersey. For the next two decades, he earned his way by teaching drawing, painting portraits, engraving banknotes, and designing ceiling decorations for the House of Representatives in Washington, D.C. During the War Between the States, he served with the Army of the Potomac, using the occasion to do studies of army life that he later developed into paintings.

From 1852, when he was confirmed in the Episcopal Church, it was Oertel's desire, however, to return to the ministry, as well as to paint a series of monumental paintings that would illustrate the redemption of mankind. Ordained an Episcopal priest in 1871, he was put in charge of a rural church and two mission stations in Lenoir, North Carolina. For the next twenty years he served, successively, parishes in North Carolina, Florida, Sewanee, Tennessee, St. Louis, and Washington, D.C., all the while continuing to paint landscapes, animal subjects, and religious paintings, including not only his monumental "Redemption" series which he sub-

sequently donated to the University of the South in Sewanee in 1902, but also ceiling decorations for the National Cathedral in Washington and other churches. He also taught art at Washington University in St. Louis between 1889 and 1891.

After retiring from the active priesthood in 1895, Oertel completed his major religious paintings and once again attempted to sell his landscape and animal paintings, most of them completed two and three decades earlier. Although he obtained the cooperation of Macbeth Galleries in New York in this enterprise, Oertel discovered that his paintings were no longer in fashion and failed to attract buyers. He died in his home at Vienna, Virginia, in 1909.

Oertel's importance as a landscape painter lies in his willingness to explore the scenery at hand, much of which—like South Carolina's marshes or the islands of Chincoteague and Assateague—had received little attention from other artists to that time. His religious instincts, too, helped him to distance himself from his subjects, idealizing them into essays on the underlying divinity of their source.

DAB, XIII, 630; NCAB, VII, 466; Groce & Wallace, 476; Fielding, 263; PITS, 98, 262

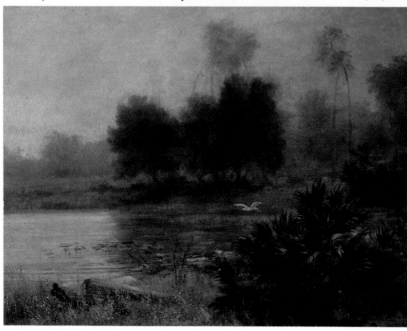

40. *South Carolina Marsh.* 1870s.

Oil on board. 18½″ × 24½″.
Signed, lower right: "J. A. S. Oertel".
Provenance: Robert M. Hicklin, Jr., Spartanburg, S.C.

HERMAN HERZOG (1831–1932)

Born in Bremen, Germany, Herzog enrolled in the Düsseldorf Academy at age 17. He studied there first with J. W. Schirmer, and then privately with Hans Gude, who encouraged him to paint the fjords and mountains of Gude's native Norway. Herzog's talent as a landscape painter was soon recognized; the Queen of Hanover, Queen Victoria of Great Britain, Emperor Alexander of Russia, and other European royalty were among his earliest purchasers.

With the proceeds from these sales, Herzog set off on further travels which included trips to the United States, possibly as early as 1861. By 1869, he had emigrated to Pennsylvania, although he was to continue his peripatetic search for the rugged solitudes of nature with tours of the Adirondacks in 1871, and of the West and Mexico in 1874.

A hardy individualist, he claimed to have left Europe to avoid "Prussian rule," and was known to bicycle regularly from his home in Philadelphia (after 1876) to the Delaware Water Gap—a round trip of some 180 miles. He also enjoyed traveling by train: from 1888 to 1910, he went annually to Gainesville, Florida, to visit his son, Herman, Jr., and from 1902 to about 1930, he journeyed in the opposite direction, to see his other son, Lewis—also a painter—in Maine. Shortly after his 100th birthday, he held a joint exhibition with Lewis at Ferargil Galleries in New York City, and expressed hopes at the time for a similar exhibition to be held in 1941!

Needless to say, Herzog was both an optimist and an idealist in his landscape paintings. No mountain was so grand, nor palmetto stand so tropical, that he could not find ways to intensify the experience or give it a more poetic atmosphere and illumination. As a result, his views of Florida, particularly, reinforce the image of a primordial Eden that utopians, tourists, and promoters alike found irresistible in the late nineteenth century.

Chapellier Galleries, *Herman Herzog (1831–1932)*, New York, N.Y., n.d.

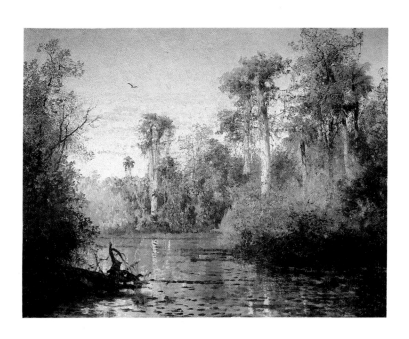

41. *Florida Marsh.* Between 1888 and 1910.

Oil on canvas. 15⅝″ × 20½″.
Signed, lower left: "Herzog".
Provenance: Judy Hagopian Conn, Atlanta, Ga.

JOSEPH RUSLING MEEKER (1827–1889)

Joseph Rusling Meeker, the leading nineteenth-century painter of the Mississippi swamps and Louisiana bayous, was born in Newark, New Jersey, in 1827. A year later, his family moved to Auburn, New York, where Meeker's adolescent interest in art was encouraged, first by the carriage painter, Thomas J. Kennedy, and then by the landscape painter, George L. Clough. Meeker then studied at the National Academy of Design in New York under Charles Loring Elliott from 1845 to 1848, returning to Auburn in the latter year because of financial difficulties.

He next moved to Buffalo, New York, in 1849, and then to Louisville, Kentucky, in 1852, where he taught painting in order to improve his income. In 1859, after further travels,

he settled in St. Louis, which was to remain his home base until his death.

In 1861, Meeker joined the Union Navy, and was stationed aboard a gunboat that traveled the length of the Mississippi River during the course of the war. It was on these tours of the river that Meeker decided on the subjects that were to preoccupy him thereafter. For, between 1865 and 1878, although he visited Colorado, Wyoming, Minnesota, and possibly California as well, he returned every summer to paint the Mississippi delta.

Like Daingerfield in North Carolina, or Herzog, Heade and Thomas Moran in Florida, Meeker extracted from the swamps and bayous of the Mississippi and its tributaries an

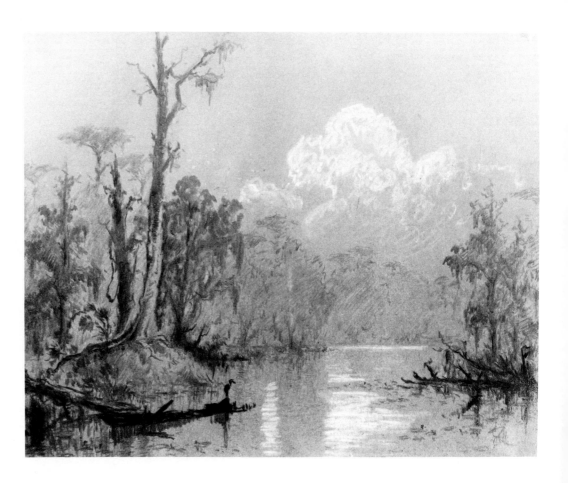

42. *A Louisiana Swamp.*

Charcoal and white chalk on paper. 15⅝″ × 19″.
Signed, lower right: "J.R.M."
Provenance: Vose Galleries, Inc., Boston, Mass.

idealized, aesthetically harmonious, and ultimately mysterious paradigm of a particular type of Southern landscape, elusive because based, not on that which was actually seen, but rather on a concept of what should appear in such a place. And what should appear, in Meeker's vision of it, was all that was silent, suffused with an unearthly light, drenched in damp, exotic foliage, and inhabited solely by the poetic ghosts of Evangeline and her fellow Acadians.

NCAB, XII, 52; C. Reynolds Brown, *Joseph Rusling Meeker: Images of the Mississippi Delta*, Montgomery, Ala., 1981

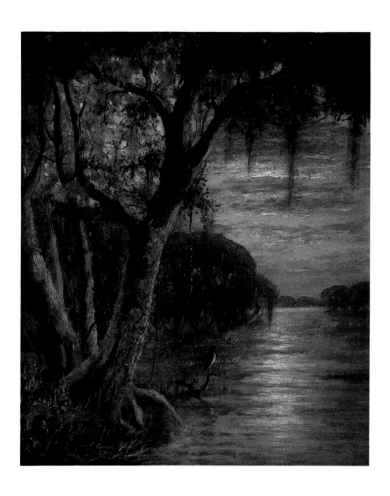

43. *Near Yazoo Pass, Mississippi.* 1889.

Oil on board. 17½″ × 14″.
Signed, lower left: "J. R. Meeker 1889"; inscribed on verso: "Near Yazoo Pass, Mississippi, J.R.M. 1889".
Provenance: Berry-Hill Galleries, Inc., New York

SOUTHERN STILL-LIFE PAINTING

One of the least well-defined and recognized facets of nineteenth- and early twentieth-century Southern art is its still-life painting. Yet scores of still lifes seem to have been produced from the 1830s through the turn of the century, following the patterns of development of American still-life painting generally. It is understandable that this was so, since still lifes were of a size and nature to fit as easily into the decorative schemes of a Southern home as a Northern one.

Among the earliest and most unusual of these still lifes is a watercolor by George Washington Sully. It is a trompe l'oeil rack picture, one of three known to have been done by this amateur painter after he had moved to New Orleans in 1835. A similar ink and pencil rack picture of 1802 by Raphaelle Peale is known, and both his and Sully's works depend on eighteenth-century French precedents. They are also both autobiographical, in the sense that the calling cards, theatre tickets, and other paper ephemera which had accumulated beneath the tacked ribbons formed a memoir of the artist's daily activities and contacts. The planarity of the card rack lent itself nicely to the playful illusionism of the exercise, by which means, of course, the artist advertised his virtuosity as a draughtsman.

Thomas Wightman's *Strawberries* follows another still life tradition, that of the tabletop laden with nature's bounties—the most popular form of still life painting in America in the first half of the nineteenth century. Both Thomas and his brother, William, practiced their craft in Charleston in the 1830s and 1840s, producing dozens of such very attractively painted compositions.

By the 1860s, when Thomas Addison Richards had begun to include still-life painting in his repertoire, American still life painters were increasingly placing their compositions of fruit or flowers in outdoors settings, thus alluding to the underlying harmony between the fruits of nature and their source. Peaches freshly picked and still in the picker's basket had an immediacy of relationship to the out-of-doors that no artificial indoors arrangement could possess. The same feel for rural life is found in Willie M. Chambers' *Apples in a Straw Hat*, probably dating to the 1880s, for, even though the hat and apples form a tabletop composition, the naively particularist rendering of wood grain, straw, and worm hole convey the artist's direct knowledge of the humble facts.

The Washington, D.C., and Richmond artist, John A. Mooney, who seems to have been a self-taught painter, also gives his floral still life a natural setting; the informal profusion of his bouquet is quite unlike anything that appears elsewhere in American art. So, too, is Rosetta Rivers' 1899 still-life of cotton. Rivers, who taught for many years at Wesleyan College in Macon, Georgia, presents the cotton bolls as if they were blossoms in a floral arrangement. To this author's knowledge, this is the only still life extant of the South's dominant crop.

Still-lifes of game were highly popular in the South as well, especially after 1880 when hunting and fishing had become an organized tourist recreation. Both Hal Morrison and William Aiken Walker produced such still-lifes, as did the father of New Orleans still life painting, Achille Perelli. One of Perelli's students was George L. Viavant, whose *Meadowlark* is included. Like Perelli, Viavant was a master of watercolor portraits of dead game, illusionistically rendered (though reduced from life size) against blank background walls, so that the linear patterns of outline and shadow were accentuated.

By the end of the century, in more academic artistic circles, still life painting had become a subject for tour de force handling of paint and compositional complexity. Elliott Daingerfield's *Chrysanthemums in a Devil Vase* of 1886 is just such a showpiece, displaying Daingerfield's mastery of rich color harmonies and textual effects. The subject, in a phrase, has become subordinate to the art.

GEORGE WASHINGTON SULLY (1816–1890)

FOR BIOGRAPHY SEE #8

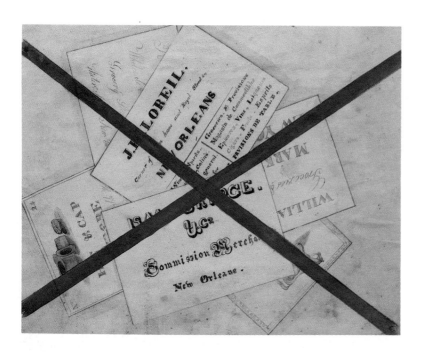

44. *New Orleans Rack Picture.* ca. 1836–38.

Watercolor on paper. 6½″ × 8″.

Depicts in trompe l'oeil style the calling cards of Loreil of
 New Orleans, Bridge & Co Commission Merchants, and
 others.

Provenance for both works: The artist, to his son, the New
 Orleans architect, Thomas Sully, to his daughter, Jeanne
 Sully West, to William Barrow Floyd, Lexington,
 Kentucky, to Berry-Hill Galleries, Inc., New York City.

THOMAS WIGHTMAN (1811–1888)

Thomas Wightman was a portrait and still-life painter from Charleston, South Carolina, who studied under Henry Inman in New York and first exhibited at the National Academy of Design in 1836. He seems to have returned to Charleston by that date, but in June, 1841, he left once again to complete his studies in New York. He apparently remained in New York until after 1854, living in Brooklyn and exhibiting at the National Academy, although he made additional trips South to Georgia and South Carolina during this period. He was elected an associate member of the National Academy in 1849. About the time of the War between the States, Wightman returned to South Carolina, and disappears from the records.

Both Wightman's brother, William (flourished ca. 1845 in Charleston), and his son, Horace, were also painters.

Anna Wells Rutledge, *Artists in the Life of Charleston, Through Colony and State from Restoration to Reconstruction,* In *American Philosophical Transactions,* new series 39 (November, 1949), 102, 153, 166; Groce & Wallace, 685

45. *Strawberries.* ca. 1861

Oil on canvas. 9″ × 16″.
Inscribed, verso: "Given to Leggett by Mr. Wightman, 1861".
Provenance: Robert M. Hicklin, Jr., Spartanburg, S.C.

THOMAS ADDISON RICHARDS (1820–1900)

FOR BIOGRAPHY SEE #12

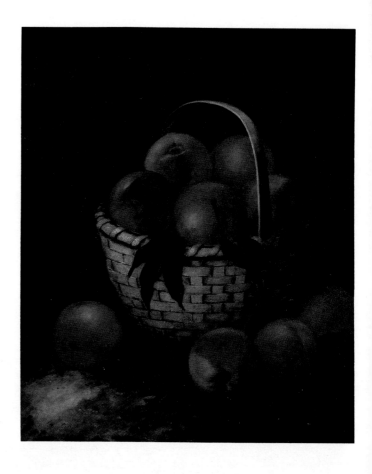

46. *Still Life—Basket of Peaches.* ca. 1865–70.

Oil on canvas. 14″ × 12″.
Signed, lower left: "T. A. Richards".
Provenance: Kennedy Galleries, Inc., New York; Bentley-
 Sellars Collection, Marietta, Ga.
Exhibitions: ? National Academy of Design, 1865, No. 351;
 ? National Academy of Design, 1869, No. 370; ? Brooklyn
 Art Association, November, 1883, No. 200; Memorial
 Art Gallery of the University of Rochester, "Selections
 from the Robert P. Coggins Collection of American Paint-
 ing," The High Museum of Art, Atlanta, Ga., December
 3, 1976–January 16, 1977; Memorial Art Gallery of the
 University of Rochester (N.Y.), February 25–April 10,
 1977; Herbert F. Johnson Museum of Art, Cornell Univer-
 sity, Ithaca, N.Y., May 4–June 12, 1977 (illustrated in cat-
 alogue, p. 73).
Publications: Mary Levin Koch, "The Art of Thomas Addi-
 son Richards," *op. cit.*, No. 28 in catalogue, p. 34.

WILLIE M. CHAMBERS (Late 19th–Early 20th Centuries)

FOR BIOGRAPHY SEE #38

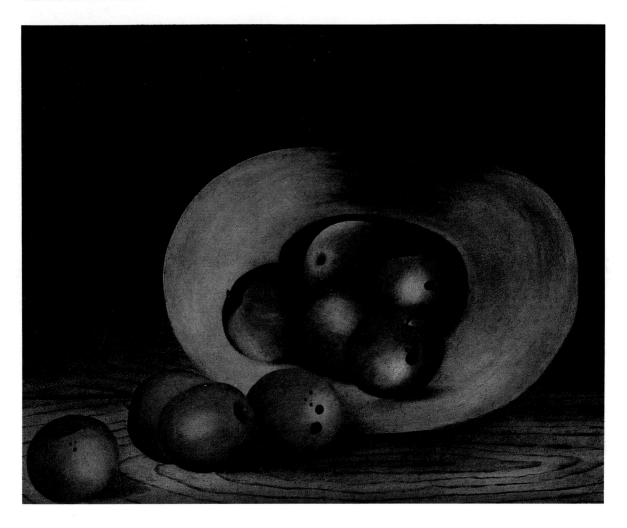

47. *Apples in a Straw Hat.*

Oil on canvas. 17⅜″ × 22⅛″.
Provenance: The family of the artist, Montezuma, Georgia.
Exhibitions: Arnold Gallery, Shorter College, "Women in
 Art; Early Twentieth Century Selections from the collec-
 tion of Robert P. Coggins, M.D.," Rome, Georgia,
 November 16–25, 1980, No. 6.

JOHN A. MOONEY (ca. 1843–1918)

FOR BIOGRAPHY SEE #26

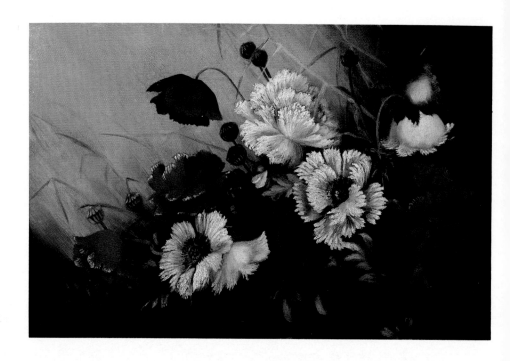

48. *Still Life—Flowers*

Oil on canvas. 12″ × 18″.
Provenance: James A. Williams, Savannah, Ga.

ROSETTA RAULSTON RIVERS (Active 1899–1936)

Rosetta R. Rivers, for many years teacher and principal of the Art Department at Wesleyan College and Conservatory in Macon, Georgia, was trained at the Art Students League and the School of the Art Institute of Chicago, and studied as well with Charles Webster Hawthorne, Ernest Thurn, and Charles H. Woodbury. She exhibited with the Georgia Association of Artists from 1926 to 1936, and with the Southern States Art League in 1935. Besides paintings, Rivers was known for her watercolors, textile block prints, and textile and wallpaper designs.

Her early still life of *Cotton*—what would seem to be a natural Southern subject—is nonetheless the only still life of cotton in American art known to this author.—James M. Sauls, Curator, The Robert P. Coggins Collection

WWAA, 1936–37, 356; Coggins Collection of American Art: Artist Files

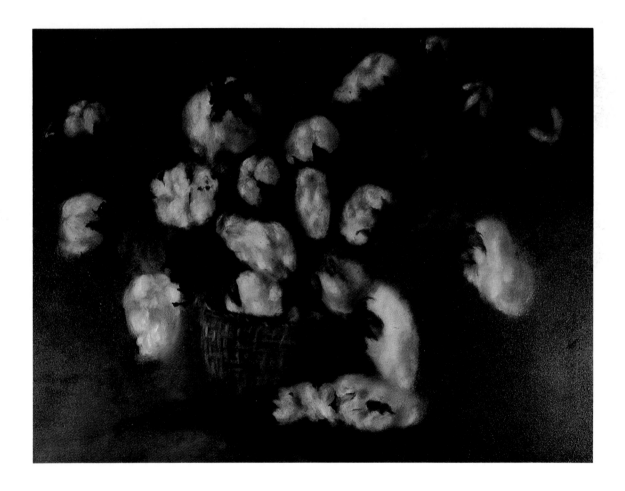

49. *Cotton. 1899.*

Oil on board. 18″ × 24″.
Signed and dated, lower right: "R. Rivers 1899".
Provenance: Judy Hagopian Conn, Atlanta, Ga.

GEORGE L. VIAVANT (1872–1935)

Viavant, a student of the New Orleans still-life painter Achille Perelli, specialized in watercolors of birds. His father was a wealthy cotton broker who lost his fortune in the Panic of 1897, and retreated to the family's remaining property in East New Orleans, then a rural area. To help support his family, Viavant began to sell his watercolors of birds native to Louisiana, the first of which he had painted at age 16, in 1888. He continued to specialize in these subjects into the 1920s, although a few bayou landscapes by his hand are also known.

Martin and Margaret Wiesendanger, *Nineteenth-Century Louisiana Painter and Paintings from the Collection of W. E. Groves*, New Orleans, La., 1971 101

50. *Meadowlark.* 1914.

Watercolor on paper. 16⅝″ × 10¾″.
Signed and dated, lower left: "G. L. Viavant, N.O. 1914".
Provenance: Berry-Hill Galleries, Inc., New York

ELLIOTT DAINGERFIELD (1859–1932)

Elliott Daingerfield was born in Harper's Ferry, Virginia (now West Virginia) on March 26, 1859. In 1861 he moved with his parents to Fayetteville, North Carolina, where his father had been appointed commander of the Confederate Armory. As a youth in Fayetteville, Daingerfield pursued his interest in art with a local china painter and then with a local photographer, but his desire for professional training as a painter took him to New York City in 1880. There he first worked as an assistant to Walter Satterlee and also enrolled at the Art Students League.

The decisive turn in Daingerfield's career took place in 1884 when, moving into the Holbein Studios on West 55th Street, he met George Inness with whom he formed a close friendship based on his admiration of Inness's interest in the spiritual aspects of art. It was from Inness that Daingerfield learned the techniques of complex glazing as well as the late Barbizon presentation of landscape as an idealized unity. It was through Inness, too, that Daingerfield came to know the works of Albert Pinkham Ryder and Ralph Blakelock, about whom—as with Inness—Daingerfield was later to write sympathetic and insightful essays.

In 1885, Daingerfield began to spend his summers in Blowing Rock, North Carolina, where he was soon to construct the first of three consecutive studio homes, each larger than the last. The North Carolina landscape, partly pastoral, partly wild and isolated, served as a focus for his idealized landscape style. It was about this same time, too, that Daingerfield first encountered the writings of Algernon Blackwood, whose *fin-de-siècle* pantheism (e.g., "The Man Whom the Trees Loved") was to strengthen the painter's symbolist inclinations.

Daingerfield's first wife died in childbirth in 1891, and *The Mystic Brim* of 1893 almost certainly interprets that event, portraying as it does both the artist and his wife, accompanied by an angel, standing upon a precipice looking out towards the heavens where seraphim swirl in chorus. As in many of his major symbolist paintings, Daingerfield composed a poem to accompany and expand upon the meaning of the work:

> I stood upon the mystic
> brim of all Immensity
> and now about me
> Were forms like seraphim.
> Gentle light fell round
> the place
> I saw go by a company
> Moving on eternally,
> Their voices mingling in
> pure melody.
> Dazed I stood and heard
> the sound of Hallelujahs
> Then this—a soul is saved!
> Hallelujah!

After Inness's death in 1894, and Daingerfield's remarriage in 1895, Daingerfield's interests turned increasingly to religious themes, culminating in a mural commission for the Lady Chapel of the Church of St. Mary the Virgin in New York City—a congregation that followed the principles of Ritualist renewal first enunciated by the Cambridge-Camden Society in England. Completing these murals—*The Epiphany* and *The Magnificat*—in 1906, the artist then turned his attention less toward the overtly religious and more toward the allegorical.

After 1906, too, Daingerfield experimented increasingly with the expressive possibilities of painting, departing especially from any mimetic use of color to suggest instead an underlying "reality" of intensified feeling and symbolic association. Among the artist's most elaborate imaginary landscapes are those that derived from his visits to the Grand Canyon between 1911 and 1915, visits that were sponsored by the Santa Fe Railway Company to promote its routes but which served to provide Daingerfield with visionary inspiration. *The Genius of the Canyon* is one of these monumental paintings which embodies the painter's disdain of literalness and his belief in the artist's calling to a higher spiritual plane. As Daingerfield announced in a lecture in 1895: "Art is the principle flowing out of God through certain men and women, by which they perceive and understand the beautiful."

In the latter part of his career, between 1916 and his death in 1932, Daingerfield turned away from these larger symbolic compositions to more intimate, densely atmospheric landscapes drawn from the environs of Blowing Rock. At times referred to as "the American Millet," a term that applies primarily to his earliest works, Daingerfield, through his intense idealism, instead provides an important bridge between the art of the late nineteenth century and the evocative but no longer naturalistic paintings of the early modernists.

Elliott Daingerfield, *George Inness: The Man and His Art*, New York, N.Y., 1911; Elliott Daingerfield, "Nature Versus Art," *Scribner's Magazine*, XLIX (February, 1911), 253–256; Wanda M. Corn, *The Color of Mood: American Tonalism 1880–1910*, San Francisco, Cal., 1972

51. *Chrysanthemums in a Devil Vase.* 1886.

Oil on canvas. 34″ × 24″.
Signed, lower left: "Elliott Daingerfield '86".
Provenance: Christie's, Manson and Wood Sale, New York
Exhibitions: The Museum of Arts and Sciences, Macon, Ga.,
 "Two Hundred Years of American Painting, 1700–1900,"
 Macon, June 4–November 8, 1981, No. 88 in catalogue;
 Berry-Hill Galleries, Inc., New York, "Elliott Daingerfield:
 American Mystic (1859–1932)—Paintings and Drawings,"
 May 4–June 8, 1983, No. 13 in catalogue.

SEE ALSO #58, 59, 66, 67, 68, 86

SOUTHERN LANDSCAPE ALTERNATIVES: REALISM AND IMPRESSIONISM

With the approach of the end of the nineteenth century, despite the continuing dominance of certain types of landscape subjects and styles, there was a greater willingness to explore alternative ways of presenting the Southern landscape. Some of these were logical extensions of now-established precedents; others were chosen consciously for their differences from what had gone before. The influence of new painting styles developed in Europe—first, by the painters of the Barbizon and then by the Impressionists—played its part, but so, too, did artists' perceptions of changes taking place in the South itself.

Conrad Wise Chapman was a devout Southerner, so dedicated to the Confederate cause that he had served that, after the conclusion of the war, he did not set foot in the United States again until 1897. From 1897 to 1899, and again from 1909 until his death in 1910, he returned to Virginia where, as he had during his service with the Confederacy, he painted the landscape with loving attention to its character. *Tidewater Creek in Evening Light* is a sensitive and richly-handled study, crisply drawn yet suffused with an aura of serenity and order—in stark contrast to the battered hulk of Fort Sumter that he had depicted some thirty-five years earlier.

Plagued by impoverished circumstances and isolated from the art world, Chapman could nonetheless summon his considerable skills in one final burst of idealism. Henry Ossawa Tanner, at the beginning of his career no less impoverished, sought refuge in the summer of 1889 in the mountains of North Carolina and the northern part of Georgia. Soon to become America's most honored black artist (although he had had to go to France to gain such recognition), Tanner had tried to launch his professional career in Atlanta in the company of his Pennsylvania Academy classmate, Harry Wilson Barnitz. Nothing Tanner attempted worked, whether it was the teaching of art or studio photography: his talents were met by resounding silence on the part of Atlanta's provincial clientele. Seeking ways to overcome his destitution, he set out to photograph the Smoky Mountains with the intent of selling his views to tourists. So many of his photographs were bought that he was able to return to Atlanta, where he obtained a position teaching art at Clark University. In the Spring of 1890, with the assistance of a patron, Bishop Hartzell, he sold enough of his paintings to fund a trip to France. There he completed his studies at the Académie Julian and then settled down for the remainder of his life, returning to the United States thereafter only for brief visits to his family

and friends.

One of the landscapes that Tanner painted during his years in Georgia is depicted in this book. It shows Tanner's sensitivity to the tangible qualities of light and atmosphere absent any idealizing sentiment—a lesson he would have learned from his Philadelphia teacher, Thomas Eakins. The raw bite of autumn under a brooding sky is conveyed with a directness that is both precisely observant—and rare among portrayals of Southern landscape.

William Posey Silva, after pursuing a business career in Tennessee, also went to Paris to improve his landscape painting skills, studying at the Académie Julian at about the same time as Tanner. Exposed to French Impressionism, Silva adapted its higher color key and broken brushwork to the representation of landscape and floral subjects both in the South and in California, where he was a founder of the artists' colony at Carmel-by-the-Sea (he was also involved in the establishment of the Southern States Art League in 1921, and remained one of its major supporters until his death in 1936).

Silva's *Chattanooga from Lookout Mountain*, painted between 1910 and 1920, shows not only the artist's early Impressionist style, but also his interest in the diffusion of light and color caused by the hanging fog and rising smoke of the industrial valley. This very description of Silva's choice of scenery marks a dramatic change not only in how the Southern landscape was coming to be seen, but also in *what* was to be seen in it.

Silva's interest in the New South of enterprise and industry, however, was uncommon this early in the twentieth century. More typical of Southern landscape painting influenced by Impressionism (indeed, more typical of American Impressionist painting generally) were scenes of gardens, sunlit meadows and tree-lined boulevards, inhabited by persons whose primary occupations were rest and leisure.

Representative of such paintings are both Charles F. Naegele's *The Garden Path* and Anthony Thieme's *Charleston Doorway*, in which the special qualities (one might even say, fecundity) of Southern sunlight are celebrated in the bright surfaces and sparkling shadows of the vegetation. Although stylistically different from the paintings of Southern swampland of such artists as Meeker and Oertel, the message of these works is much the same. For, though these are now cultivated gardens, they still possess a cornucopian potential that Davy Crockett might have envied.

CONRAD WISE CHAPMAN (1842–1910)

Son of the painter John Gadsby Chapman, and brother of the painter John Linton Chapman, Conrad Wise Chapman was born in Washington, D.C., in 1842. As the namesake of his father's friends, David Holmes Conrad and Henry Alexander Wise (later Governor of Virginia), Conrad Wise Chapman was from the beginning encouraged to identify with his family's Alexandria, Virginia, roots and, ultimately, with the Confederate cause.

In 1848, the Chapman family left America for Europe, the father leaving behind a successful career as an illustrator for the prospect of greater fortune in Italy. Because of the Revolutions of 1848, the Chapmans did not arrive in Rome until 1850. It was there that Conrad Wise Chapman grew up, learning to paint alongside his father, who had begun specializing in landscapes and genre scenes for American and English tourists.

His Confederate sympathies deeply felt, Conrad Wise ignored his parents' protestations and left Italy in 1861 to join the Confederate Army. He first enlisted at Bowling Green, Kentucky, with a Kentucky regiment. Continuing to paint landscapes and scenes of army life, he acquired the affectionate nickname, "Old Rome," from his camp mates. Injured at Shiloh, he was persuaded on recovery to transfer to the Virginia Volunteer Brigade then under the command of his father's old friend, Henry Wise. He spent the winter of 1862–63 on active duty in the Tidewater, after having been a spectator at the siege of Vicksburg. In Charleston, South Carolina, from September, 1863, to March, 1864, Chapman was detailed to make paintings of Charleston's fortifications. He was then granted furlough to visit his ailing mother in Rome, making a daring escape through the Federal blockade for that purpose.

When he learned on arriving in Rome in August, 1864, that his parents had written Wise requesting their son's discharge, Conrad Wise Chapman, indignant, started back to America. But illness delayed him, and he arrived in Texas shortly after the end of the war. He then decided to join Confederate General John B. Magruder in Mexico, who was assisting the government of Emperor Maximilian. When Maximilian was overthrown, Chapman chose to remain in Mexico, painting landscapes of Mexican scenery, including a "Valley of Mexico" that measured seven by fourteen feet.

Chapman then returned to Rome in 1866, and next went to Paris with the goal of further training under Jean-Léon Gérôme. The Franco-Prussian War, however, intervened, and Chapman next found himself in England. There, in 1871, when painting a frescoed ceiling, Chapman became violently insane, and for the next three years was confined to an asylum. By the time he was released in 1874, his mother had died, and Chapman, after a brief stay in Rome, returned to Paris, when he met and married Anne Marie Martin.

In 1883, Chapman moved back to Mexico City. Five years previously, his brother John Linton had moved from Italy to Brooklyn and was joined there by John Gadsby Chapman, now struggling in poverty. As John Linton proved to be improvident, in 1884 the father joined his other son in Mexico but, when Conrad Wise's wife died in 1889, John Gadsby was sent back to live with John Linton, where he died eleven weeks after his arrival.

Faced with increasing financial difficulties himself, Conrad Wise Chapman went, first, to Paris, and then back to Mexico in 1892. He seems through this period to have been experimenting with photography rather than painting. In Mexico City, he remarried, and resumed his portrayal of the Mexican landscape. With the outbreak of the Spanish-American War, he came to the United States for the first time since the War Between the States, living in Richmond among family friends. In about 1899, he returned again to Mexico, and then in 1901 joined John Linton Chapman in Brooklyn. By coloring engravings, Conrad Wise was able to afford, first, his father, and then also his brother (who died in 1905) with proper burials. In 1906, he made his final visit to Mexico, traveling on borrowed money, and in 1909, his last move, to Hampton, Virginia, where he died in 1910.

Although the pinnacle of Conrad Wise Chapman's career occurred early in his life, in the 1860s, when as a landscape and military subject painter his precise delineations, sunny illumination, and subtle sense of composition placed him in the first rank of American painters, toward the end of his career when he had returned to Virginia, he was able—as in this example—to recapture much of the spirit of his earlier work.

Louise F. Catterall, ed., *Conrad Wise Chapman, 1842–1910: An Exhibition of His Works*, Richmond, Va., 1962; also acknowledgment to Robert B. Mayo, Richmond, Va.

52. *Tidewater Creek in Evening Light.*
 ca. 1895–99, or 1909–10.

Oil on canvas.
9″ × 11″.
Unsigned.
Provenance: Gallery Mayo, Richmond, Va.

HENRY OSSAWA TANNER (1859–1937)

Henry Ossawa Tanner, America's foremost black painter of the late nineteenth and early twentieth centuries, is still too little known or celebrated. An expatriate in France for most of his career, he was a regular exhibitor at the Paris Salon, Chevalier of the Legion of Honor, and the only American to have two of his works purchased by the French government for inclusion in the Musée de Luxembourg. Yet he was also a full member of the National Academy of Design, a prize-winner in many American exhibitions, and a major influence in the development of religious painting in this country.

Born in Pittsburgh in 1859, he moved with his family to Philadelphia in 1866, where his father became a bishop in the African Methodist Episcopal Church. Between 1880 and 1882, Tanner studied at the Pennsylvania Academy of the Fine Arts under Thomas Eakins, who was later to paint Tanner's portrait (in 1902). Between 1882 and 1887, Tanner lived in Philadelphia with his parents, attempting to become established as a painter and selling illustrations to New York publications.

In 1887, Tanner resettled in Atlanta, Georgia, to work with his Pennsylvania Academy classmate and fellow Eakins student, Harry Wilson Barnitz. Barnitz and Tanner occupied the studio of the Georgia painter, Horace Bradley, who had moved to New York City in 1886; Barnitz advertised as a portrait painter, Tanner as a photographer, and both attempted to set up classes in art, but their collective efforts met with little economic success (small wonder, when Tanner was perceived by the Atlanta public as the studio's "caretaker," and Barnitz was reduced to painting hackneyed likenesses of Jefferson Davis and still lifes of magnolias!) (see Carlyn Gaye Crannell on Barnitz and Tanner in Atlanta: "In Pursuit of Culture: A History of Art Activity in Atlanta, 1847–1926," Ph.D. dissertation, Institute of Liberal Arts, Emory University, Atlanta, 1981, pp. 196–204).

Barnitz returned to Philadelphia in the Spring of 1889. In the summer of the same year, Tanner rented a cabin at Highlands, North Carolina. Tanner recounted both his struggle to make a living as an artist in Atlanta and his North Carolina experiences in an autobiographical sketch that appeared in *The World's Work* in 1909 (Henry Ossawa Tanner, "The Story of an Artist's Life," *World Work*, Vol. 18 (June, 1909)):

The calculation that I should have some time [in Atlanta] was well made; the calculation that I should take some photos, a mistake. I had so much more leisure than I had calculated upon, and this so distressed me, that I could not work. So it turned out that I did nothing. I could neither make it go, nor dare let it go—because with "blood and tears" I got enough out of it to pay my board each week. (cited in Crannel, "In Pursuit of Culture," p. 202).

Perhaps my most trying experience—trying in relation to my physical existence—was yet to come. It was, however, only bodily discomfort, and caused me little or no sighing. I had gone to Highlands, N.C., with the thought that with my camera I could at least make my expenses. I should be able to study and at the same time the mountains would be good for my health. I had made photos of the whole immediate region, a most lovely country, and, as no photographer had ever visited it before, they were a success, and my hard times—very hard times—vanished as the mountain mists before the sun. In the fall, I was back in Atlanta . . . "(cited in *The Art of Henry O. Tanner*, The Frederick Douglass Institute in collaboration with the National Collection of Fine Arts, Washington, D.C., 1969, p. 20).

When he returned to Atlanta in the Fall of 1889, Tanner obtained a position teaching drawing at Clark University, which he retained through the following Spring. He also painted portraits of a number of the Clark faculty, among them Bishop and Mrs. Hartzell. It was the Hartzells who, later that same year, purchased the bulk of the works that Tanner had exhibited in Cincinnati in hopes of raising enough money to go to Europe, but for which he had failed to find any buyers. Among the landscape paintings that returned to Atlanta by these means was *Georgia Landscape*, probably painted in the Fall of 1889 after Tanner's return from Highlands.

With the money provided by the Hartzells and other patrons, Tanner sailed for Europe in 1891. Though he was to return to visit his native country, except for a brief residence in England between 1914 and 1917 Tanner lived in France the remainder of his life. He studied at the Académie Julian in Paris from 1891 to 1894 under Benjamin-Constant and Laurens, and by the latter year had received his first acceptance at the Salon. In 1896, his first major religious painting, *Daniel in the Lion's Den*, received honorable mention at the Salon, and set him on a path on which he was to continue with notable success. Tanner's visits to the Holy Land in 1897 and 1898 only intensified his belief in placing his subjects both in believable settings and in providing them with spiritual qualities of illumination and color.

In 1903, Tanner moved from Paris to a farmhouse he had purchased at Trépied, near Etaples. Although he went to England in 1914 to escape the war, he returned to France in 1917 to work as a lieutenant with the American Red Cross. He continued to live and work at his farm studio until his death in 1937.

DAB, supp. II, 648; NCAB, III, 89; Marcia M. Mathews, *Henry Ossawa Tanner: American Artist*, Chicago, Ill., 1969

53. *Georgia Landscape.*
1889–90.

Oil on canvas. 17¾″ × 32¼″.
Signed, lower left: "H. O. Tanner".
Provenance: Sammy J. Hardeman, Atlanta, Georgia.
Exhibitions: Trosby Auction Galleries, "Atlanta Collects,"
 Atlanta, Ga. April 27–May 1, 1980, ill. in cat., p. 49.

WILLIAM POSEY SILVA (1859–1936)

Born in Savannah in 1859, William Posey Silva first went into business in Tennessee. Although a talented amateur painter, he did not begin formal artistic training until the last decade of the nineteenth century. He studied at the Julian Academy in Paris under Laurens and Royer, and then for a summer with Chauncey F. Ryder in Etaples, France.

It was during these studies in France that Silva began working in the Impressionist style that he would identify with for the rest of his career. An active member of the artists' colony at Carmel-by-the-Sea, California, after 1915, he nonetheless spent much of his time in the South, finding landscape and floral subjects in Tennessee, Georgia, the Carolinas, and Texas. He also painted in Ogunquit, Maine, and Gloucester, Massachusetts.

Silva was a frequent and popular prizewinner whose works were much in demand. He was also a loyal participant in the Southern States Art League annual exhibitions from the League's founding in 1921 until his death in 1936.

Chattanooga from Lookout Mountain, painted between 1910 and 1920, is a fine example of Silva's early style, with its broken brushwork and tonalist color, combining the hanging fog of the valley with the smoke of its industrial stacks to achieve its luminosity of atmospheric effect. The obvious presence of industry in this idyllic setting enforces a correlation between Silva's optimistic view of (Southern) nature and the philosophy of the New South as articulated by Henry W. Grady.

Fielding, 332–333; WWAA, 1936–37, 388–389; PITS, 99, 272

54. *Chattanooga from Lookout Mountain.* ca. 1910– 20.

Oil on board. 8⅝″ × 11¾″.
Signed, lower right: "William P. Silva".
Provenance: Sammy J. Hardeman, Atlanta, Ga.
Exhibitions: Southern Arts Federation, "Southern Works on Paper, 1900–1950," catalogue by Richard Cox, Atlanta, 1981, No. 10 (illustrated, p. 29).

CHARLES FREDERICK NAEGELE (1857–1944)

Born in Knoxville, Tennessee, as a child Naegele moved with his parents to Memphis, where by 1873 he was apprenticed to a tombstone carver at three dollars a week. He also earned money painting signs, and it was through a sign commission that he met the marine painter, Charles Myles Collier, who gave painting lessons to the younger artist and then, in 1880, sent him to study in New York with William Sartain and William Merritt Chase. After completing his studies in 1882, Naegele remained in New York, quickly gaining favor as a portrait painter. He also designed medals and painted idealized figures of women portraying "Motherhood" and "American Beauty".

Later in his career, he turned increasingly to landscape paintings, particularly after his retirement to his hilltop studio, "Artcrest," near Marietta, Georgia. A winner of many exhibition prizes, he was a member of the Artists' Fund Society, the National Arts, Salmagundi and Lotos Clubs in New York, and the Atlanta Art Association. He died in Marietta in 1944.

NCAB, XII, 81; Fielding, 254; Richard J. Koke, comp., *American Landscape and Genre Paintings in the New-York Historical Society*, Boston, Mass., 1982, III, 1–2.

55. *The Garden Path (Cabbage Patch)*.

Oil on canvas. 25″ × 21½″.
Signed, left center: "C. F. Naegele"; inscribed, lower right, "Ga.".
Provenance: Berry-Hill Galleries, Inc., New York

ANTHONY THIEME (1888–1954)

Anthony Thieme was born in Rotterdam, Holland. He studied at the Academy of Fine Arts in Rotterdam (1902–04), at the Royal Academy at The Hague (1905), as an apprentice artist in Düsseldorf, Germany, under George Hoecker, Germany's foremost stage designer (1906–08), and at the School of Fine Arts, Turin (1909–10). After completing his studies he traveled in Europe, England, and South America, and he worked as a stage designer in these places both before and after coming to the United States in 1917. In 1919 he settled in Boston where for nine years he worked as a designer and painter of stage settings for the Copley Theatre, while also doing book illustrations for Boston publishers.

By 1927, he had established a studio at Cape Ann in Rockport, Massachusetts, where he taught summer painting classes and became well-known for his seascapes and shore

56. Charleston Doorway. 1946–47.

Oil on canvas. 30½″ × 36½″.
Signed, lower left: "A. Thieme"
Provenance: Memorial Art Gallery of the University of
 Rochester, Gift of Elizabeth Grover Johnson, 1975;
 deaccessioned in 1978.

scenes. While he worked in an Impressionist manner, he was also profoundly influenced by the Dutch seascape tradition, and was particularly interested in the effects of light on water. His work was exhibited in New York, Washington, Paris, and London, and was acquired by many museums.

In 1946, Thieme's Cape Ann studio burned down, together with much of his work of the previous thirty years. Rather than rebuild his life in Massachusetts, Thieme struck out for territory which he had not previously explored. His first stop was Charleston, South Carolina, where he spent two months in prolific activity, inspired by the revelation of light and color far more intense than that to which he had become accustomed. The paintings that he produced in Charleston were a far cry from his "picturesque New England harbor scenes," as the reviewer of Thieme's exhibition in 1947 at the Grand Central Art Galleries acknowledged. The serenity and tonal discipline of his seascapes was abandoned for the elaborations of wrought iron and profusion of blossoms that Charleston imposed on his senses. The heady aroma of the Southern landscape induced him to continue his travels—to St. Augustine and Nassau in 1948, to Guatemala in 1949, to the Riviera in 1951, and to Spain in the year of his death, in 1954.

NCAB, XLII, 640; Memorial Art Gallery of the University of Rochester: Artist Files

THE SYMBOLIST LANDSCAPE

Despite what would appear to be the South's natural affinity for the Impressionist palette, it is surprising how few artists actually worked in the style. The greater number of painters exploring the Southern landscape at the turn of the century were more involved with interpreting the world that lay behind appearances than they were with the transient effects of surface. In part, this reflected the South's general distrust of "foreign" styles, but there was also a pride in the principle that the South was somehow removed from the mundane, materialistic concerns of the North and was a place holier and more sacrosanct in its associations.

Even though he worked most of his life in Europe and in the North, George Inness, Jr., maintained a studio in Tarpon Springs, Florida, and found the Southern landscape particularly sympathetic to his belief in an underlying spiritual plane. Like his father, he perceived beneath the transitory surfaces of the landscape a truer, more permanent reality, akin to that of Heaven, which could be but glimpsed and intimated, but which it was the artist's highest calling to portray. His *Rainbow in Georgia* manifests such an attempt, for the landscape as composed by the artist possesses a formal order that, in combination with its all-encompassing, detail-effacing haze of glowing color, removes it from the sphere of the ordinary into that of the ideal and ethereal. The inclusion of the rainbow—sign of God's covenant with man—only underscores the artist's religious perspective.

Elliott Daingerfield was also a protégé of George Inness. Born in Harper's Ferry, Virginia (now West Virginia), he grew up in Fayetteville, North Carolina, where his father was commander of the Confederate Armory there. Although he studied and maintained a studio in New York (which is where he was befriended by Inness), from 1885 Daingerfield also lived much of each year in Blowing Rock, North Carolina, the scene of many of his best landscapes. The two landscapes, both watercolors—*Grandfather Mountain* and *Mysterious Night*—show not only Daingerfield's mastery of the fluid, evocative properties of the watercolor medium, but also his poetic feeling for elusive nature, shrouded in atmosphere and in the muted tonalities of evening light.

Alexander Drysdale's bayou scenes, painted in the first three decades of this century, share in this symbolist inclination. Painted in watercolor or in oil thinned with kerosene so as to resemble watercolor in its effects, Drysdale's landscapes capture the humidity-laden, vaporous environment of the lower Mississippi bayous with much the same spirit as Daingerfield's North Carolina mountains or Inness, Jr.'s Florida and Georgia pine breaks. That is, Drysdale's emphasis lies, not with the picturesque particulars of a given region, but rather with the universality of nature as a generalized poetic ambience to which man responds with his feelings rather than with his objective senses.

A salient feature of the work of all three painters is its removal, as landscape, from the ordinary processes of time. Yankee time, in the popular Southern view, was compulsive, a driven, sequential process that got one from point A to point B with the greatest possible efficiency. In the landscape of the South as portrayed by these artists and by the artists who had preceded them in the 1870s and 1880s, such a sense of time does not exist. It is not even that the pace of time is more leisurely in the South; these dreamlike landscapes contain no sense whatsoever of the movement of time. What is perceived is a landscape outside of time, that could exist at any time, and therefore exists in none. The landscape recalls a more halcyon time, or a more primordial one, without specifying precisely when that occurred, if it occurred at all. It is, in this view, a kind of sanctified, mythic, immortal space free from the ravages of time and free, too, from the secular preoccupations of mortal man. It is a time, then, and a place instilled with grace which, if not demonstrably divine, was blessedly close.

An almost perfect instance of this point of view is the work of Alice Ravenel Huger Smith of Charleston. The daughter of one of Charleston's most distinguished families, Alice Smith disdained artistic training in the North or in Europe, believing that the close study of her own natural environment would give her sufficient inspiration and practice. Her life's work was to capture the beauties of the South Carolina lowlands and the verities of South Carolina's memorable past. As a writer, working with her historian father, she wrote *The Dwelling Houses of Charleston* (1917), a biography of the Charleston miniaturist, Charles Fraser (1924), and her family's recollections of plantation life (*A Carolina Rice Plantation of the Fifties*, 1936). She was an active member of the Carolina Art Association, the Charleston Etcher's Club, and the Society for the Preservation of Old Dwellings, all of which were dedicated in one way or another both to documenting and restoring the special character of antebellum Charleston, or to reviving its spirit.

In her extraordinary watercolors of the low country, her interest was focused on its essential—which is to say, poetic—facets, its intensity of color, its pure, reflective pools of water, and its passing birds. Like Drysdale, she worked almost entirely from her memory of what she had seen, allowing memory to distill from the whole what seemed to be the underlying truth. And like the Japanese woodblock prints that appealed to her sense of clear, forceful design, her watercolors succeed as affirmative summaries of place, even as they exist outside the particular referents of history.

It was with an entirely different kind of symbolic vocabulary, one that was intensely personal, that Charles Burchfield recorded his brief career in the Army when he was stationed at Camp Jackson, South Carolina. Early in his career, Burchfield was struggling to find an artistic vocabulary that could express his feelings about the world around him in a direct way, unmitigated by the layers of artistic tradition that were usually assembled to provide "aesthetic distance." He began to include in his drawings of things he had seen complex layers of private symbolic signs, signs that articulated specific moods, such as his *Early Night* which, in Burchfield's words, embodies a "mood of apprehension." Later in his career, these private symbols were to become a powerful motif in his landscapes of eastern Ohio and upstate New York; they make one of their earliest appearances during his South Carolina service—unsurprisingly, given the degree to which that service depressed him.

GEORGE INNESS, JR. (1853–1926)

The son of the painter George Inness, George Inness, Jr., was born in Paris, France, in 1853. He studied art both with his father in Rome and Paris, and at the Académie Julian, in 1875, with Leon Bonnat. In 1871, he established his own studio in Boston, later moving to New York where he was employed primarily as a magazine illustrator. Following his marriage in 1879, he moved to Montclair, New Jersey, living near his parents.

Feeling that his work was too similar to his father's, after his father's death in 1894, he destroyed most of his early paintings, and sailed for Europe, where he achieved distinction as a painter of religious subjects. In 1900 he moved to Cragsmoor, New York, where he had purchased "Chetolah," the former home of the artist, Eliza Greatorex. He also maintained a studio in Tarpon Springs, Florida, for whose Church of the Good Shepherd he painted eight large mystical canvases. In 1917, he wrote the first definitive book on his father's life and works (*The Life and Letters of George Inness*), and also composed a volume of "Random Thoughts".

Although ambivalent about his father's example on his own work, he painted several Georgia and Florida landscapes—probably on trips with his father between 1886 and 1892—which are among his finest, most lyrical works. Like George Inness' paintings, his son's *Rainbow in Georgia* evinces a formal order and glowing, atmospheric color that acts to signify the deeper spiritual harmonies of nature.

NCAB, XXII, 181; Fielding, 184; Cragsmoor Free Library, *The Cragsmoor Artist's Vision of Nature*, Cragsmoor, N.Y., 1977

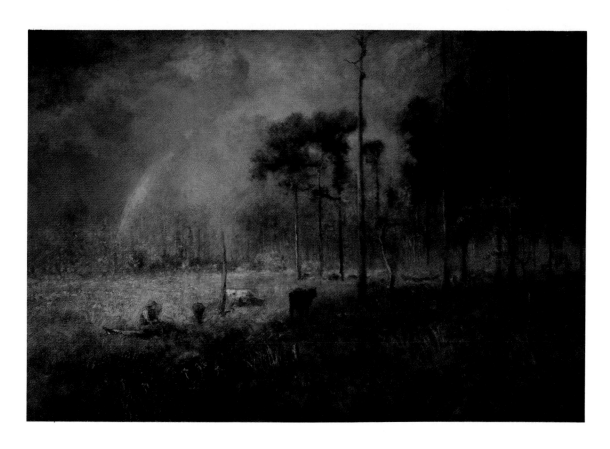

57. *Rainbow in Georgia.* Between 1886 and 1892.

Oil on canvas. 16″ × 24″.
Signed, lower left: "Inness, Jr."
Provenance: Bentley-Sellers Collection, Marietta, Georgia

ELLIOTT DAINGERFIELD (1859–1932)

FOR BIOGRAPHY SEE # 51

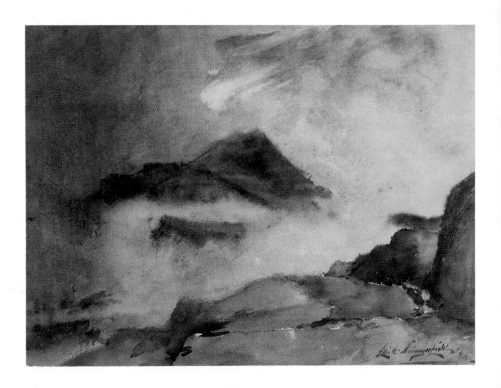

58. *Grandfather Mountain, North Carolina.*
ca. 1910.

Watercolor on paper. 9″ × 12¼″ (sight).
Signed, lower right: "Elliott Daingerfield".
Provenance: The Mint Museum, Charlotte, North Carolina.
Exhibitions: Southern Art Federation, Atlanta, Georgia,
 "Southern Works on Paper, 1900–1950," 1981–82, No. 3
 in catalogue (illustrated p. 19).

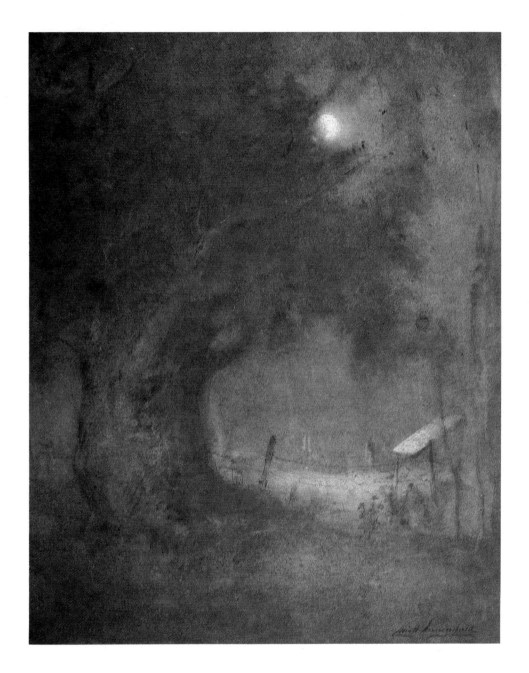

59. *Mysterious Night.* ca. 1895.

Watercolor on board 30½″ × 21½″.
Signed, lower right: "Elliott Daingerfield".
Provenance: Mrs. Arthur E. Howlett and Mrs. Worth B. Ply-
ler, Blowing Rock, North Carolina.
Exhibitions: The Mint Museum of Art, "Elliott Daingerfield
Retrospective Exhibition," No. 33 in catalogue (illustrated
p. 15);

Southern Arts Federation, Atlanta, Georgia, "Southern
Works on Paper, 1900–1950," 1981–82, No. 4 in catalogue
(illustrated p. 4);
Berry-Hill Galleries, Inc., New York City, "Elliott Dainger-
field: American Mystic," May 4–June 8, 1983, No. 20 in
catalogue.

SEE ALSO # 67, 68, 86

ALEXANDER JOHN DRYSDALE (1870–1934)

Born in Marietta, Georgia, on March 2, 1870, Drysdale was the son of the Reverend Alexander I. Drysdale, who was then performing missionary work in Cartersville, Kingston, Cave Springs, and Dalton, Georgia, and who would next serve parishes in Atlanta, Chattanooga, Tennessee, Athens, Georgia, Mobile, Alabama, and New Orleans, where he and his family settled in 1883. Drysdale's first art lessons were taken under a Miss Haskell, who was visiting New Orleans as an instructor at the Art Union. He later studied under Paul Poincy of New Orleans, and at the Art Students League in New York with Charles Courtney Curran, Bryson Burroughs, and Frank Vincent DuMond.

Returning to New Orleans from New York in 1903, Drysdale, serving as his own promotion agent, managed to develop a following for his impressionistic bayou landscape studies, painted in watercolor or in oil thinned with kerosene so that it behaved much like watercolor. He exhibited his work regularly at the New Orleans Art Association, where he had been a member since 1889.

According to Rick Stewart, Drysdale was influenced as much by the work of George Inness as he was by his knowledge of Impressionism. He described Inness' work as having to do with the "transitory effects of nature" that Inness had "painted from memory" (cited in Stewart, "Toward a New South: The Regionalist Approach, 1900–1950," in the Virginia Museum of Art catalogue, *Painting in the South*, Richmond, Virginia, 1983,). Drysdale's paintings, with their tonalist color, atmospheric effects, and evocative generality, were not—any more than Inness' or Daingerfield's landscapes—intended as portraits of specific locations, but were instead summary reconstructions of 'bayou-ness' in all its primordiality and mystery.

WWAA, 1936–37, 397; PITS, 106–107, 276; Coggins Collection of American Art: Artist Files

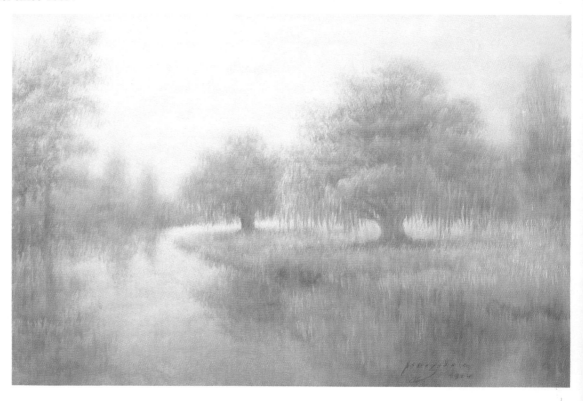

60. *Bayou Landscape.* ca. 1910.

Kerosene-thinned oil on paper. 19¼″ × 29½″ (sight).
Signed, lower right: "A. J. Drysdale".
Provenance: Sammy J. Hardeman, Atlanta, Ga.

ALICE RAVENEL HUGER SMITH (1876–1958)

Alice Ravenel Huger Smith was the leading figure in Charleston's renascence as an art center in the early twentieth century. The energies she put into this task—as painter, printmaker, author, illustrator, historian, and historic preservationist—were both enormous and deliberate. As Martha Severens, Curator of the Gibbes Art Gallery, has written, Alice Smith, who came from a distinguished South Carolina family, "associated the year of her birth, 1876, not with the nation's centennial, but with the resurgence of the South. For her, 1876 was the year that saw the determined uprising of the people of South Carolina against the terrible Reconstruction government" (Martha Severens, "Lady of the Low Country," *South Carolina Wildlife*, March–April, 1979, p. 16).

Inspired by her family's recollections of the past, and particularly by her father's wide-ranging knowledge of South Carolina history and wildlife, she set about in diverse ways to reconstruct an image of South Carolina that was both positive and poetic. In doing so, she inspired her Charleston contemporaries—among them, Elizabeth O'Neill Verner and DuBose Heyward—to exert their own considerable talents on Charleston's behalf.

Informed early in life by her grandmother that she was to become an artist, Alice Smith studied painting and watercolor in classes held at the Carolina Art Association in the 1890s. She chose not to venture to New York City or to Europe for formal training, believing that the direct study of

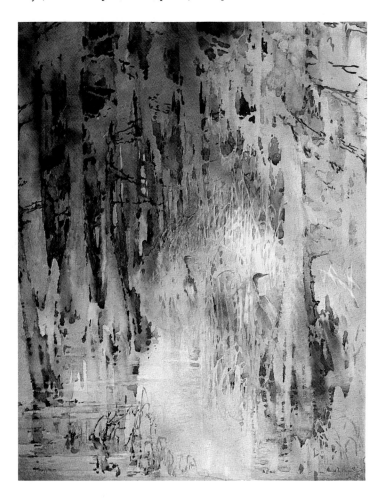

61. *Bayou Scene.*

Watercolor on Whatman board. 21½″ × 16¾″.
Signed, lower right: "Alice R. Huger Smith."
Provenance: Robert M. Hicklin, Jr., Spartanburg, S.C.

nature would provide her with sufficient inspiration and practice. At first she painted place cards, fans, glove cases, and other fancies; then she turned to picturesque sketches of blacks and watercolor copies of old portraits. In about 1910, she met Birge Harrison, founder of the Woodstock Art Association, who had come to Charleston for relaxation, and who obtained instead an interested friend in Alice Smith. Harrison became the only artist whose influence Smith would acknowledge; his own poetic view of nature and inclination to filter landscape through memory jibed well with her tendencies, which were then strongly reinforced by her growing knowledge of Japanese Ukiyo-e woodblock prints.

Although she did a number of her own woodblock prints, as well as etchings and paintings in oil, by 1924 she had come to concentrate on the watercolor medium exclusively. She explained:

I began to broaden and loosen my method of watercolor—and I dropped oils altogether. Perhaps because, although the latter is the easier medium, I had the feeling even then that this country, in its soft haze and quiet distances, its usually gentle character and simple friendly intimacies, was more easily depicted by the more transparent medium (cited in Severens, *op. cit.*, p. 19).

Smith's approach to the use of her medium depended on memory, the absorbing in her mind of what she had seen, and the subsequent rendering of its general effects rather than its literal appearance. Helen McCormack, in her biographical sketch of Smith, related how, "on long buggy rides, boat trips into marshes, dawn expeditions into swamps, moonlight excursions to beaches, 'Miss Alice' silently looked and absorbed while others were lost in the enjoyment of the moment." (cited in *Alice Ravenel Huger Smith: An Appreciation on the Occasion of Her Eightieth Birthday, from Her Friends,* privately printed: Charleston, 1956, p. 7).

In the resulting paintings, Alice Smith captured the evanescent moods of the Carolina lowcountry, its slow changes over times of day and seasons, and its more rapid shifts with the weather. The transitory nature of her beloved environment was symbolized most in the presence of water, which reflected all changes, and by the great herons, egrets, and pelicans who inhabited the land only in passing through it.

But Smith's paintings were only one facet of her contributions to the revival of an indigenous Southern (and specifically Carolina) self-awareness. With her father, D. E. Huger Smith, she wrote or illustrated *The Dwelling Houses of Charleston* (1917), a biography of the Charleston miniaturist and portrait painter, Charles Fraser (1924), *A Carolina Rice Plantation of the Fifties* (1936), and *A Charlestonian's Recollections, 1846–1913* (1950), the latter two being completed after her father's death. She was an active member of the Carolina Art Association, and helped to organize many of its exhibitions, and "she took part in the movements which stirred the city in the Twenties and Thirties, sharing responsibility of membership in the Museum and Poetry Society, the Historical Society, and other organizations." (McCormack, in *Alice Ravenel Huger Smith, op. cit.*, p. 8). Like other major Southern painters of the early twentieth century (for instance, Alexander Drysdale, Elliott Daingerfield, or Will Henry Stevens), Alice Smith's unwavering perception of the South was both idealized and actively affirmative.

PITS, 114, 293; Also acknowledgment to Martha Severens, Charleston, S.C.

CHARLES EPHRAIM BURCHFIELD
(1893–1967)

Charles Burchfield was born in Ashtabula Harbor, Ohio. On the death of his father in 1898, he moved with his mother to Salem, Ohio, where as a child his favorite occupation was wandering alone through the fields and woods near the town. Burchfield's deep love of nature and of its changing seasons and moods was fixed early by these experiences, and was reinforced by his reading of Thoreau, John Burroughs, and other naturalists.

In 1912–16, he attended the Cleveland School of Art, studying under Henry Keller and Frank Wilcox, who introduced him to the music of Sibelius, Wagner and Stravinsky, the costumes and stage designs of Diaghelev, and the illustrations of Rackham, Dulac and Bilibin, as well as to Chinese and Japanese art. All of these influences acted to free Burchfield's imagination, and helped lead him to the invention of a private vocabulary of artistic symbols that he was to use throughout his career to express his emotional responses to the visible world.

In July, 1918, Burchfield was inducted into the Army, and was attached to Field Artillery at Camp Jackson, South Carolina. The abrupt dislocation led at first to depression and to morbid and eerie dreams that are reflected in these drawings of his encampment. Later transferred to the Camouflage Section, his mood brightened, and when he was provided

63. *Early Night.* 1918.

Pencil on paper. 8¼″ × 5″.
Signed, lower left, with monogram, and dated 1918; inscribed, verso, upper center: "C. J.—1919/16—Early Night/8⅜ × 5¼—V/(A Mood of Apprehension)."

62. *Tents at Twilight.* 1918.

Pencil on paper. 6⅝″ × 8¼″.
Signed, lower left, with monogram, and dated 1918; inscribed, verso, upper center: "C. J.—1919/6—Tents at Twilight—/ 11 × 8½—V."

64. *Guard House.* 1918.

Pencil on paper. 8¼″ × 5″.
Signed, lower left, with monogram, and dated 1918; inscribed, lower center, "Guard House"; inscribed, verso, upper center: "C. J.—1919/22—Guard House/ 8¼ × 5⅜—V."
Provenance for all three drawings: Christie's, Manson and Woods Sale, New York City.

with additional leave time by a sympathetic lieutenant, he became entranced with the dusty roads and dilapidated cabins of the South Carolina countryside. This fascination with the man-made environment was later carried over into his watercolors and drawings of Salem, where he returned in January, 1919, and of Buffalo, New York, his home after 1921. Yet both the natural and the man-made worlds are enhanced in Burchfield's art by his interposition of complex layers of private symbolic invention, as in his drawing here of *Early Night*, which the artist himself describes as filled with "a mood of apprehension."

Memoral Art Gallery of the University of Rochester and the Smithsonian Institution Traveling Exhibition Service, *Charles Burchfield: The Charles Rand Penney Collection* (essay by Bruce W. Chambers), Washington, D.C., 1978

RELIGIOUS PAINTING IN THE SOUTH

If religious feeling was a tacit component of Southern landscape painting in the late nineteenth and early twentieth centuries, it was also an explicit facet of Southern painting more generally. Most surveys of American painting ignore its religious painters and subjects, even when those were an integral part of the culture. In any survey of Southern painting, that would be difficult to do, insofar as some of the South's more important artists were involved in religion to a degree comparable to the South's own well-documented inclination in that direction. The two most notable of these painters were Robert Loftin Newman and Elliott Daingerfield, united by common bonds of friendship to one of the nineteenth century's most independent visionaries, Albert Pinkham Ryder, and united as well in their belief that the pictorial expression of religious belief was one of the highest callings of the painter. (It should be noted that Newman and Daingerfield were not unique in this interest: among other painters included in this collection, J. A. S. Oertel, Henry Ossawa Tanner, and George Inness, Jr., were all best known as religious painters in their day.)

Newman's *Rabboni*, which depicts the risen Christ appearing to one of the three Marys, is in its jewel-like color and dark, indefinite spaces, a paradigm of the silent, timeless landscape of mystery, now inhabited by figures that are equally timeless in their apparition. Daingerfield's *Christ Stilling the Tempest*, though more tumultuous in line with its theme, might easily be mistaken as Newman's pair in the similarity of its symbolic and coloristic vocabulary.

One of Daingerfield's most important and typical religious works is his *The Mystic Brim* of 1893, painted to memorialize the death of his first wife in 1891. As with other of his important religious or allegorical paintings, Daingerfield composed a poem[12] (see biographical sketch) to accompany this work.

Daingerfield returned to the theme of the heavenly city (and the awakening soul) in several major allegorical paintings that he made of the Grand Canyon between 1911 and 1915, during visits sponsored by the Santa Fe Railway Company to promote the star attraction of its routes. While he painted sweeping, color-filled views of the canyon to satisfy the railroad's commission, he also painted epic allegorical statements for himself, such as *The Genius of the Canyon*, in which the canyon's forms are metamorphosized into approximations of Xanadu inhabited by a race of giants who are only half-emerged from the elemental rock.

Two other, very different types of Southern religious art are included in this collection as well. Sister Agnes Berchmans, a Virginia nun who was born in Canada and may have received her artistic training in France, painted a superbly-rendered copy of Étienne Gautier's *Saint Cecilia* (1878, Cathédrale Saint-Jean, Lyon, France), probably for use in her convent (about a half-dozen such works by Sister Agnes have recently come to light). At the other end of the spectrum of church decoration is *Moses in the Bullrushes*, a naive work in oil and crewel on muslin that is said to have hung originally in a Black church in Savannah, and which is a wonderfully imaginative interpretation of that familiar biblical landscape.

ROBERT LOFTIN NEWMAN (1827–1912)

Robert Loftin Newman was, like his friend Albert Pinkham Ryder, one of the major independent visionaries of American painting of the last half of the nineteenth century. Born in Richmond, Virginia, in 1827, he had moved with his mother to Luisa Court House, Virginia, by 1832, following his father's death. His mother remarried, and Newman again moved with his family, to Clarksville, Tennessee, in 1839—where his stepfather died in 1844.

After a brief stint in college in Clarksville in about 1846, and an unsuccessful appeal to Asher B. Durand in New York to take him on as a student, Newman traveled to Paris in 1850, where he was befriended by William Morris Hunt and was introduced by Hunt to Thomas Couture, under whom he studied for five months before returning to Tennessee in 1851.

Again in Paris in 1854, he discovered the paintings of Titian at the Louvre, and was entranced by their intensity of color. He was also introduced—again by Hunt—to Jean-François Millet, the Barbizon painter, whom he visited in the company of his contemporary (and fellow Couture student) William Babcock. Newman also came to know, at first hand, the impassioned Romanticism of Eugene Delacroix, who was to become a third major force in Newman's later work.

All of these influences were eventually to converge in Newman's small religious and literary subject paintings, which he created largely in isolation from the rest of the art world, despite his large circle of artist friends. From 1854 to 1864, he again lived in Clarksville, where he advertised himself as a portrait painter and drawing teacher. Conscripted into the Army of the Confederacy in April, 1864, he served his tour of duty in Richmond, and was released from the army in 1865 after Richmond's fall.

After 1865, Newman seems to have lived in New York City, at least until 1872, when he returned to Tennessee where he lived until his mother's death in 1873. He then returned to New York, working there briefly in the stained glass studio of Francis Lathrop and renewing his friendships with William Morris Hunt and John LaFarge.

After a third trip to France in 1882, Newman moved permanently to New York in 1883, establishing a studio in the same building as Albert P. Ryder, with whom he is known to have collaborated on a painting in at least one instance. Like Ryder, Newman was protected by a circle of loyal friends, among them Wyatt Eaton, William Merritt Chase, Stanford White, and Daniel Chester French, who saw to the exhibition and sale of his paintings as well as the provision of his daily needs.

Newman was an artist who carried his art almost entirely inside his own head. His jewel-like colors hover in dark, indefinite spaces, defining figures and events without detailing them. Thus the stories he tells—like that of the appearance of Christ to the two Marys at the Tomb, in *Rabboni*, neither take place in the real world, nor involve any action, but exist rather in the timeless silence of the artist's imagination.

65. *Rabboni*, ca. 1882–86.

Oil on canvas. 16⅛″ × 20⅛″
Signed, Lower right: "R. L. Newman".
Provenance: Purchased from the artist by Mrs. Richard K.
 Maguire, Brooklyn, N.Y.; to her son, Richard K. Maguire,
 II; to Fred Bentley, Marietta, Georgia.
Exhibitions: Whitney Museum of American Art, "Paintings
 by Robert Loftin Newman," New York, 1935, No. 20 in
 catalogue.
Other references: Frederic Fairchild Sherman, "Robert Loftin
 Newman," *Art in America*, Vol. 27 (April, 1939), p. 75;
 Marchal E. Landgren, *Robert Loftin Newman, 1827–1912*,
 Washington, D.C.: Smithsonian Institution Press for the
 National Collection of Fine Arts, 1974, No. 39, Catalogue
 of Known Works, p. 135.

ELLIOTT DAINGERFIELD (1859–1932)

FOR BIOGRAPHY SEE #51.

66. *Christ Stilling the Tempest.* 1905–10.

Oil on canvas. 20″ × 24″.
Signed, lower left: "Elliott Daingerfield".
Provenance: Metropolitan Museum of Art, New York; Auction, New York; Bentley-Sellars Collection, Marietta, Ga.
Exhibitions: The Mint Museum of Art, "Elliott Daingerfield Retrospective Exhibition," The Mint Museum of Art, Charlotte, N.C., April 14–May 16, 1971; The North Carolina Museum of Art, Raleigh, May 23–June 20, 1971, No. 145 in catalogue (illustrated, p. 25); Trosby Auction Galleries, "Atlanta Collects," Atlanta, Ga., April 27–May 1, 1980 (illustrated in catalogue, p. 18); The Museum of Arts and Sciences, Macon, Ga., "Two Hundred Years of American Painting, 1700–1900," Macon, June 4–November 8, 1981, No. 83 in catalogue.

67. *The Genius of the Canyon.* 1913.

Oil on canvas. 36 × 48½″.
Signed, lower right center: "Elliott Daingerfield 1913".
Provenance: Mrs. Arthur E. Howlett and Mrs. Worth B. Plyler, daughters of the artist, Blowing Rock, N.C.

Exhibitions: The Mint Museum of Art, "Elliott Daingerfield Retrospective Exhibition," The Mint Museum of Art, Charlotte, N.C., April 14,–May 16, 1971; The North Carolina Museum of Art, Raleigh, May 23–June 20, 1971, No. 172 in catalogue (illustrated, p. 39).

68. *The Mystic Brim.* 1893.

Oil on canvas. 29¾″ × 36″.
Signed, lower right: "Elliott Daingerfield 1893".
Provenance: Mrs. Arthur E. Howlett, daughter of the artist,
 Blowing Rock, North Carolina; Judy Hagopian Conn,
 Charlotte, North Carolina.
Exhibitions: Memorial Art Gallery of the University of
 Rochester, "Selections from the Robert P. Coggins Collec-
 tion of American Painting," The High Museum of Art,
 Atlanta, Georgia, December 3, 1976–January 16, 1977;
 Memorial Art Gallery of the University of Rochester,
 Rochester, New York, February 25–April 10, 1977; Herbert
 F. Johnson Museum of Art, Cornell University, Ithaca,
 New York, May 4–June 12, 1977 (illustrated in catalogue,
 p. 35);
 The Museum of Arts and Sciences, Macon, Georgia, "Two
 Hundred Years of American Painting, 1700–1900," June
 4–November 8, 1981, No. 87 in catalogue.

SEE ALSO # 58, 59, 86

SISTER AGNES BERCHMANS (Late 19th Century)

Sister Agnes Berchmans was a nun from Canada, and later, Virginia, who painted works of biblical and other religious subjects. Nothing is presently known of the order to which she belonged, or of her artistic training.

This painting is an expert copy by Berchmans of Étienne Gautier's *St. Cecilia* of 1878, now located at the Cathédrale Saint-Jean in Lyon, France. Given the quality of the copy, it is likely that Sister Agnes had seen Gautier's work in the original, either in Paris or in Lyon—James M. Sauls, Curator, The Robert P. Coggins Collection.

Coggins Collection of American Art: Artist Files

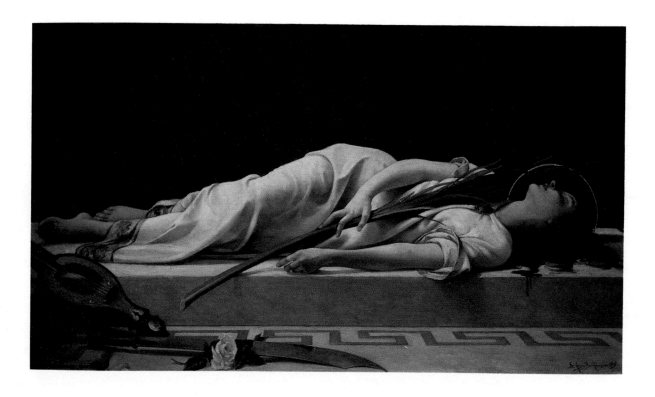

69. *Saint Cecilia.* 1890s.

Oil on canvas. 23½″ × 42¼″.
Signed, lower right: "Sr. Agnes Berchmans".
Provenance: Estate Sale, Virginia, to Charleston, South Carolina, "flea market", to Judy Hagopian Conn, Atlanta, Georgia.
Exhibitions: Arnold Gallery, Shorter College, "Women in Art: Early Twentieth Century Selections from the collection of Robert P. Coggins, M.D.," Rome, Georgia, November 16–25, 1980, No. 34, illustrated in catalogue.

ARTIST UNKNOWN.

Traditional crewelwork, combined with oil painting, on a monumental scale, with wonderful elements of fantasy in the depiction of vegetation. The composition and color scheme are both handled with subtlety and charm in this anonymous Savannah work.

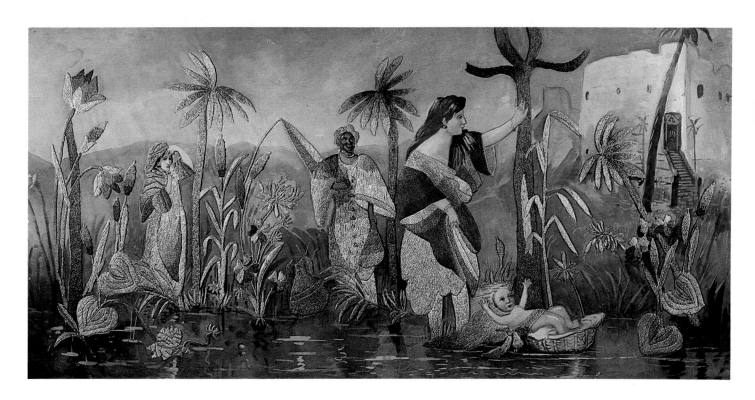

70. *Moses in the Bullrushes.*
 2nd half of 19th century.

Oil and crewel on muslin. 29½″ × 62″.
Provenance: Said to have come out of a Black church in Savannah, Georgia; to a consignment shop in Savannah; to Terry H. Lowenthal, Savannah.
Exhibitions: Arnold Gallery, Shorter College, Rome, Georgia, "Women in Art: Early Twentieth Century Selections from the Collection of Robert P. Coggins, M.D.," November 16–25, 1980, No. 12 (illustrated in catalogue).

REGIONALISM

REGIONALISM: n. 1. a) the use of a particular region of a country as the setting of stories, plays, etc., representing it as affecting the lives of the characters. b) the tendency to emphasize and value the qualities of life in a particular region, especially an agrarian region as opposed to an urban and industrial one. c) often confused with "sectionalism" ("undue concern for or devotion to the interests of a particular section of the country", as in "The South's sectionalism was a major factor in the hostilities that led to the War between the States"). d) equally often confused with "provincialism" ("narrowness of outlook"). e) a much-abused and over-used word. Yet a word of critical importance to understanding the course of Southern painting after the end of the First World War, which was self-consciously "regionalist" in both the proper dictionary senses given under a) and b) above.[13]

During the two decades following World War I, the South was the subject of a wide variety of explorations and critiques, whose conclusions were often antipodal in nature. Southerners, particularly, were wont to ask what it was that made their culture "Southern," and whether that was good, or bad, or merely there. It was a time as much of asking whether the South might be "improved" as of determining those virtues of character that needed no improvement.

When criticized, as by H. L. Mencken in his "Sahara of the Bozart," for their cultural poverty, Southerners responded in either of two ways. They might agree that the cultural life of the South could stand improvement, while insisting that it be Southerners who determined the nature and course of the improvement, or they could suggest, as did the Agrarians in their manifesto, *I'll Take My Stand* (first published in 1930),[14] that the true "improvement" that was required was the restoration of the South's original traditions, which had been allowed to deteriorate into the crass materialism and mercantile ordering of society of the New South's much ballyhooed industrialism.

In short, there was throughout the South, and in each of her aspects, a dialogue between "holding on" and "letting go," between the modernization of Southern life and of its literary and artistic expressions and, on the other hand, the preservation of the South's distinctive character against all myopic schemes for "Progress". If labor unions were repressed, it was not only that they threatened the self-interests of the mill-owners; it was also because they were inventions of Yankee devils designed to upset the courtly paternalism of Southern management-labor relationships. Yet just as often as there were Scopes Trials that seemed to reaffirm the stubborn anti-intellectualism of Southern popular culture, there were a host of Southern Women's Clubs organized against lynchings and for the development of decent public education.

There was also, in the work of Howard Odum and W. T. Couch, a careful and thorough exploration of the particulars of Southern folkways as of the facts of Southern agriculture and of its distinctive ethnic patterns, leading to a reevaluation of the very "traditions" that others sought to preserve. In his preface to *Culture in the South*, Couch took up the Agrarians' arguments and neatly skewered them with his own sociological observations:

> Consider, for instance, the doctrine that the agrarian way of life is essentially different from the industrial, that it is better—or, at least, better for the South, and that it is worthy of being preserved even at the price of economic obscurantism. If one looks at agrarian life in the South without colored spectacles, what does one find?. . . . One finds 1,790,000 tenant farmers, white and black. One finds the last stronghold of child labor. One finds women . . . who are not protected by any laws or customs regulating their hours of labor.
>
> The comparison made by the agrarian is strangely confused. Now we hear that country life in the South (superior to country life in the North, of course) is good because it is slow, leisurely, affording plenty of time to invite the soul or to contemplate the infinite variety and moods of nature. At the same time we hear that country life is good because men cannot learn how to use leisure and because farming does not leave them long, idle hours. . . . I am constrained to believe that [these agrarian] gentlemen have never known or imagined the misery, the long drawn-out misery, of over-work and undernourishment, of poverty and isolation, of ignorance and hopelessness."[15]

Yet each of these critiques, the conservative and the progressive, were addressed to a single issue, how to restore vitality to a region that seemed impossibly mired in contradiction and stagnation. One might go forward or one might retreat, but it was no longer possible to stay put, for to do so was to lose entirely a grasp on one's identity.

In art, as in most other aspects of Southern life, the preferred solution was to move forward with caution, to avoid excess and keep one foot, at least, firmly planted in Southern soil. The Southern States Art League, developed in the early

1920s to provide—at last—a forum for the exhibition and critical review of the work of Southern artists, nonetheless encouraged a largely traditional view of the role of art in society:

If you continue to purchase paintings from New England, or England, or France, your prospective home artists will flock to those well-springs of supply. They will look out for themselves. The home land will be sufferer. You will be the sufferers, because you have failed to understand that art must always begin at home. It is in this belief that your League is trying by every means known to it to make this exhibition of Southern art a challenge to producer and patron, to focus their work on the one hand and their appreciation on the other, upon this fundamental truth, that it may be known to the world how gracious and beautiful the home land is, and how much a part of it is the social life and history which grew out of it.

We are dealing with a condition, not a theory. The South is a vast area sundered socially and politically from its sister states. With the loss of wealth passed also opportunity for education, the main-spring of intelligent self-realization. . . . It is our narrower desire to see symbolized on canvas and in bronze those hidden qualities of the heart, those traditions of neighborly life, those relations to the soil, which have made us what we are."[16]

Largely abandoned by the mid-1920s were the more mystical expressions of Southern landscape. In their place were revivals of interest in the local color, colloquialisms, and life styles of the South, portrayals of Southern types, and depictions of everyday life in its native ambience. If the South was no longer as timeless and unchanging as it was once thought to be, it had gained considerably in vitality and in the reality of its existence as a contributing partner in American culture. Like the characters in the novels of Ellen Glasgow, DuBose Heyward, and William Faulkner, it was a tangible, idiosyncratic, believable entity, fleshed out with motives, flaws, and occasional victories of spirit.

A contemporary of Alice Smith in Charleston was the Northern born and trained Alfred Hutty, like Smith an associate and student of the Woodstock landscape painter, Birge Harrison, and like her as well an active participant in the Charleston Etchers Club and in the historic preservation of Charleston's architecture. But unlike Smith, Hutty's interest lay not so much in the abstraction of the poetic essence of the Southern landscape as in the specific, even picturesque, details of daily life, and in the often joyous spirit of ordinary Southern people as that could be conveyed through expressive line and color. A superb example of his work is *Voodoo Ritual*, in which the rhythms of clapping and dancing are echoed in the patterns formed by the Spanish moss behind the figures.

Aiden Lassell Ripley, a well-known Boston watercolorist and illustrator, traveled to the South frequently after 1936 to paint both the plantations and the hunting preserves of the Carolinas, Georgia, and Florida. While his works evidence a careful formal restraint in their compositions, they nonetheless capture the lambent color and quiet informality of Southern living.

Pamela Vinton Ravenel, who began her career as a miniature painter, turned to large-scale portraiture after she moved to St. Mary's, Georgia, in the 1930s. Like Marie Hull, her contemporary in Mississippi, Ravenel was interested in the individual character of the Southern sharecropper, reflecting not only the writings of Erskine Caldwell but also the photography of Walker Evans and Margaret Bourke-White.

For Alexander Brook, who began visiting the South in 1938, living in Savannah, the Southern landscape had a different sort of appeal, one profoundly melancholy in its implications. For Brook, who like Ravenel and Hutty had associations with the Woodstock, New York, community of artists, the South was a land of desolation, appalling in its poverty and in the slow wreckage over time of both its buildings and its soil. His most famous image of the South was *Georgia Jungle*, which won first prize at the Carnegie International Exhibition in 1939; *Church in South Carolina*, painted eight years later, is an equally poignant image of forsaken life.

Charles Shannon, on his return to Alabama after three years of study at the Cleveland School of Art, found his interest in the expressive character of the Southern spirit truly awakened for the first time, as he built his own log cabin studio with the help of local black laborers. "I began to feel," he wrote, "what this country down here really meant to me. I worked with the Negroes in building my cabin for two months—cutting down trees (Comet on the other end of the crosscut saw singing to its rhythm): snaking them with mules to the site of the cabin—building it. I went to their churches with them, to their dances and drank with them—I saw expressions of primitive souls."[17]

Trying to find pictorial equivalents of the spiritual intensity that he felt in the life of the Southern black, Shannon evolved a powerful vocabulary of elongated figures, intense though somber color, and large rhythmical patterns that give his early works an immense and humane dignity.

For all of these "regional" artists, the human figure is indeed central, whether dispirited or energized by its relationship to the landscape. The landscape echoes in response, takes on the character and motion of its inhabitants, reinforcing their patterns with its own. If the setting in Southern regional literature affects the behavior of that literature's actors (and it assuredly does in the writings of William Faulkner, James Agee, Allen Tate, James Dickey, and Flannery O'Connor), then the regional painting of the South accomplishes the same goals by different means.

ALFRED HUTTY (1877–1954)

In 1919 Alfred Hutty came to Charleston to teach classes in art for the Carolina Art Association. He was forty years old and his move was destined to begin a love affair with the city as well as a new chapter in his life and art.

Hutty was born in Grand Haven, Michigan, in 1877. He showed an early aptitude for art and won a scholarship to art school at age fifteen. For a time, he was a designer of stained glass windows in Kansas City, St. Louis, and later at the Tiffany Glass Studios at New York.

In 1907 he began a serious study of painting with Birge Harrison at the Art Students League in Woodstock, New York, which evolved into a long association with that area. With George Bellows and others, he helped form the summer art colony at Woodstock which was popular for many years. He continued to have a summer home there for the rest of his life.

Hutty served as a Marine camofleur during World War I and in 1919 went to Charleston. He conducted art classes at the Gibbes Gallery for five years and continued to spend winters in Charleston until three years before his death in 1954.

Although Hutty was trained primarily as a painter and designer, his move to Charleston in mid-life was to mark the beginning of perhaps the most productive and significant period of his career. It was then and there that he learned etching. He established a print studio, participated with eight other artists in the formation of the historic Charleston

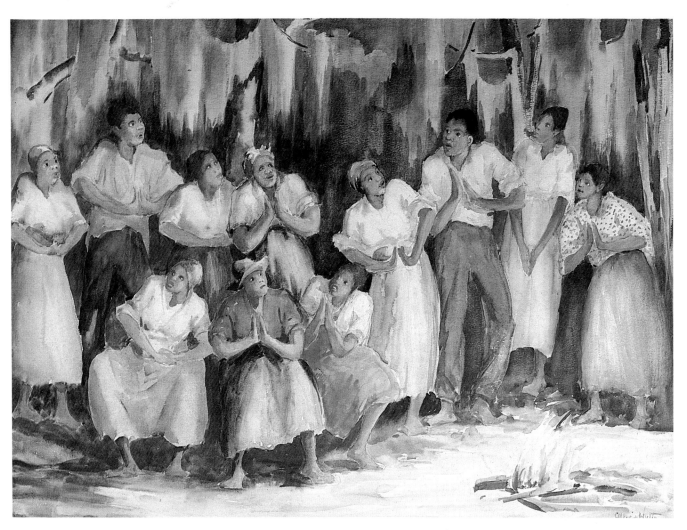

71. *Voodoo Ritual.*

Watercolor on paper. 21¾" × 29⅝".
Signed, lower right: "A Hutty".

Etchers Club, and began the production of many drawings and paintings.

Hutty adapted readily to his new mode of expression and spoke eloquently in the monochromatic linearity of the language of etching. The rapid certainty of his bitten lines and the rich bloom and shimmer of his drypoints authoritatively declare his mastery of the medium.

He and his wife were among the first to try and preserve historic Charleston. They purchased and restored a house at 46 Tradd Street as a home and studio. He was also actively involved in the Footlight Players. He helped restore their building on Queen Street and worked on a mural in the lobby. He also painted murals for several other public buildings in Charleston including the Fort Sumter Hotel and City Hall.

Although he was an active member of his community and an artist of wide capabilities, his etchings won him the most recognition and financial success. They brought him the honor of being the first American to be elected to the British Society of the Graphic Arts.

He received many other honors and was a member of many art clubs. He is represented in permanent collections of the Chicago Art Institute; Detroit Institute of Art; Library of Congress; Cleveland Museum of Art; New York Public Library; Los Angeles Museum; Municipal Gallery—Phoenix, Arizona; Governor's Mansion—Jackson, Mississippi; U.S. National Museum; California State Library; University of Michigan; Colorado State Library; Bibliotheque Nationale—France; John Herron Art Gallery; Gibbes Art Gallery—Charleston; Metropolitan Museum of Art; British Museum; Princeton University; Harvard Medical School; Ashmolean Musuem—Oxford; League of Nations—Geneva; Pasteur Institute; Toronto Art Gallery; Honolulu Art Academy; Illinois State College; Montclair Museum; Fogg Museum of Art—Cambridge; and in many private collections.

Boyd Saunders,
University of South Carolina

NCAB, XLVI, 277.

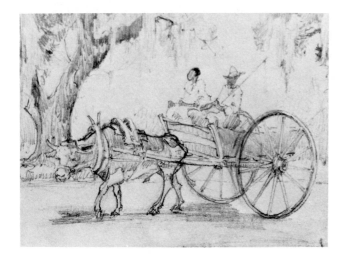

72. *Oxcart.*

Pencil on paper. 3⅝″ × 4½″.

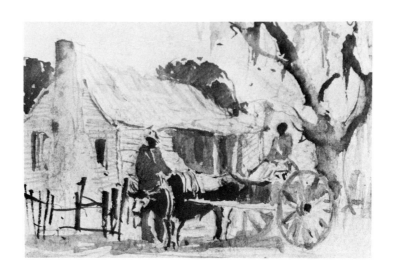

73. *Oxcart and Cabin.*

Pencil and ink wash on paper. $3^{15}/_{16}'' \times 5^{3}/_{4}''$.
Signed, lower right: "by Alfred Hutty".
Exhibitions: Southern Arts Federation, "Southern Works on
 Paper, 1900–1950," catalogue by Richard Cox, Atlanta,
 1981, No. 15 (illustrated p. 21).
Provenance of all three works: Robert M. Hicklin, Jr., Spar-
 tanburg, S.C.

AIDEN LASSELL RIPLEY (1896–1969)

Aiden Lassell Ripley was born in Wakefield, Massachusetts, in 1896. He grew up in the Boston area, and studied briefly at the Fenway School of Illustration before joining the Army in 1917. Upon his discharge from service in Europe, he attended the Boston Museum School where he studied under Frank Weston Benson and Philip Leslie Hale. It was Benson who encouraged Ripley's interest in wildlife and hunting sub-

jects, subjects with which Ripley has since been most closely identified.

Ripley went to Europe on a Paige Traveling Fellowship provided by the Museum School in 1924. He spent two years abroad, working in France, Holland, and North Africa. When he returned to Boston in 1926, he turned to painting watercolors full-time, continuing to travel along the East

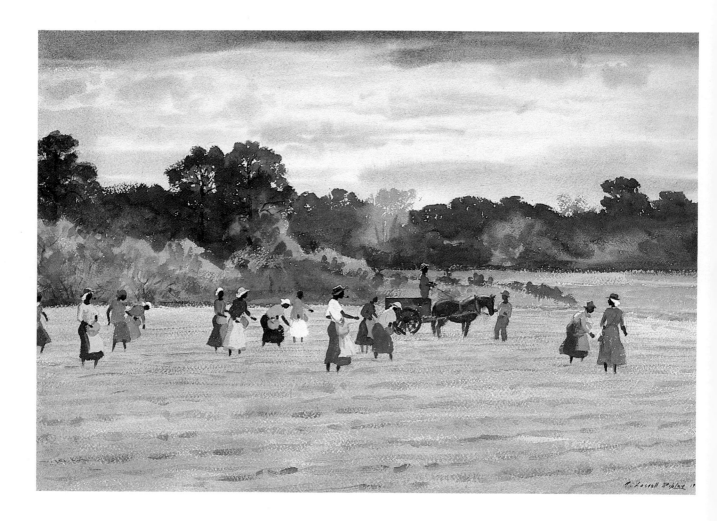

74. *Planters in a Field.* 1940.

Watercolor on paper. 21⅛″ × 30¾″.
Signed and dated, lower right: "A. Lassell Ripley 1940".
Provenance: Robert M. Hicklin, Jr., Spartanburg, S.C.
Exhibitions: Southern Arts Federation, "Southern Works on Paper, 1900–1950," catalogue by Richard Cox, Atlanta, Ga., 1981, No. 40 (illustrated in catalogue, p. 25).

Coast, and finally settling in Lexington, Massachusetts, in the mid-1930s. In 1936, Ripley's dealer, The Sportsman's Gallery of Art and Books of New York, sponsored Ripley on the first of many winter trips to the South, to paint the plantations and hunting preserves of the Carolinas, Georgia, and Florida. These two watercolors exemplify Ripley's dual interests in Southern work and leisure.

(Acknowledgment for this information is made to Kelly Anderson, Coe Kerr Galleries, Inc., New York, to Albert Walker of Boston, and to the Aiden Lassell Ripley Papers, Archives of American Art, Smithsonian Institution.)

NCAB, LV, 34; Coe Kerr Gallery, *Aiden Lassell Ripley, 1896–1969, Watercolors*, New York, N.Y., 1981

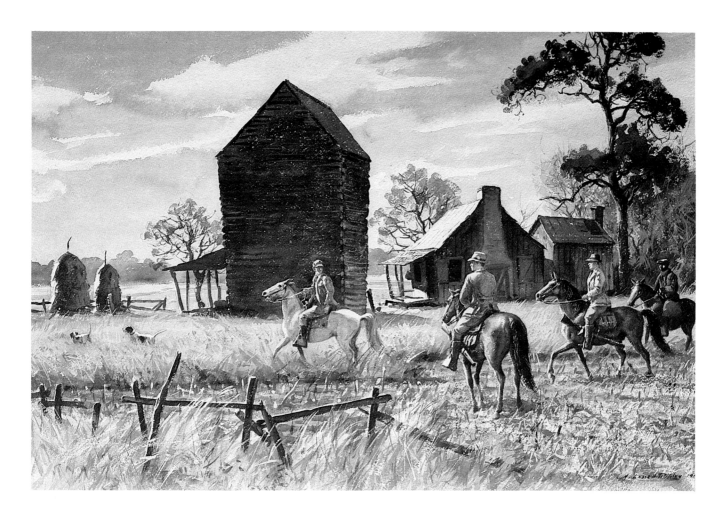

75. *Unexpected Point, Florence, South Carolina.* 1940.

Watercolor on paper. 20″ × 30⅞″.
Signed and dated, lower right: "A. Lassell Ripley 1940".

PAMELA HART VINTON BROWN RAVENEL (1888–?)

Pamela Vinton Ravenel was born in Brookline, Massachusetts, on January 28, 1888. She studied art first at the Maryland Institute in Baltimore with Edwin Whiteman, and then in Paris with Collin and Courtois. Recognized at first as an important miniature painter, she was a member of the American Society of Miniature Painters and the Philadelphia, and New Orleans, Miniature Painters Societies.

Less is known about her career in the 1930s, which she split between Woodstock, New York, and St. Mary's, Georgia. Her large genre portraits, painted in this later period, display an expressive figurative style and at least a passing awareness of the literary motifs of William Faulkner and Erskine Caldwell.

Coggins Collection of American Art; Artist Files

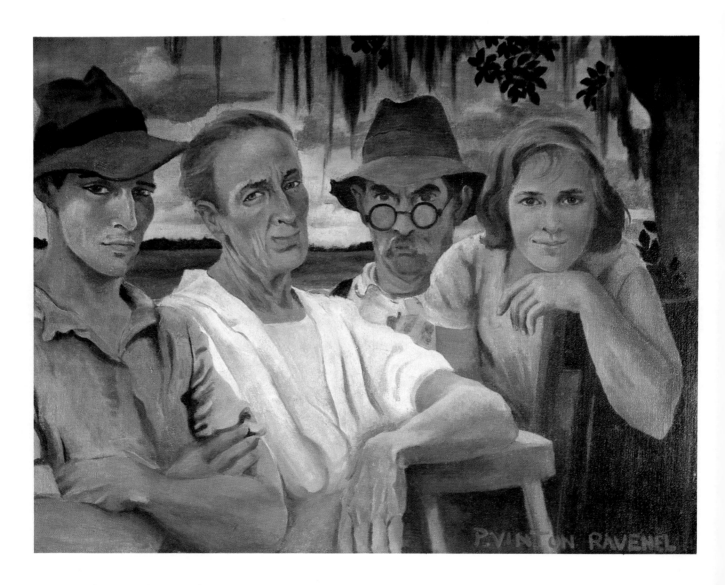

76. *"Southern Gothic"*. early 1930s.

Oil on canvas. 30″ × 40″.
Signed, lower right: "P. Vinton Ravenel".
Provenance: Artist, to private collector, St. Mary's, Ga.;
 Terry H. Lowenthal, Savannah, Ga.

ALEXANDER BROOK (1898–1980)

One of the leading American realist painters of the period 1925–50, Alexander Brook was closely identified with the 14th Street Group of painters that included not only his first wife, Peggy Bacon, but also the Soyer brothers, Reginald Marsh, Yasuo Kuniyoshi, and Eugene Speicher. He was also active in the Whitney Studio Club (precursor to the Whitney Museum of American Art), and the Woodstock Art Association.

Brook's aesthetic was deliberately non-modernist; his view of civilization was both intimate and elegiac in tone, suffused with a world-weariness that seems at times to belie his enjoyment of pictorial effect. In 1938, he moved from New York City to Savannah, Georgia, where he rented a studio and apartment overlooking the Savannah River. The poverty of the South appalled him, yet he also found in it a subject that would lead to some of his finest and most moving images. Among these is the renowned *Georgia Jungle*, which won first prize at the Carnegie International Exhibition of 1939. *Church in South Carolina*, painted during his final visit to Savannah in 1947, is a similarly haunting image of the melancholy wreckage of the Southern landscape at the close of the Depression.

A. W. Kelly for Salander O'Reilly Galleries, Inc., *A Retrospective Exhibition of Paintings by Alexander Brook (1898–1980)*, New York, N.Y., 1980; PITS, 127, 297–298.

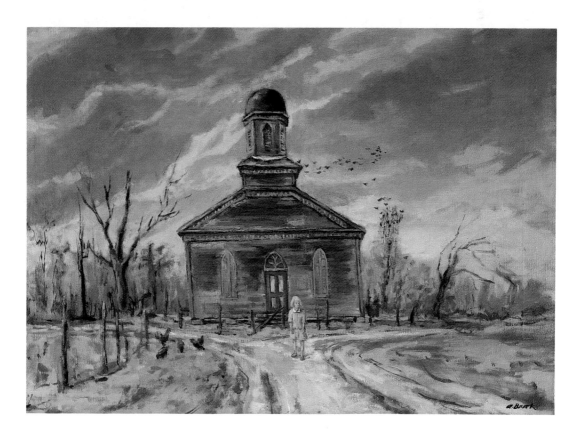

77. *Church in South Carolina.* 1947.

Oil on canvas. 18″ × 26″.
Signed, lower right: "A. Brook".
Provenance: Estate of the Artist: Salander-O'Reilly Galleries, Inc., New York City

CHARLES SHANNON (1914–)

Born in Montgomery, Alabama, Shannon spent six of the first nine years of his life living with relatives in Ohio. It was there that he received his first art lessons, gaining a desire at the same time to return to the South and to capture its uniqueness of character in his art. Returning to live with his parents in 1923, he grew up in Little Rock, Arkansas, Montgomery, and Atlanta, where he graduated from high school and attended Emory University for two years before resolving to enter art school. In 1932 he enrolled in the Cleveland School of Art intending to study commercial art. Due to the influence of his teachers, Henry G. Keller and Frank N. Wilcox, however, and his exposure to great paintings at the Cleveland Museum of Art, Shannon decided instead to pursue a career as a painter.

A visit in the summer of 1935 to the home of his aunt and uncle near Montgomery awakened his interest in Southern life and spirit so strongly that he spent the summer building a log cabin studio in the woods on his uncle's farm.

On returning to the Cleveland School of Art for his fourth and final year of study, Shannon evolved a highly personal style "marked by elongation of figures, rhythmical forms of somber color" in which he sought to express the deeper spiritual life of the Southern black (see ArtSouth, Inc., *Charles Shannon: Paintings and Drawings*, Montgomery, Ala., 1981, p. 7). Although Shannon claims that his undulating figures derived from the atmospheric and optical distortions of the smokestacks of the Ford Motor Company assembly plant across from his apartment in Cleveland, they also bear a strong resemblance to the works of El Greco that he had seen at the Cleveland Museum and that he had come to admire.

The emotionally-powerful paintings that resulted from Shannon's deep empathy with the South won instant national acclaim. In 1936, he won a Gund Travelling Fellowship to Mexico, where he studied the murals of Orozco and the paintings of Tamayo. He was given a one-person show at the Montgomery Museum of Fine Arts in 1937, another at the Cleveland School of Art in 1938, and a third the same year at the Jacques Seligmann Galleries in New York. In 1938 he also received a Julius Rosenwald Fellowship, the first time an artist was so honored, and for the next two years he exhibited his work in San Francisco, Pittsburgh, New York, St. Louis, and Cleveland.

In 1939, Shannon and a group of friends founded New South, a cooperative gallery in Montgomery intended to improve exhibition opportunities and art instruction for Southern artists. Among the artists whom Shannon assisted through New South was the eighty-five-year-old former slave and naive painter, Bill Traylor. Although New South closed after two years, Shannon's association continued in other ways to seek means by which the spirit as well as professional life of Southern artists could be nurtured.

After Army service in World War II, during which he worked in the War Art Program and the Belvoir Art Project, Shannon returned to Montgomery, which has remained his home ever since. Over the next several decades, he has evolved a figural style of great serenity and subtlety of color, working in watercolor, egg tempera and acrylic on unstretched linen that has been coated with gesso. His subjects still address the rural and urban life of the South and its underlying spiritual presence.

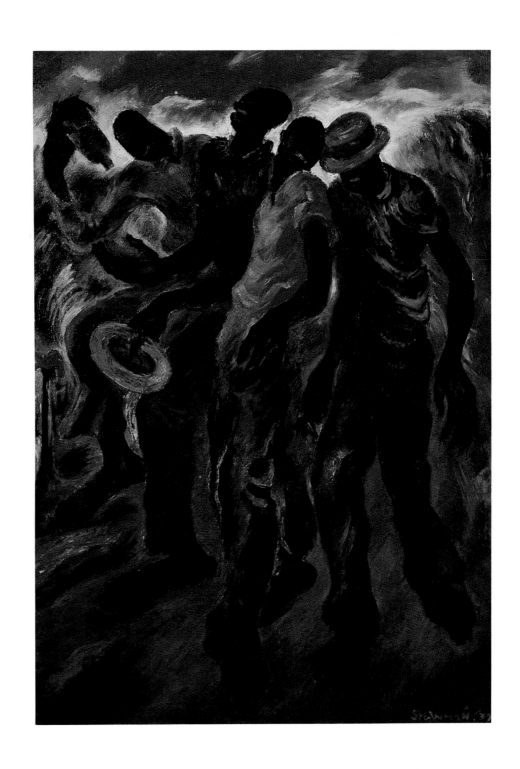

78. *Saturday Night*, 1937

Oil on canvas. 34″ × 24″
Provenance: The artist

THREE SELF-TAUGHT ARTISTS

Among the discoveries of the 1920s and 1930s was the existence of a separate and legitimate black culture, with deep roots of its own in Southern life as well as in its African heritage. From Odum's studies of black folklore to the Harlem Renaissance, links began to be forged between the life and art of the black in the present, and the richness and variety of his cultural past. An essential piece of the complex fabric of the South came to be the subject of serious inquiry for the first time, and in the process, the nation discovered a wide range of artistic accomplishments that it had previously ignored.

Among the works in this collection are those of two black artists whose achievements came to light in the decade of the 1930s—William O. Golding and Bill Traylor. Both essentially self-taught, they turned to art at the end of long careers in other occupations. The images of both—Golding's ships (he was a former seaman) and Traylor's figural narratives—are direct and deceptively simple representations of their subjects which are also marked by a profound originality of construction and design. Traylor's work, particularly, seems to incorporate traditional African sculptural motifs without in the least affecting knowledge of them.

No less powerful a work is Eugene A. Thompson's *Christ Preaching on the Mount* (*"Eve of the Great Feast. A.D. 33 Jerusalem"*), worked in ink, pencil, and scratched lines on a gessoed panel. Extremely sophisticated in its use of materials, whether arrived at intuitively or by training, it possesses all the force of a great German Expressionist woodcut.

WILLIAM O. GOLDING (1847–1943)

The sole essay on Golding appears in Anna Wadsworth's catalogue for the exhibition, "Missing Pieces: Georgia Folk Art, 1770–1976" (Georgia Council for the Arts and Humanities, 1976). It describes Golding as a self-taught black artist who, "from a lifetime of experience as a seaman, produced sixty drawings of turn-of-the-century sailing vessels" while hospitalized as a patient in the former Marine Hospital in Savannah, Georgia between 1925 and 1935. He described his seagoing travels in a letter to Miss Stiles, the recreation director ⌐t the hospital:

Since I left home (in 1882) I have been all over the world from North to South, East and West and plenty of ports in the seven seas, from England to China, Japan, India, Australia, Africa, West Indies, Central America, South America, around Cape Horn 23 times, Cape of Good Hope 25 or 30 times. Am old now, 59 years old, can't get along as I used to do on a ship, so I have to give up going to sea. Now only goes to sea in my sleep and get among other old shell-backs, swap yarns of old times, is all I can do now.

Well, 49 years is long enough to be going to sea. All that time I never accumulated any fortune but hard knocks, hardship, and a lot of experience. Was in all kinds of ships, from a whaler to a Man of War, so I have had my time knocking around the world.

79. St. Yacht Ramona. 1935.

Crayon and pencil on paper. 8¾″ × 11¾″
Signed and inscribed across bottom: "Wm. O. Golding.
 6.5.35. ⟨⟨˙St. Yacht. Ramona.˙⟩⟩".
Provenance: Hirschl & Adler Galleries, New York; Texas art
 market; Robert M. Hicklin, Jr., Spartanburg,
 South Carolina.

BILL TRAYLOR (1854–1947)

Bill Traylor was an eighty-five-year-old former slave when first discovered by the Montgomery artist, Charles Shannon. Shannon, looking for subjects for his own paintings, found Traylor sitting on a box in downtown Montgomery in the summer of 1939 making "what I later learned were his first marks on a piece of cardboard. Using a little stick for a straightedge and holding a stub of a pencil in his big hand, he was completely engrossed in making clean, straight lines. . . . He was—bent over and drawing silently. He was depicting objects; shoes, and cups were arranged neatly in rows. On the following day he was making his version of the nearby blacksmith shop; a man was shoeing a horse in one corner and the tools of the shop were distributed in orderly silhouette across the horizontal panel."

Shannon began to supply Traylor with materials and paints, and to sit with him and chat about the experiences that led, through recollection, to Traylor's images. Drinking bouts and chicken stealing were frequent subjects, as were farm animals and more elaborate constructions that combined figural narrative with abstract plant forms. Traylor's rich and often humorous imagery even seemed to Shannon to recall more ancient African sculptural forms, such as are intimated in the tree-trunk-enclosed female figure in *Figures and Construction*, a work dating from near the end of Traylor's active involvement with Shannon.

During World War II, Traylor went to live with his children up North, and returned to Montgomery in 1945 less a leg that he had lost to gangrene. He lived for a while in the back room of an undertaker's establishment, and tried to resume his drawing, but he was then placed by relief workers with a Montgomery relative, where he was isolated from the life of the streets. He died shortly thereafter, in 1947.

(Acknowledgment is made to Charles Shannon, whose writings and conversations about his friend, Bill Traylor, provided this author with the necessary biographical material. Particular acknowledgment is made to Shannon's essay, "The Folk Art of Bill Traylor" in Richard Cox, *Southern Works on Paper, 1900–1950* (Southern Arts Federation: Atlanta, Ga., 1981), p. 16.)

80. *Figures and Construction.* ca. 1941–42.

Construction color and gouache on board. 10 5/16″ × 7¼″.
Exhibited: Mississippi Museum of Art, "Bill Traylor", Jackson, Miss., 1982,
Provenance: Charles Shannon, Montgomery, Alabama.

EUGENE A. THOMPSON

This powerful work, reminiscent of German Expressionist woodcuts, is said to have been done by an itinerant black minister working in Savannah, Georgia.

Coggins Collection of American Art: Artist Files

81. *Christ Preaching on the Mount ("Eve of the Great Feast. A.D. 33 Jerusalem")*

Ink, pencil and scratchboard technique on gessoed panel. 38½″ × 48″.
Signed and inscribed, upper right: "Eve of the Great Feast. A.D. 33 Jerusalem. Eugene A. Thompson".
Provenance: Savannah art market; Marilyn Pennington, Smyrna, Ga.

TWENTIETH CENTURY PORTRAITURE

After a long hiatus of interest, the portrayal of the individual also came back into prominence as a subject for art in the early twentieth century. Among other factors in this development, perhaps the most influential in American art were the examples set by Thomas Eakins, Mary Cassatt, John Singer Sargent, James Whistler, and William Merrit Chase, each in his own way mastering the art of portraiture and giving it renewed status. Their students and followers, among them Robert Henri, Charles W. Hawthorne, George Bellows, and others equally skilled, conveyed their renewed enthusiasm for the human figure and personality to the next generation, many of whom happened to practice their art in the South.

J. C. Leyendecker, while best-known as one of America's premier magazine and poster illustrators, portrayed his friend, the author Rex Beach, in a souvenir of their hunting trip on the Santee River in South Carolina in 1912. Leyendecker's crisp, slashing brushwork combined with Beach's summary masculinity create a period portrait that could as easily have served as an advertisement for *Field and Stream*.

More in the classic tradition of American portraiture is Wayman Adams' *New Orleans Mammy*. Adams' direct, rapid brushwork and simplification of composition to its essential contrasts of light and dark give the sitter an immediacy and dignity of presence that was also characteristic of the best work of Adams' teachers, Chase and Henri. Equally marked

in its strength of handling and design is David Silvette's *Uncle Josh*, painted when the artist was twenty-one. Although Silvette has gone on to prominence as a Richmond portrait painter, he still considers this early genre portrait among his finest works.

Where Silvette turned to professional portraiture when, in his words, "realism was out-moded" by abstract art, Ann Coles turned to the same career in order to earn a living, finding that her earlier Impressionist work, while admired, did not sell readily in her home town of Columbia, South Carolina. Yet her earliest work, like Silvette's, has a freshness and quality that leads one to regret the circumstances that forced her to change her personal style for one that, being more "representational," was more easily accepted by her patrons.

Charleston Bride, by Carrie Stubbs, painted in 1948, is a complete enigma, insofar as nothing can be found out about this obviously talented artist. Anne Goldthwaite, on the other hand, was early acknowledged as one of the South's most influential painters, not only for her position as a dedicated modernist (she was one of the organizers of the Académie Moderne in Paris in the years preceding World War I, and was a close friend of Gertrude Stein, Isadora Duncan, and others equally prominent in the Anglo-American community in Paris), but also for her strong support of the cause of women in the arts.

J. C. Leyendecker was one of the most successful illustrators of the first half of the twentieth century, known for his many *Saturday Evening Post* covers, Arrow Shirt advertisements, and war posters. Born in 1874 at Montabour, Germany, he moved to Chicago with his parents in 1882. There he apprenticed to an engraving house and studied at the Art Institute of Chicago under John H. Vanderpoel (1889–94). From 1896 to 1898, he and his brother Frank, also an artist, were enrolled at the Académie Julian in Paris, returning in the latter year to Chicago to open a studio in the Stock Exchange Building. Both J. C. and Frank received many orders for magazine covers, advertisements and posters thereafter, both in Chicago and, after 1900, in New York.

J. C. Leyendecker only rarely painted easel paintings. This portrait commemorates a hunting trip down the Santee River in South Carolina which the artist had made with the novelist and playwright, Rex E. Beach, in 1912. It is painted in Leyendecker's typically crisp, angular style, and its summary masculinity neatly reflects Beach's preoccupations as a writer (*The Spoilers*, (1906); *Going Some* (1910); *The Iron Trail* (1913), and, among the plays, *Beyond Control* (1932) and *The World in His Arms* (1946)).

Beach, it should be noted, was also responsible for writing a rather fabulous little volume entitled *The Miracle of Coral Gables* (1926), which was commissioned by George Merrick for his visionary real estate development of the same name.

DAB, supp. V, 428

82. *Portrait of Rex Beach.* 1912.

Oil on canvas board. 12″ × 10″.
Signed and inscribed, lower right: "To my friend Rex Beach, a souvenir of our trip to the Santee. J. C. Leyendecker '12."
Provenance: Berry-Hill Galleries, Inc., New York City; Kennedy Galleries, Inc., New York City; Fred Bentley, Marietta, Georgia.
Publications: Michael Schau, *J. C. Leyendecker*, Watson-Guptill Publications, New York, 1974, illustrated, p. 29.

WAYMAN ADAMS (1883–1959)

Wayman Adams was one of America's foremost portrait painters of the first half of the twentieth century. Born in Muncie, Indiana, he studied art at the Herron Art Institute in Indianapolis, and then with William Merritt Chase in Florence, Italy, in 1910, and with Robert Henri in Spain in 1912. Like his teachers, Chase and Henri, Adams was an advocate of painting directly from the subject, without use of preparatory drawings; he was described by Helen Earle, in her biographical sketch of Adams, as a "lightning" artist, who completed his portraits in one sitting.

Adams made many trips to Mexico, Texas, California, and New Orleans in search of subjects for his spirited brush, subjects that would embody his romantic outlook. *New Orleans Mammy* is one of his finest such essays, capturing not only the broad contrasts of dark and light on a hot afternoon, but also the dignity and strength of its sitter.

NCAB, XLIX, 19; NCAB, supp. B, 37; Berry-Hill Galleries, Inc., New York: Artist Files.

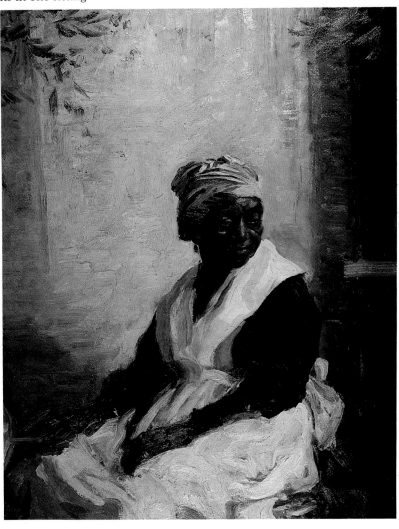

83. *New Orleans Mammy.* ca. 1920

Oil on canvas. 50″ × 40″.
Signed, center left: "Wayman Adams".

Provenance: Estate of the artist; Berry-Hill Galleries, Inc., New York.
References: Helen L. Earle, comp., *Biographical Sketches of American Artists* (Michigan State Library, 1924; reprinted, Garnier & Co., Charleston, S. C., 1972), p. 22.

DAVID SILVETTE (1909–)

Born in Pittsburgh, Pennsylvania, Silvette studied art with his father, Ellis M. Silvette, and with Charles W. Hawthorne and Cecilia Beaux. His first public recognition came with winning the Third William A. Clark Prize and Bronze Medal in the Corcoran Gallery of Art's Thirteenth Biennial (1932/33), for *Thornton Nye of Wytheville*, subsequently purchased by the Corcoran. He worked with the W.P.A. Federal Art Project in the late 1930s.

Silvette's comments on the rest of his career, and on *Uncle Josh*, are contained in a letter that he wrote to Thetis B. Rush, Director of Research at the Robert M. Hicklin, Jr., Gallery in July, 1982:

Uncle Josh was painted at Virginia Beach—Uncle Josh was thrilled with sitting—said "I always wondered why God spared me so long: it was to do this great work." . . . By the way, Gari Melchers selected it for purchase by the Richmond Art Academy. . . . *Uncle Josh* was, I think, also exhibited in the early thirties at one-man show at Brooklyn Museum.

For myself, I showed in most of the big shows before the war—I lost interest in showing when realism was out-moded. Won Corcoran Third and Medal; exhibited at Carnegie International; Represented by National Portrait Gallery, universities, courts, state houses (South Carolina with portrait of Gov. Evans painted in Spartanburg). Been active portrait painter mostly in South for 50 years & still working. . . ."

Corcoran Gallery of Art, *A Catalogue of the Collection of American Paintings in the Corcoran Gallery of Art*, Washington, D.C., 1973, II, 195; also acknowledgment to the artist himself

84. *Uncle Josh.* 1930.

Oil on canvas. 51⅛" × 38¼".
Signed, lower left: "David Silvette 1930".
Provenance: The artist; purchased by the Richmond Academy of Arts; subsequently sold; Richmond antique shop; Robert M. Hicklin, Jr., Spartanburg, South Carolina.

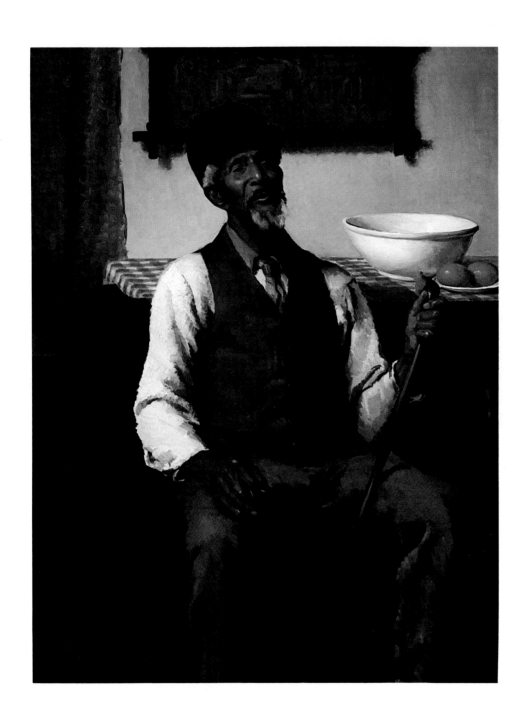

CARRIE STUBBS

Nothing is known about the identity of this artist or her sitter.

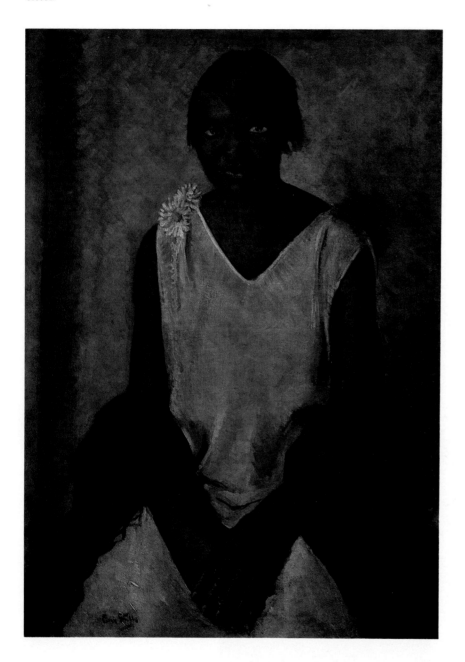

85. *Charleston Bride.* 1948.

Oil on canvas. 36″ × 25⅞″.
Signed, lower left: "Carrie Stubbs"; inscribed, verso,
 "Charleston Bride 19-XII-48".
Provenance: Robert M. Hicklin, Jr., Spartanburg, S.C.

ELLIOTT DAINGERFIELD (1859–1932)

FOR BIOGRAPHY SEE #51

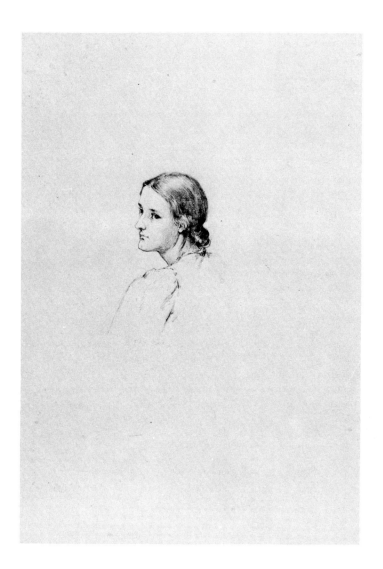

86. *Head of a Mountain Woman*. ca. 1894.

Pencil on paper. 15″ × 11″ (sight).
Provenance: The Mint Museum of Art, Charlotte, N.C.

SEE ALSO 58, 59, 66, 67, 68

ANNE GOLDTHWAITE (1869–1944)

Anne Goldthwaite was born in Montgomery, Alabama, the daughter of a Confederate artillery captain, and the granddaughter of an Alabama Supreme Court Justice and Senator. Descended from a distinguished Boston family, Anne, together with her parents and siblings, was subjected to the genteel poverty that accompanied the South's aristocracy in the period of Reconstruction. In her reminiscences, Anne wrote of her childhood: "In the South after the Civil War it was a disgrace to be rich, so my grandfather could not have had much money. . . . Men were then without hope of a better future. Consequently, my father . . . decided to seek his fortune in Texas where my grandfather owned plantations." (cited in Adelyn D. Breeskin, "Anne Goldthwaite," in catalogue of The Montgomery Museum of Fine Arts exhibition, "Anne Goldthwaite, 1869–1944," Montgomery, Ala., March 22–May 1, 1977, p. 11).

Anne was thus educated in a Texas "young ladies' school" and an Ursuline Nun's Convent School. When both of her parents died, she and her brothers and sisters were brought back to Montgomery to be raised. In about 1898, her uncle Henry Goldthwaite promised to fund her art education in New York City, an offer which she accepted. She studied with Walter Shirlaw from 1898 to 1904, and also at the National Academy of Design with Charles Mielatz and Francis Coates Jones.

She then went to Paris, in 1906, where she became friends with Elizabeth Duncan (Isadora's sister) and Gertrude Stein. She studied with David Rosen, who conducted summer art classes in Ile-aux-Moines, and with Rosen's help, she became one of the organizers of the Académie Moderne, which included among its instructors Charles Guérin, Pierre Laprade, Albert Marquet, and Othon Friesz. Anne's training thus quickly bypassed Impressionism and absorbed the lessons of the Fauves, Cubists, and, to a lesser degree, the Expressionists.

On her return to New York in 1913—driven from Paris by the war—she established a studio and entered a painting in the Armory Show. An accomplished etcher as well as painter, she won prizes in 1915 at the National Association of Women Painters and Sculptors and the Panama-Pacific Exposition exhibitions, as well as receiving her first one-person show at the Berlin Photographic Company in New York. From that point on, she was recognized as a leading figure in painting and printmaking, particularly of Southern subjects drawn from her annual visits to Montgomery every summer. Besides paintings and etchings, she produced drypoints, lithographs, and glazed terra cotta sculpture. She became a member of the faculty at the Art Students League in 1922, and continued to teach there until just shortly before her death in 1944. Both Knoedler's Gallery and the Art Students League gave her retrospectives after her death.

The quiet poignancy of her art, with its enlivening line and color, was complemented by her staunch support of women's causes, particularly in the arts. An active participant in the National Association of Women Artists, Goldthwaite gave a prescient radio talk on the subject of women artists on March 22, 1934:

In exhibitions where women shine as subject matter they are gradually acquiring glory as artists as well. If this ascendancy continues it will be great for women, since nobody's art can flourish unless it gains appreciation. The best praise that women have been able to command until now is to have said that she paints like a man. . . . We want more—we want to speak to eyes and ears wide open and without prejudice—an audience that asks simply—is it good, not—was it done by a woman." (Breeskin, p. 9).

NCAB, XXXIX, 114; The Research Institute of the College Art Association, *The Index of Twentieth Century Artists*, 1933–37, II, Nos. 1 and 12, New York, N.Y.

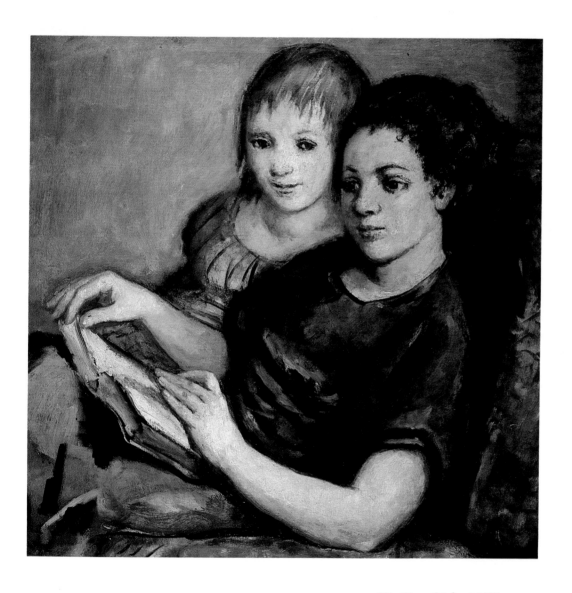

87. *Two Girls.* 1933.

Oil on canvas. 28¼″ × 27″.
Signed, lower right: "Anne Goldthwaite".
Provenance: Robert M. Hicklin, Jr., Spartanburg, S.C.
Exhibitions: Worcester Art Museum, "American Painting of
 Today," Worcester, Mass., December 1, 1933–January 15,
 1934 (illustrated in catalogue, No. 51).

ANN CADWALLADER COLES (1882–1969)

Born in Columbia, South Carolina, Ann Coles studied at Columbia College until she was sixteen, at which time she entered Converse College in Spartanburg. After receiving her degree in 1902, she went to New York City where she continued her art studies at the Whipple School of Art and the Art Students League. Coles spent a summer painting in France, and then returned to a long career as a portrait and landscape painter, maintaining studios in New York City intermittently over her lifetime, but spending most of her time in Columbia. During her career, she completed more than one hundred commissioned portraits, painting landscapes and figure pieces for her own private pleasure and satisfaction.

This painting of a young girl shows Coles' early interest in the Impressionism of Renoir, although the figure is handled with a firmness of modeling that is more typically American. Although she turned to more realistic portraiture in order to earn a living by her art, she had the grace and humor, late in life, to say to a reporter: "I've made a success of living from my painting alone after 60 years. If I had concentrated on this [earlier] style, I might be famous as a Modern." (quoted in an interview with Coles in the Columbia *State* on February 6, 1955).—James M. Sauls, Curator, The Robert P. Coggins Collection

Columbia Museums of Art and Science, Columbia, S.C.: Artist Files; also acknowledgment to Nina Parris

88. *Portrait of a Young Girl*. 1913.

Oil on board. 16″ × 20″.
Signed, lower left: "A. C. Coles"; dated, lower right: "1913".
Provenance: John Garnier, Charleston, South Carolina.

CHARLESTON AND SAVANNAH:
TWO ART CENTERS OF THE TWENTIETH CENTURY

The increasing role of women in positions of leadership in Southern art, the formation of professional art communities dedicated to improving the quality of art education at all levels in the schools as well as to enhancing opportunities for the exhibition and sale of art works, and a strong commitment to the Southern environment as an emotionally supportive and intellectually rewarding context are all evident in the development of art in two Southern cities—Charleston and Savannah—in the first half of this century. Each city had a strong sense of its past and of its future potential, but both had been bypassed by the railroads of the New South and therefore by the New South's industry. Each city possessed an Art Association that had provided, in the late nineteenth century, a modest public art collection together with opportunities for aspiring artists to study and copy art in the building that housed that collection. And each city was blessed with one or more artists who provided examples of leadership and tenacity in their profession.

For Charleston, this pioneer figure was Alice Smith, accompanied by her friends Lelia Waring and Ellen Day Hale, and later by her colleague Alfred Hutty. In Savannah, the Cabaniss sisters, Lila and Mary, together with Christopher P. H. Murphy and his wife, Lucile Desbouillons, gave comparable impetus to the art scene. Their students—in Charleston, Elizabeth O'Neill Verner and Anne Taylor Nash, and in Savannah, Emma Wilkins, Hattie Saussy, Myrtle Jones, Christopher A. Murphy, and his sister, Margaret—continued to give support not only to the local art associations and etching clubs, but also to the arts at both the state and regional levels. And all, to one degree or another, were also involved in the preservation of their city's architecture, its gardens, and its honored customs.

This pattern was repeated with increasing frequency throughout the South. While New Orleans had maintained an active artists community right through the end of the nineteenth century, it was given fresh direction with the establishment in 1887 by Ellsworth Woodward of Newcomb College, where for the first time professional art education could be obtained by Southern women in a regular program of study in the South. In Atlanta, first Horace Bradley and then Adelaide Everhart and Lucy May Stanton were instrumental in laying the groundwork for the Atlanta Art Association, chartered in 1905.

To their credit, there was no one dominant style in either Charleston or Savannah, although fine draughtsmanship was emphasized due to the strength in each community of its printmakers. The subjects that most naturally appealed, given the interest in preservation in each community, were the streets and buildings, and their occupants, that gave each city its individual character. And, given the paucity of opportunities for professional training once an artist's initial studies were completed, each artist tended to depend on the other artists of the community for encouragement and support—a pattern followed on a larger scale with the founding of the Southern States Art League in 1921, which for the first decade and a half of its existence was an intensely cooperative enterprise, relying on the personal examples and persuasiveness not only of its directors but of anyone with a mind to volunteer in "the cause."

What did not appear in the art of these two communities was any prominent urge to experiment with abstraction or other avant-garde developments in the art of the twentieth century. Part of this was due to the conscious effort on the part of artists associated with the Southern States Art League to emphasize Southern subject matter; the positive end of this goal was the heightening of public awareness of the virtues of Southern culture in its best and most characteristic manifestations. If the South that was portrayed as a result of this bias tended toward the picturesque and pre-industrial, it was also a South that was rich in literary and historic associations, and that possessed an evident beauty and vitality. It was also a South in which blacks were portrayed sympathetically, with little condescension and with respect for their traditions (Elizabeth O'Neill Verner, for instance, fought the city of Charleston in the cause of Charleston's flower vendors, whom the city wished to banish from the streets as a traffic nuisance).

ELIZABETH O'NEILL VERNER (1883–1979)

Probably the best-known twentieth-century woman artist of Charleston was Elizabeth O'Neill Verner. The daughter of a rice-broker, she received her early education in Charleston and Columbia, South Carolina. Her artistic ability already apparent at the age of fourteen (the year she sold her first painting), she received encouragement from Alice Ravenel Huger Smith, the Charleston artist. Verner enrolled at the Pennsylvania Academy of the Fine Arts in 1903, studying for two years before returning to Charleston. Soon after her return, she married E. Pettigrew Verner, and raised a family of two children while painting scenes of Charleston in her spare time. In 1923, shortly after completing her first etching, she helped to organize the Charleston Society of Etchers. When her husband died in 1925, Verner turned to her art as a means of supporting herself and her family, and became a prolific pastellist and printmaker.

The Flower Vendor is an example of the sensitivity that Verner conveyed in her carefully drawn and richly colored images of these black street merchants. She considered the flower vendors to be an integral part of the charm of Charleston, and once had to champion their cause to prevent the city of Charleston from banning them from the streets as a traffic nuisance. Verner's unique technique of drawing in pastel on dampened silk mounted on wood is also represented here.

In addition to Verner's many art memberships and awards (she had been, among her other activities, a founder of the Southern States Art League and chairman of the Carolina Art Association), she was also a staunch preservationist, being a charter member of the Preservation Society of Charleston who helped to inspire similar efforts in Fayetteville, North Carolina, and Savannah, Georgia. She lectured on art and architecture at art and other clubs and universities in this country, Cuba, Mexico, and the Phillipines, and during both the First and Second World Wars she taught art to enlisted men in Charleston.

Verner continued her education after 1925, studying etching in 1930 at the Central School of Art in London, and sumi painting with Rakasan in Kyoto, Japan. She received commissions from the Mount Vernon Ladies Association, Rockefeller Center, Historic Williamsburg, the City of Fayetteville, Harvard Medical School, the United States Military Academy, Princeton University, and the University of South Carolina, all to portray their buildings and gardens in drawings and etchings. She wrote four books illustrated with her etchings—*Prints and Impressions of Charleston* (1939); *Mellowed by Time* (1941); *Other Places* (1946); and *Stonewall Ladies* (1963), and also illustrated DuBose Heyward's *Porgy*. The recipient in her lifetime of three honorary degrees, Verner died in 1979 at the age of 95.—James M. Sauls, Curator, The Robert P. Coggins Collection

(The most complete biography of Verner can be found in McKissick Museums, The University of South Carolina, *Mirror of Time: Elizabeth O'Neill Verner's Charleston*, Columbia, S.C., 1983.) NCAB, supp. L, 133; Gibbes Art Gallery, *Elizabeth O'Neill Verner, A Retrospective Exhibition on Her 80th Birthday*, Charleston, S.C., 1963; McKissick Museums, University of South Carolina, *Mirror of Time: Elizabeth O'Neill Verner's Charleston*, Columbia, S.C., 1983; Coggins Collection of American Art: Artist Files; also acknowledgment to Nina Parris and Martha Severens

89. *The Flower Vendor.*

Pastel on silk. 27⅞″ × 23″.
Signed, lower right: "Elizabeth O'Neill Verner".
Provenance: Robert M. Hicklin, Jr., Spartanburg, South
 Carolina.

CHRISTOPHER PATRICK HUSSEY MURPHY (1869–1939)

C. P. H. Murphy was a major figure in the development of the art of Savannah, Georgia, in the early twentieth century. Little is known about his early life or training, although it is known that he studied art with Eban Comins in Gloucester, Massachusetts, and that he was a friend of the printmaker, Joseph Pennell. Murphy's preferred medium was watercolor, but he also worked in pastel, charcoal, and oil. He traveled widely, finding subjects in Gloucester, New York, Washington, D.C., and North Carolina as well as in the landscapes, architecture, and city life of Savannah. He was a member of the American Watercolor Society, and an active participant in the early years of the Savannah Art Club and the Southern States Art League. He was married to the artist, Lucile Desbouillons, and both of their children—Christopher, Jr., and Margaret—also became painters.

Coggins Collection of American Art: Artist Files; also acknowledgment to Terry H. Lowenthal, Elizabeth Scott Shatto, and Miss Margaret A. Murphy

90. *Big Top.*

Watercolor on board. 9¾" × 14¾".
Signed, upper left: "Christopher P. H. Murphy".

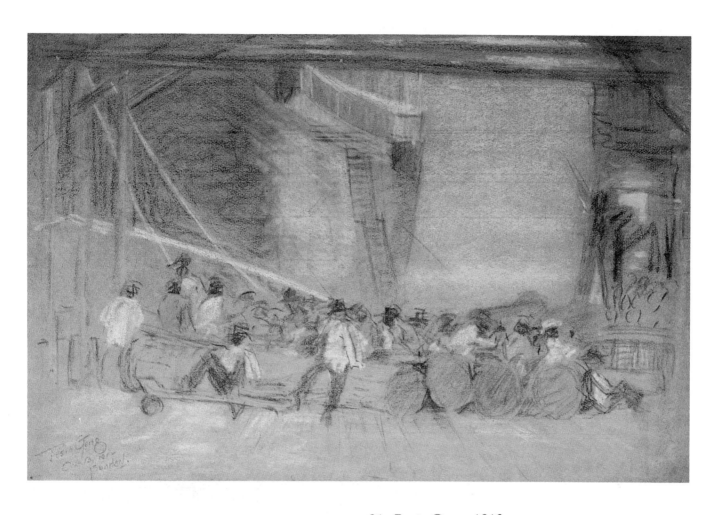

91. *Rosin Gang.* 1912

Pastel on board. 12¼″ × 18½″
Inscribed, lower left: "Rosin Gang. Oct. 13, 1912. Sunday".
Provenance of both works: Family of the artist; Terry H. Low-
 enthal, Savannah, Ga.

LUCILE DESBOUILLONS MURPHY (1873–1956)

Lucile Desbouillons Murphy was the daughter of Aristide Louis Desbouillons (b. Chateau-Gontier, France), a physician and jeweler who had first studied medicine in London, and then had emigrated to Savannah where he owned and managed a jewelry store. Her mother, also born in France, was Louise Merckling Desbouillons.

Lucile Desbouillons first studied art at the Telfair Academy of Arts and Sciences under its first director, Carl Brandt. She then went abroad, to Paris, where she enrolled in 1895 at the studio of Courtois, where other artists—among them, Bernard Boutet de Monvel—served as critics. The Savannah painter, Emma Wilkins, accompanied Lucile Desbouillons to Paris and worked in the same studio.

In 1900, Lucile Desbouillons married Christopher P. H. Murphy, another Savannah artist. Later in her career she taught French at the Saint Vincent's Academy in Savannah. With her husband and her two artist-children, Christopher, Jr., and Margaret, she was part of an active community of Savannah artists that included not only Emma Wilkins, but also Lila and Mary Cabaniss, Hattie Saussy, and William Posey Silva.

Coggins Collection of American Art: Artist Files; also acknowledgment to Terry H. Lowenthal, Elizabeth Scott Shatto, and Margaret A. Murphy.

92. *Black Man Seated on a Chair.* ca. 1910.

Sepia wash on paper. 12⅜" × 9 1/16".
Signed, lower right: "Lucile Desbouillons".
Provenance: Family of the artist; Terry H. Lowenthal, Savannah, Ga.

ANNE TAYLOR NASH (1884–1968)

Anne Taylor Nash is one of those fascinating mysteries that continue to appear in Southern painting. Born Anne Mauger Taylor in Pittsboro, North Carolina, she attended Pittsboro Scientific Academy, St. Mary's Junior College in Raleigh, and Winthrop College in Rock Hill, South Carolina. In 1906 she married Edmund S. Nash of Wilmington, North Carolina, later moving with him to Charleston, where she raised a family of three children.

Persuaded by her friend, Elizabeth O'Neill Verner, to try her hand at painting in about 1924, she studied art at the Gibbes Art Gallery, at the Pennsylvania Academy of Fine Arts, and at the art schools in Fontainebleau, France, and San Miguel del Allende, Mexico (with Wayman Adams). She also studied privately with Robert Brackman. She then exhibited regularly at the Southern States Art League's annual exhibitions from 1931 to 1935, and with the Charleston and Savannah art clubs. She seems, however, to have stopped painting at about the time that she and her husband moved to Savannah in 1937, and did not take her art up again until after her husband's death in 1948, when she began doing occasional portraits on commission in what can only be described as a flaccid society-portrait style.

According to her family, she did go back to art school after 1948, but Nash's most creative and experimental period as a painter certainly dates to the late 1920s and early 1930s, when she had developed a strongly-constructed, somberly-colored, and unique personal style that placed her briefly in the ranks of Southern modernists.

Telfair Academy of Arts and Sciences, Savannah, Ga.: Artist Files; also acknowledgment to Terry H. Lowenthal, Elizabeth Scott Shatto, and Hugh Nash

93. *Lady in a Porch Chair.* early 1930s.

Oil on canvas. 34¾″ × 30″.
Provenance: Family of artist; Terry H. Lowenthal, Savannah, Ga.

HATTIE SAUSSY (1890–1978)

Born in Savannah, Georgia, of a distinguished Georgia family, Hattie Saussy first studied art in elementary and secondary school with Lila Cabaniss and Mrs. Wilkins (mother of the artist, Emma Wilkins). She was a frequent visitor to the Telfair Academy of Arts and Sciences, where she took courses and studied the collection of American and European Impressionist paintings. Blind in one eye due to a childhood accident, she compensated with an intensity of interest and application that persuaded her now-widowed mother to move to New York City so that her daughter could receive further art training. Saussy thus continued her studies at the New York School of Fine and Applied Art (now the Parsons School of Design) from 1908–1909; at the National Academy of Design from 1911–1912; and at the Art Students League (1912) under Eugene Speicher, Frank Vincent DuMond, and George Bridgman. Between 1913 and 1914, Saussy traveled in Europe, returning to this country only with the advance of World War I. While in Europe she visited and sketched in Luxembourg and Switzerland and the cities of Munich, Verona, Florence, and Venice.

The following year, the death of her younger brother "Rad" in a drowning accident dealt her a severe blow. For the next three years, during the war, she worked in a government office in Washington, D.C. She then taught art for a year (1920–21) at Chatham Hall in Virginia. By the mid-1920s, however, Saussy had resumed painting full time, designing and supervising the building of her own house and studio in Savannah, her home until her death. From this base, she traveled to the Carolinas, north Georgia, and New Orleans to paint land- and cityscapes; she also painted still lifes and portraits.

According to her biographer, Thetis B. Rush, while Saussy "did not have to depend upon the sale of her work to provide subsistence," and "did not generally seek commercial outlets" (see Robert M. Hicklin, Jr., Inc., *Hattie Saussy, Georgia Painter*, Spartanburg, S.C., 1983, p. 3), she remained an active participant in and supporter of the Savannah art community and served as president of the Association of Georgia Artists (1933–34). She also continued both to study and to teach art intermittently. In her paintings, her deft touch and gentle, unobtrusive sense of light and color won her many supporters and friends.

94. *In the Hall.* ca. 1927.

Oil on board, 20″ × 24″.

Signed, lower right: "Hattie Saussy"

Provenance: The artist to her friend, Myrtle Jones; Terry H. Lowenthal, Savannah, Ga.

Exhibitions: Southern States Art League, 7th Annual Exhibition, Gibbes Art Gallery, Charleston, S.C., 1927, No. 50; Davison-Paxon Company, "Exhibition of Georgia Art," Atlanta, Ga., January 16–25, 1928, No. 81; Arnold Gallery, Shorter College, "Women in Art: Early Twentieth Century Selections from the collection of Robert P. Coggins, M.D., Rome, Ga., November 16–25, 1980, No. 24.

CHRISTOPHER ARISTIDE DESBOUILLONS MURPHY
(Christopher Murphy, Jr.) (1902–1973)

Son of the artists Christopher P. H. Murphy and Lucile Desbouillons Murphy, and brother to the artist Margaret A. Murphy, Christopher Murphy, Jr., was the most prolific and successful member of this Savannah family of painters. Already drawing and painting at age 11, he went from high school studies at the Benedictine School in Savannah to three years of additional practice at the Art Students League in New York, where he worked under Frank Vincent DuMond and George Bridgman. Even before he had completed high school, however, he had through his parents become a familiar participant in the Savannah art scene, influenced in his choice of a profession not only by family example but also by such visiting artists and art theorists as Joseph Pennell and Hardesty G. Maratta, the inventor of the Maratta Theory of

Color that was to have a lasting effect not only on Murphy's work but also on the work of Robert Henri and George Bellows in New York.

After completing his studies at the League, and another year of work at the Beaux Arts Institute in the same city, and after working for a time with the New York City architect, Lloyd Warren, who provided him with the fundamentals of architectural drawing techniques, Murphy received a Tiffany Foundation Fellowship that enabled him to travel and to develop his knowledge of different media, most notably etching, at which he became a master (his etchings of historic Savannah buildings are still much in demand).

When he was not teaching at Armstrong College or the Telfair Academy of Arts and Sciences, both in Savannah,

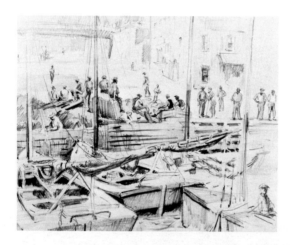

95. *Barnard Street Slip.*

Pencil and charcoal on paper. 8½″ × 11″.
Signed, lower right: "C. M. Jr."

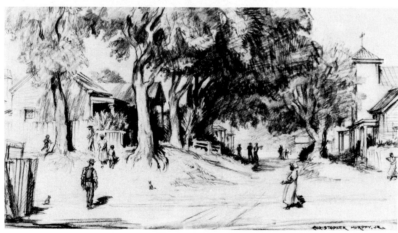

96. *Joe Street, Savannah.*

Charcoal on paper. 9¾″ × 15½″.
Signed, lower right: "Christopher Murphy, Jr."; inscribed, upper right: "Joe Street, Savannah".

97. *Theresa in Orange.* ca. 1932.

Oil on canvas. 20¼″ × 24″.
Signed, lower left: "Christopher Murphy, Jr."
Exhibited: Southern States Art League, 12th Annual Exhibition, Highland Park Society of Arts, Dallas, Texas, 1932, No. 11.

Murphy was painting and drawing a wide range of subjects—landscapes, portraits, architecture, and still lifes being his preferences—along the Eastern seaboard from North Carolina to Florida.

Joe Street and *Barnard Street Slip* show Murphy's sure-handed drawing skills and his sense, too, of the atmosphere and character of place, while the two portraits in this exhibition evince his love of bold, vibrant color in unusual combinations. Murphy once wrote that his approach to art was "to depict the subject without swamping it with technical mannerisms. . . . to convey clearly the innate interest of the subject . . . in a pleasurable form" (cited in Telfair Academy of Arts and Sciences, "Christopher A. Murphy," exhibition catalogue, Savannah, Georgia, 1974).

Telfair Academy of Arts and Sciences, *Christopher A. Murphy*, Savannah, Ga., 1974; Coggins Collection of American Art: Artist Files; also acknowledgment to Terry H. Lowenthal, Elizabeth Scott Shatto, and Margaret A. Murphy

98. *Green Kimono.*

Oil on canvas. 22″ × 18″.
Signed, lower left: "Christopher Murphy, Jr."
Provenance for all four works: Estate of the artist; Terry H. Lowenthal, Savannah, Ga.

MARGARET A. MURPHY (1908–)

Margaret A. Murphy is the daughter of the artists C. P. H. Murphy and Lucile Desbouillons Murphy, and the sister of the artist Christopher Murphy, Jr. She studied painting with her parents and brother, and, in 1931, began teaching art in the Savannah-Chatham County Public School system, where she was the first supervisor of art programs for the elementary schools. She continued teaching at the elementary and high school levels in Savannah until her retirement in 1971; she also taught at Southern Teachers College, Mercer University, and Armstrong College, all in the state of Georgia. She re-

ceived her bachelor's degree in art, under Lamar Dodd, at the University of Georgia in 1942, and her Master's degree—funded by a Ford Foundation Fellowship—at Columbia University in New York in 1955. She also earned a Masters of Education degree at the University of Georgia in 1971.

Proud of her achievements in the public school system—she was a pioneer in art education in the Savannah schools at a time when there was little support for the idea—and modest about her accomplishments as a painter, "Miss Margaret" sums up her career simply in conversation: "I consider

99. *Tybee Beach.*

Oil on canvas-textured paper. 20″ × 15⅞″.
Signed, lower right: "Margaret A. Murphy".
Exhibitions: Arnold Gallery, Shorter College, "Women in Art: Early Twentieth Century Selections from the collection of Robert P. Coggins, M.D.," Rome, Georgia, November 16–25, 1980, No. 15.

growing up in a family of artists, where books and magazines of art were always available, to have had a great influence on my interest in art. The other major experience was a year in New York City studying and visiting outstanding teachers, followed by a tour of Europe in the summer."

Coggins Collection of American Art: Artist Files; also acknowledgment to Terry H. Lowenthal and to the artist herself

100. *Still Life with Guitar.*

Oil on canvas. 19⅞″ × 23¹⁵⁄₁₆″.
Signed, lower left: "Margaret A. Murphy".
Provenance of both works: The artist; Terry H. Lowenthal, Savannah, Georgia.

THE DISCOVERY OF MODERNISM:
NELL CHOATE JONES AND WILL HENRY STEVENS

The works of these artists—Smith, Hutty, Verner, Nash, the four Murphys, and Saussy, of those who are included in this collection—stand in their own right as strong evidence of the maturing of Southern art in the twentieth century, and in sum give the lie to Mencken's sardonic appraisal.

The works, finally, of two other Southern artists, Nell Choate Jones and Will Henry Stevens, lead the way to the next phase of Southern art, the discovery of modernism, which was largely a post-World War II development. Nell Choate Jones, born in Hawkinsville, Georgia, was the daughter of a Confederate Army captain. When her father died in 1884, she moved with her mother and her siblings to Brooklyn, where she was to live for the remainder of her life (she died in 1981 at the age of 101). For many years a schoolteacher, it was not until the mid-1920s that she took up professional art studies, winning critical favor by 1927 for her Impressionist landscapes done in Italy, France, and Brooklyn.

A trip back to Georgia in 1936 made a profound impression, and for the next two decades continued to be the source of much of her best painting. Her vivid colors and openly Expressionist style, most evident in *Georgia Red Clay* of 1946, find their closest parallel in the early work of Charles Shannon and the rural scenes of Robert Gwathmey without imitating either of those contemporaries.

Like Anne Goldthwaite, Nell Choate Jones was a staunch supporter of the cause of women in the arts, serving as president of the National Association of Women Artists and receiving their Medal of Honor in 1955. Clearly free of derivation and filled with an independent energy and strength, her work deserves to be better known.

The same can be said as well of the work of Will Henry Stevens, one of the South's pioneer abstract painters. Born in Indiana, a student at the Cincinnati Art Academy and a ceramic tile designer at Rookwood Pottery, in 1901 Stevens found himself in New York City with little clear sense of direction. With the encouragement of Van Dearing Perrine and Albert Pinkham Ryder, among others, Stevens was led to the discovery of Oriental art and thereby to Taoist philosophy. His work thereafter was a search for the order of nature as nature revealed it to an artist willing to abandon preconceptions of "reality." Working with a wide variety of media, often experimenting to achieve particular solutions to problems, Stevens relied extensively on intuition and on random accident to suggest images that then were discovered to approximate nature's effects as the artist perceived them.

If this process seems more than a little visionary, it was; and it represented the logical continuance of the work of Drysdale and Meeker. And, like Drysdale and Meeker, Stevens was entranced by the Mississippi bayou country, where he settled in 1920, invited by Ellsworth Woodward to become part of the teaching faculty of Newcomb College. He would spend the winters in New Orleans, but he would also travel each summer to the North Carolina mountains, where on one trip he executed *The Brook*, a typical study in charcoal of the concealed formal life of nature.

Before returning to New Orleans in the fall, Stevens made a habit of returning to New York City to renew his friendships with artists such as Robert Henri and George Bellows, or simply to look around at the latest developments of modern art. It was on one of these trips, in the early 1930s, that Stevens encountered the Guggenheim collection of nonobjective painting, then recently opened to the public. The works there, particularly, of Kandinsky and Klee were a revelation, and suggested to Stevens further ways of refining his essentially meditative art. From that point until his death in 1949, Stevens maintained two parallel and complementary tracks in his painting, the one still dependent on observing nature, and the other openly abstract on the surface, but still related to his earlier visionary style in its distillation of effects.

There it is, the grand sweep of Southern artistic events, from the portraiture and landscape views of the early nineteenth century right through to the advent of a modernist consciousness. Even then, it is only a fragmentary view, dependent on the choices of a particular collector as on the limits of our present knowledge of Southern art and artists. But it is enough to suggest a far greater panorama, extending beyond the boundaries of vision. It is enough to suggest, too, the many questions that remain unresolved about Southern art, and the many issues that will require further exploration. It was never enough to remain in blissful, unheeding ignorance of our own heritage, and perhaps, just perhaps, collections such as this one will prick us back into inquiring life.

NELL CHOATE JONES (1879–1981)

Nell Choate Jones was born in Hawkinsville, Georgia, the daughter of a Confederate army captain. When her father died in 1884, she moved with her mother, brother, and sister to Brooklyn, New York, where she remained a permanent resident for the remainder of her extraordinarily long life. (She died in 1981 at the age of 101). For many years she taught kindergarten and elementary school classes. It was not until the mid-1920s that, with the encouragement of her husband, the painter and etcher Eugene A. Jones, she began to paint regularly. With her husband she exhibited at the Holt Gallery in New York in 1927; her bright Impressionist views of France and Italy, where they had traveled the previous year, won immediate critical favor.

Awarded a scholarship in 1929 to study at the art school at Fontainebleau, France, she worked there for a year, and then later continued her art training in England. She also appar-

101. *Georgia Red Clay.* 1946.

Oil on canvas. 25″ × 30″.
Signed, lower right: "Nell Choate Jones".
Exhibitions: The Marbella Gallery, Inc., "Paintings by Nell Choate Jones," New York, May 22–June 2, 1979, No. 4 (Illustrated, cover of brochure); The Atlanta Historical Society, "Land of Our Own: 250 Years of Landscape and Gardening Tradition in Georgia, 1733–1983," Atlanta Historical Society, Atlanta, Ga., March 1–August 31, 1983.

ently took some art courses in New York, and worked in New Mexico where she lived among the Quieres Indians.

A trip back to Georgia in 1936 for the burial of her sister made a deep impression on Jones, and was the source for many of her drawings and paintings of the next two decades. While she emphasizes the picturesque qualities of Southern life, her simplified forms, rhythmic designs, and intense though often somber color combine to produce a unique and almost Expressionist sense of latent energies.

An active participant in the Brooklyn art community, she served as president of the Brooklyn Society of Artists from 1949–1952, and later was a board member of the Brooklyn Museum. She also was president of the American Society of Contemporary Artists and, from 1951–1955, president of the National Association of Women Artists, from whom she received the Medal of Honor in 1955, and by whom she was

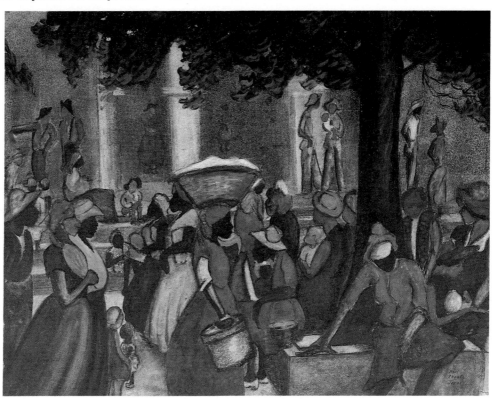

102. *Court Day, Marietta.*

Charcoal, pencil, ink and gouache on tracing paper.
19″ × 24″.
Signed, lower right: "Nell Choate Jones".
Exhibitions: The Marbella Gallery, Inc., "Paintings by Nell Choate Jones," New York, May 22–June 2, 1979, No. 29.

named Woman of the Year in 1975. She was also active in the Southern States Art League, the Boston Art Club, and the Pen and Brush Club, was awarded an honorary doctorate by Hamilton State University in 1972, and was given the Brooklyn Museum's Distinguished Citizen Award in 1979.

Coggins Collection of American Art: Artist Files

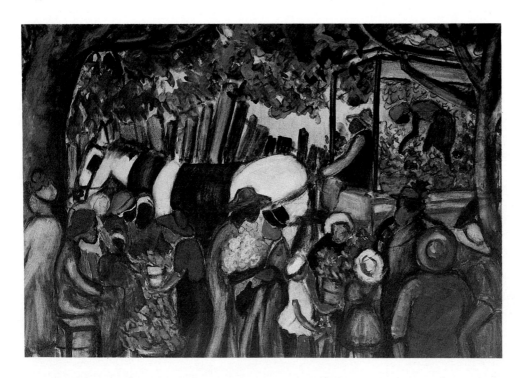

103. *Spring Time—Flower Vendor Entering Atlanta.*

Charcoal, pencil, ink and gouache on tracing paper. 13¾″ × 20¼″.

Signed, lower right: "Nell Choate Jones".

Exhibitions: The Marbella Gallery, Inc., "Paintings by Nell Choate Jones," New York, May 22–June 2, 1979, No. 26; Southern Arts Federation, "Southern Works on Paper, 1900–1950", catalogue by Richard Cox, Atlanta, 1981, No. 13 (Illustrated p. 22).

Provenance for all three works: Marbella Gallery, Inc., New York

WILL HENRY STEVENS (1881–1949)

Of all the rediscoveries of this and other recent collections of Southern art, the works of Will Henry Stevens are among the most interesting, for Stevens worked out an intuitive and highly personal mode of pictorial abstraction that grew directly from regional landscape painting foundations.

Born in Vevay, Indiana, on the Ohio River, Stevens grew up amid the woods, glacial hills, fossil beds, and Federal houses of the Indiana-Kentucky border country. His great-grandfather was the Cincinnati architect, William Stevens, although his family had generally taken more to literary and publishing pursuits. His father, an apothecary, taught Stevens the elements of chemistry and the techniques of emulsions, which were later to play a large part in Stevens' experiments with various media.

In 1897, at age 16, Stevens enrolled in the Cincinnati Art Academy, where he studied for three years under Frank Duveneck, Lewis Henry Meakin, and Vincent Nowottny. In what would have been his fourth year in art school, he chose instead to work as a designer of tiles at Rookwood Pottery. Stevens then went to New York City to study at the Art Students League. Dissatisfied with the classroom style of William Merritt Chase, however, Stevens soon dropped out of the League to seek his fortunes elsewhere. He discovered the New Gallery on 30th Street, which displayed an active interest in the more contemporary art movements under the guidance of its owner, Mary Bacon Ford.

At the New Gallery, Stevens met and received the encouragement of Jonas Lie, Van Dearing Perrine, and Albert Pinkham Ryder. He was also given his first one-man show at the gallery in April, 1901. On his return to Vevay later that same Spring, he visited the Freer Gallery in Washington, D.C., where he discovered the Sung Dynasty paintings that were to have a lifelong effect on his paintings.

Seeking more information on Oriental art and philosophy, Stevens turned to his friend Perrine, who introduced him (through the architect, Claude Bragdon) to Lawrence Binyon's *Flight of the Dragon* and Ouspensky's *Tertium Organum*. These led to further reading, and eventually to the teachings of Lao-Tzu, in which Stevens saw creative parallels not only to the poetry of Walt Whitman that had captured his interest as a boy, but even to the advice he had received earlier from Albert Pinkham Ryder: "Now remember, you are a poet. Don't go do what so many painters are doing today—painting out before nature all the time. Just walk out in the pleasant time of evening" (quoted in Bernard Lemann, "Will Henry's Nature: The Pictorial Ideas of W. H. Stevens," unpublished manuscript, New Orleans, ca. 1946–47—hereafter acknowledged as the major source of information for this essay).

What Stevens felt all of these diverse sources held in common was an attitude toward the world, summed up in Steven's own statement: "The best thing a human can do in life is to get rid of his separateness or selfness and hand himself over to the nature of things—to this mysterious thing called the Universal Order, that any artist must sense."

That is to say, there is no "right" or preordained order to be imposed on the world in the act of seeing; there is only one's own ordering of "reality", which—in a typical Taoist paradox—if it is coherent with the underlying, intuitively-sensed order of the universe itself, is never an order possessed, but merely shared momentarily.

As in Ryder's advice, the artist does not go out to paint what is already visible, but rather absorbs the world through casual encounters with it, and then constructs his or her own subjective—even "poetic"—account, fully aware at the same time that even this activity represents an incomplete and transient comprehension.

Nonetheless, the artist is thus freed to pursue his or her own unique path, for all subjectivities are equally legitimate—if equally fragmentary—as entrances into spiritual understanding (hence the parallel to Whitman's songs of the self). In Stevens's words, the picture is but a "by-product" of this search, a step towards a whole that can never be fully realized.

This aesthetic philosophy had a profound impact not only on what Stevens chose to paint—he inclined toward a wide variety of landscapes, from the deciduous woods of Indiana to the bayous of the Mississippi Delta and, for contrast, the mountains of North Carolina where he spent each summer from about 1910 until the year before his death—but also on how he chose to paint it. This was not a matter even of the degree to which he abstracted formal design elements from what he saw, but as much his willingness to work with his media empirically and intuitively, inventing solutions to pictorial problems as he went along. These solutions involved the development of a type of nonrubbing chalks for his pastels that would fix their own colors as they were applied to the paper, and a whole sequence of emulsions, from tempera and oil to wax, used in such a range of combinations that they are today almost impossible to distinguish. But perhaps his most interesting technical innovation was to allow random strokes and blots of color to float onto and penetrate a prepared wet paper, thus defining of themselves the starting point for the emergence of the final image—this independently of the experiments with accident and chance of the Dada and Surrealist painters.

Between 1901 and 1920, Stevens lived in Vevay, making

annual excursions to sketch around Gatlinburg, Tennessee, Mobile, Alabama, Biloxi, Mississippi, and New Orleans. He also visited his friends in New York on an annual basis, finding himself included there in the circle of writers and artists who gathered at Petitpas' restaurant—Robert Henri, George Bellows, William Butler Yeats, and the naturalist John Burroughs among them.

In 1920, Stevens was invited by Ellsworth Woodward, the New Orleans painter, to teach in the art school of Newcomb College—a position Stevens was to hold until his retirement in 1948. As he had in New York, Stevens quickly became part of a community of painters and writers that included not only the Woodward brothers, Ellsworth and William, but also Oliver LaFarge, Sherwood Anderson, William Faulkner, and the other young lions of the *Double-Dealer*. Through these friendships Stevens maintained an active contact with a wide range of ideas and cultural changes, while still quietly pursuing his own idiosyncratic path. But one encounter was to have a lasting effect on his later work, for, in the early 1930s, during one of his regular trips to New York on his way back from North Carolina to his classes in New Orleans, Stevens discovered the Guggenheim collection of nonobjective painting, recently opened to the public. The works there of Kandinsky and Klee, particularly, were a revelation, and a confirmation of Stevens's own sense of aesthetic direction. He began to work in a "nonobjective" mode while he continued to produce his more "objective" landscapes, perceiving that the two styles were complementary, the landscapes deriving from and maintaining his contacts with nature, and the abstractions serving as clarifying meditations upon the underlying order. In 1941 he exhibited each type of work at separate galleries in New Orleans, thus confounding his friends and followers who had come to expect a single "Stevens style." But for the artist, the two types of painting were of a whole cloth, neither dominating, and both equally logical in light of his philosophical development. In a taped interview with Bernard Lemann, Stevens observed: "I do not draw a line between objective and non-objective and have painted in the former way this winter and will continue to do so when I feel I have something to say in that way. . . . I am doing both and will continue to, so long as either seems vital to me."

James E. Neumann, *An Exhibition of Late Works by Will Henry Stevens*, Greenville, S.C., 1967; also acknowledgment to Bernard Lemann, New Orleans, La.

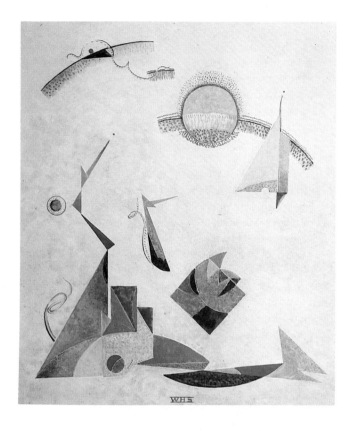

104. *Abstraction*. 1936–41.

Watercolor on paper. 16″ × 14″.
Signed, lower center: "W. H. S."

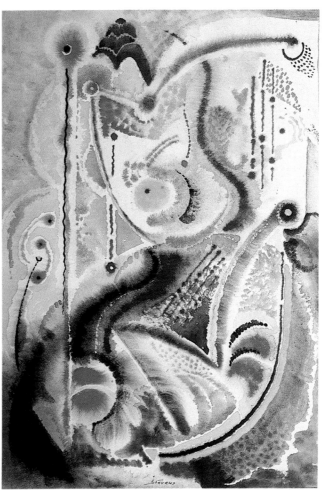

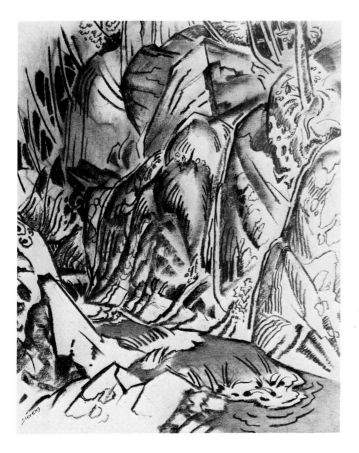

106. *Musical Abstraction.* ca. 1935

Watercolor on paper. 19⅞″ × 13⅞″.
Signed, lower center: "Stevens"; on verso is a student work
 signed: "Anne Gause, Oct. 22.35".
Provenance for all three works: Estate of the artist; Joh Cram,
 New Morning Gallery, Asheville, N.C.

105. *The Brook.*

Charcoal on paper. 17″ × 14″.
Signed, lower left: "Stevens".

NOTES

1. The Corcoran Gallery of Art, *American Painters of the South*, The Corcoran Gallery of Art, Washington, D.C., 1960; and The Virginia Museum, *Painting in the South: 1564–1980*, The Virginia Museum, Richmond, 1983 (hereafter abbreviated as *P.I.T.S.*)

2. *P.I.T.S.*, xiii

3. Wilbur Joseph Cash, *The Mind of the South*, Alfred A. Knopf, New York, 1941/1968, 94

4. C. Vann Woodward, *Origins of the New South, 1877–1913 (A History of the South*, Vol. IX), Louisiana State University Press and The Littlefield Fund for Southern History of the University of Texas, Baton Rouge, 1961, 453–454

5. H. L. Mencken, *The American Scene: A Reader*, ed. By Huntington Cairns, Alfred A. Knopf, New York, 1965, 158–159

6. Cited in Virginia E. Lewis, *Russell Smith, Romantic Realist*, University of Pittsburgh Press, Pittsburgh, 1956, 100–101

7. Cited in Elliot James Mackle, Jr., "The Eden of the South: Florida's Image in American Travel Literature and Painting, 1865–1900," Ph.D. diss., The Graduate Institute of Liberal Arts, Emory University, Atlanta, 1977, 18, 19, 20

8. Cited in Mackle, *op. cit.*, 72

9. Cited in Mackle, *op. cit.*, 95

10. Cited in Anne Rowe, *The Enchanted Country: Northern Writers in the South, 1865–1910*, Louisiana State University Press, Baton Rouge and London, 1978, 85

11. W. J. Cash, *op. cit.*, 46

12. Coggins Collection of American Art: Artist Files

13. *Webster's New World Dictionary of the American Language*, The World Publishing Company, Cleveland and New York, 1959, 1224, 1318, 1173

14. Twelve Southerners, *I'll Take My Stand: The South and the Agrarian Tradition*, intro. by Louis D. Rubin, Jr., Louisiana State University Press, Baton Rouge and London, 1930/1980

15. W. T. Couch, ed., *Culture in the South*, University of North Carolina Press, Chapel Hill, 1934, viii

16. Cited in Amy Helene Kirschke, "Elizabeth O'Neill Verner and the Southern States Art League," in The McKissick Museums of the University of South Carolina, *Mirror of Time: Elizabeth O'Neill Verner's Charleston*, McKissick Museum, Columbia, 1983, 31

17. Cited in Rick Stewart, "Toward a New South: The Regionalist Approach, 1900 to 1950," in *P.I.T.S.*, 126

18. Cited in Adelyn D. Breeskin, "Anne Goldthwaite," essays in catalogue, The Montgomery Museum of Fine Arts, *Anne Goldthwaite, 1869–1944*, The Montgomery Museum of Fine Arts, Montgomery, 1977, 9

BIBLIOGRAPHY

Mary Boykin Chestnut, *A Diary from Dixie*, ed. by Ben Ames Williams, Harvard University Press, Cambridge and London, 1980

Carlyn Gaye Crannell, "In Pursuit of Culture: A History of Art Activity in Atlanta, 1847–1926," Ph.D. diss., The Graduate Institute of Liberal Arts, Emory University, Atlanta, 1981

Eugene D. Genovese, *Roll, Jordan, Roll: The World the Slaves Made*, Vintage Books, New York, 1972

Patrick Gerster and Nicholas Cords, eds., *Myth and Southern History*, Rand McNally Publishing Company, Chicago, 1974

Anne Firor Scott, *The Southern Lady: From Pedestal to Politics, 1830–1930*, University of Chicago Press, Chicago and London, 1970

Daniel Joseph Singal, *The War Within: From Victorian to Modernist Thought in the South, 1919–1945*, University of North Carolina Press, Chapel Hill, 1982

C. Vann Woodward, *American Counterpoint: Slavery and Racism in the North-South Dialogue*, Oxford University Press, Oxford, New York, Toronto and Melbourne, 1983